DOCUMENTARY

Witness and Self-revelation

John Ellis

Routledge
Taylor & Francis Group

LONDON AND NEW YORK

First published 2012
by Routledge
2 Park Square, Milton Park, Abingdon, Oxon OX14 4RN

Simultaneously published in the USA and Canada
by Routledge
711 Third Avenue, New York, NY 10017

Routledge is an imprint of the Taylor & Francis Group, an informa business

British Library Cataloguing in Publication Data
A catalogue record for this book is available from the British Library

Library of Congress Cataloging in Publication Data
Ellis, John, 1952-
 Documentary: Witness and self-revelation / John Ellis.
 p. cm.
 Includes bibliographical references.
 1. Documentary films–Production and direction. 2. Documentary films–
History and criticism. 3. Cinematography. I. Title.
 PN1995.9.D6E48 2011
 070.1'8–dc22
 2011001704

ISBN: 978-0-415-57418-1 (hbk)
ISBN: 978-0-415-57419-8 (pbk)
ISBN: 978-0-203-80846-7 (ebk)

Typeset in Bembo and Stone Sans
by Taylor & Francis Books

MIX
Paper from
responsible sources
FSC FSC® C004839
www.fsc.org

Printed and bound in Great Britain by
TJ International Ltd, Padstow, Cornwall

Documentary

'*Documentary: Witness and Self-revelation* is one of the best accounts of the documentary process I've ever read: accurate, wise, perceptive and very readable.'

Roger Graef, *CEO, Films of Record*

Digital technologies have transformed documentary for both filmmakers and audiences.

Documentary: Witness and Self-revelation takes an audience-centred approach to documentary, arguing that everyday experiences of what it feels like to film and to be filmed have developed a new sophistication and scepticism in today's viewers. The book argues that documentary has developed a new third phase of its century-long history: films now tend to document the encounters between filmmakers and the filmed. But what do we really know about those encounters?

The author's extensive experience of documentary production practice also enables him to examine technological changes in detail. Innovations in technology can seem to offer greater realism but can at the same time frustrate attempts to achieve it. John Ellis therefore proposes the idea of 'Slow Film' as an antidote to the problems of increasing speed brought about by easy digital editing.

This book is ideal for students studying film, media studies and visual culture.

John Ellis is Professor of Media Arts at Royal Holloway, University of London and formerly a TV documentary producer. He is chair of the British Universities' Film and Video Council (BUFVC) and past vice-chair of both the subject association MeCCSA and the producers' organisation PACT. He has served as a member of the last two RAE panels.

He is author of several books including *TV FAQ* (2007), *Seeing Things* (2000) and *Visible Fictions* (1982), and he has published extensively in *Screen, Media Culture and Society* and other major journals. His work has been highly influential on the development of media and television studies in the UK, USA and Europe.

CONTENTS

ACKNOWLEDGEMENTS

I am indebted first to all the filmmakers with whom I have worked over the years. I hope that I have not misrepresented your methods too much by generalising from what I observed of them. I am indebted to my colleagues at Royal Holloway for their many comments as I have tried to work out the ideas contained here, and to some international study networks: Digicult, organised by Jostein Gripsrud, and a series of symposia on media witnessing organised by Paul Frosh, Gunther Thomas and others. I am very much in the debt of the students who have taken my course on documentary at Royal Holloway. I have quoted many of their comments in chapter 13. Their lively debates and fresh perspectives have changed my thinking on many issues. Above all, I am indebted to my partner Rosalind Coward, who has encouraged me to write in what I hope is an accessible way, and has contributed much to the ideas here. Without her constant support and encouragement, none of this would ever have been possible.

1

INTRODUCTION

Documentary is easy to identify but difficult to define. Anyone can tell that a particular film or TV programme is a documentary, but the range of documentary styles is vast. A film like *An Inconvenient Truth* argues passionately for a particular view; *Primary* is content to observe without comment; Chris Marker's *Sunless* knits together seemingly unconnected thoughts into a highly personal essay; *Capturing the Friedmans* tells a compelling story ... yet all of these films are called documentaries. Some filmmakers are rigorous in their belief in simply letting events unroll in front of their cameras; others will organise full-scale reconstructions of events, or see no problem in directing their subjects to behave in particular ways. Both methods have resulted in films that are called 'documentaries'. Uniting all these approaches is a need to get at 'facts'; to translate the realities of the world onto the screen; to portray the world as it is and – usually – to offer it up for critical scrutiny or to look at it anew. Documentaries insist 'these are the facts'; 'this is how things are'; 'this is what happened'; 'this is what I believe'; 'this is how they behave and why'. At the heart of documentary film- and programme-making lies an urgency to communicate. Documentary is about showing and telling.

Yet this does not get us much closer to a definition of documentary. It simply says what the aspirations of the filmmakers were, and, perhaps, what the consumers of documentaries might be expecting as well. This book takes a different approach. It looks closely at the documentary process and asks at each stage 'what exactly is it that is going on here?' If documentary is about showing and telling, then a definition of documentary should start from Lasswell's (1948) fundamental questions for communication studies ('Who says What to Whom through Which channel With What effect?'), together with what I take to be the fundamental question for visual studies ('what is the status of the image and how is it apprehended?'). There is a certain friction between these two approaches: Lasswell assumed a channel of communication that allows 'messages' to get through; visual studies assumes no such clarity. Images, even

more than words, are open to multiple interpretations. And even words have their problems. Repeatedly, in writing this book, I have come up against the inadequacy or bias of the words we have for discussing documentary. We still talk of 'film', when the overwhelming majority of documentaries are made and delivered using digital video. We talk of 'viewing' or 'watching' documentaries, when what we hear is equally important in our understanding of them. My frustration with the language sometimes creates terms that might seem overloaded. Sometimes it seems better to write 'recorded sound and image' rather than 'film' to stress the importance of sound in documentary. At other times, I have discovered a useful shorter term: the idea of a 'filmer', to mean anyone who films, whether within the film and TV industries or for other uses, seems particularly useful.

Despite the problems of 'communication' as a model, it is still useful to ask Lasswell's question of documentary because the answers are by no means simple. Documentaries involve the attempted communications of both people and agencies: for example, the filmmaker, the filmed and the broadcasting agency. All are trying to communicate differing ideas and values through their participation in the documentary. It is also important to ask who is receiving the documentary 'messages': a key contention of this book is that the viewers of documentaries have changed. Easy access to digital photography and video technologies has brought a new sense of familiarity with the basics of filming and being filmed, and this new sensitivity is brought to the viewing of documentaries. Attitudes to documentary have changed, and documentaries have changed to accommodate these new attitudes. The history of documentary is a dynamic one as the documentary process involves a two-way traffic. Filmmakers begin with events which they film and subsequently incorporate into a film text. The film's viewers come in the opposite direction: they start with the film and move towards an understanding of what the original events may have been. On each side, assumptions are made: the filmmaker will have an imaginary audience in mind when making the film (and so might the people being filmed as well). The eventual viewer will make assumptions about how the film came to be made in the first place, and what went on during the filming. The assumptions made by each side may be mistaken – one of the aims of this book is to help clarify the bases of these assumptions.

Documentary is passing through a major period of change brought about not by digital technology itself, but by how it is being used. This book argues that we are moving into a third phase in the development of documentary: the first being that of the cinema documentary, which made heavy use of reconstruction; the second that of observational documentary, which responded to the new opportunities and demands of television. This third phase is the result of new attitudes to photography in general, which have developed since the 1990s. The growth in all forms of photographic activity, enabled by digital technologies, seems to have reawoken long-held anxieties about photography.

Photography allows all kinds of activity in relation to individuals, from the creation of memories, through a constant requirement to 'look one's best', to the pervasive presence of surveillance cameras. Photography has produced a heightened awareness of being watched, evidenced in phenomena as diverse as an abiding fascination with

celebrities caught unawares, and the real public concern about surveillance cameras in public, business and institutional spaces. We are increasingly aware of being watched, and the fact that watching requires particular forms of performance of the self. We have learned what cameras require and how to provide it. Early TV gameshows involving 'ordinary' members of the public and early news 'vox pops' tend to show that such an awareness of the need for performance, and of the necessary modalities of performance, were much rarer than they are in contemporary society (Ellis 2011). To know these skills for oneself is also to be aware of them in the behaviour of others. From this familiarity emerges the frequent perception that individuals in documentaries are 'playing up' for the camera, or are behaving in ways that are somehow 'not true' to themselves.

We also know that, however good our performances may be, the camera can still catch us unawares. From the unconscious blink as the image is captured to transient grimaces frozen for ever, almost everyone has experienced the feeling of photography traducing how they might wish to appear. This feeling is as old as Kodak itself. Newer is its extension to the domain of the moving image and recorded sound. We may be able to come to terms with the strange sound of our own recorded voice compared with the sounds that resonate in our head as we speak. But the strangeness and awkward fascination that we experience on seeing our own videoed image is far harder to dispel. Photography appears to us as a treacherous activity: it produces both good and bad images, desired and undesirable images, of ourselves. In revealing our self as an other, it destabilises our perceptions of our self. Our attempts to manage this process involve forms of performance, negotiation and even pretence. Our increasing everyday encounters with photography and recording now involve far more than simply 'saying cheese' in a formal photographic setting. Photography, and particularly moving image recording, has developed at such a rate that different generations have contrasting attitudes and approaches to it. Where middle-aged people are still concerned with the possibility of being shamed by a TV appearance, younger generations have a more acute sense that any such appearance will be ephemeral and that any embarrassment will consequently be temporary: so why not 'go for it'?

Digital camera technologies have made the experience of being 'the other side of the camera' more routinely available. Kodak made the experience of being photographed commonplace; the Handycam and its successors brought the experience of being a filmer into everyday life. So most people now know about the delicate negotiations that take place to persuade someone to appear on camera; how difficult it is to get them to do what you want; how uncomfortable it sometimes feels to point a camera at someone, to ask them intrusive questions, to catch them unawares. Picking up a moving-image camera is a transformative experience: it catapults the individual into a role that often they feel unprepared to take up. No longer involved in the flow of events as a simple participant, the individual becomes something else as well. The camera gives the power to comment; it becomes an extra participant in the events, a focus for all kinds of hitherto submerged interpersonal dynamics. Amateur footage usually appears intensely ritualised as a result. It is easier to adopt standard roles than to work through the emotions stirred up by the presence of the camera in

the hands of a family member (or an interloper). The film *Capturing the Friedmans* captures much of this dynamic, from the adoption of TV modes as a communal family disguise to the decision of David Friedman to document the process of the family breaking down during the trial of the father and younger brother Jesse (Austin).

We now are familiar with what it feels like both to photograph and to be photographed. We know the processes of performance and the difficulties of adopting the position of the filmer. We know the problems and vagaries, too, of the subsequent uses of the material. Indeed, many of our anxieties relate to the subsequent uses of photos and recordings. They can easily be made 'just for fun', but they are a record, and a physical entity that can have a career of its own. The evidence of this is everywhere, unavoidable. Local newspaper users in the UK have developed a curious habit of taking out display adverts for relatives' birthdays illustrated with 'embarrassing' childhood pictures. Parents checking Facebook for their children's backpacking whereabouts sometimes come across photos not intended for their eyes. Sex tapes exposed on the internet sometimes break (or indeed make) the career of a celebrity or politician. Photographs and recordings are born in an intimate moment, but grow up quickly and take on a life of their own.

Anxieties haunt photography and recording, anxieties about the moment of making recordings and the subsequent uses to which they can be put. As recording becomes more commonplace, these anxieties have developed into a more sophisticated public attitude towards the consumption and use of recordings. The public for TV and internet moving images has become more sceptical around any material that claims to be 'factual', and more appreciative of the skills involved in manufacturing the modern fictional spectacle. A connoisseurship has developed, which asks 'how did they do that?' In relation to fiction, this enables the extension of the fiction itself into 'making of' materials. In relation to factual footage (documentary and news), it has produced a more sceptical viewing public, to which professional filmmakers and broadcasters have adapted their practices. Many of the ethical concerns that were once the subject of abstruse debates between journalists and documentary filmmakers now have a much wider currency. A public that is aware of the processes of obtaining footage now routinely ponders the nature of the shooting relationship. They assess what each side wanted from the filming, and in the case of documentaries like Molly Dineen's *Geri* (1999; about the former Spice Girl Geri Halliwell as she reinvents her career), the film actively concerns itself with the same question (Bruzzi 2006). Viewers will speculate amongst themselves about the nature of the editing and possible omissions of important material. When the issue is sufficiently important, they will scan the footage closely for tell-tale details in the background, which might indicate that an alternative version of events could be constructed. All this activity is essentially the same as that undertaken by professional organisations concerned with the truthfulness of the footage: whether journalists wanting to catch out their documentarists, or broadcasters trying to assess the nature of the 'user-generated content' that comes their way. In the new, third phase of documentary, the two-way street between filmmakers and their eventual viewers is congested with traffic.

The chapters

Chapter 2 sketches a history of documentary, from its origins in cinema to the crucial changes that took place as a result of the opportunities presented by television. It shows that reconstruction was a basic technique for filmmakers using the technology of entertainment cinema, especially after the introduction of sound recording. But reconstruction became anathema in the second phase of documentary, which instead emphasised the possibilities of observational camera and sound recording. Chapter 3 explores the roots of a sustained questioning of the idea of photography as evidence, the assumption that underlies much observational documentary work. It identifies the beginnings of this questioning in relation to still photography and the seeming ease with which still photos could be digitally altered and manipulated. This led to a more measured attitude to the role of photography as evidence (its ability to 'show and tell') rather than, as was predicted by some, a wholesale rejection of photography, and with it the possibility of documentary filming.

Chapter 4 begins a sustained examination of 'what is it that is going on' in the activity of documentary filming itself. This chapter traces the development of the filming and recording technologies available to filmmakers, from the development of lightweight 16mm film with synchronised sound at the end of the 1950s, through the ambiguous possibilities offered by analogue videotape, to the recent development of digital and then tapeless cameras. This account stresses the potentials that have been offered to filmmakers, and is drawn principally from my own experience as a documentary producer. The role of the documentary producer (in British TV at least) is one of assessing and obtaining the most appropriate resources for a project, so the accounts in the chapters devoted to technologies (chapters four and eight) rely on memory as much as written sources, which, it must be said, are scarce. Often the only accounts I have been able to find of particularly influential items of equipment have been the manufacturers' own websites and *Wikipedia* entries by enthusiasts.

Chapter 5 introduces the crucial methodology that I have drawn from the work of Erving Goffman, whose guiding notion about human interactions in concrete situations ('what is it that is going on here?') I have adopted to explore the documentary process. His ideas about the performance of self, about the framing and keying of personal interactions, are introduced here. Chapter 6 then applies them to the documentary situation, and particularly to the most deceptively simple of exchanges: the interview. Interviews are a special form of interaction, drawing on conversation, but with crucial differences in that the interviewer will not perform the usual part of the interlocutor. In addition, both parties are not only speaking to each other: they are addressing an eventual viewer, who exists at that moment only in their imagination, yet adds another framing to the exchange.

Chapter 7 explores the subsequent phase of editing, but as a further set of personal interactions. The director has to reassess the filmed encounter as a piece of film, as a document or text, rather than as a situation involving individuals. This crucial change of perspective is enabled by the editor. It also tends to leave the filmed subjects in something of a limbo: they do not go on the same journey of reassessment as the

director. Instead, they wait to see how their attempted communication with the eventual viewer will 'come across'. The director, in other words, is engaged in a new act of communication, moulding their footage into a film, where the filmed subjects are left with an incomplete communication. This has many practical and ethical consequences for the conduct of documentary filmmaking.

Chapter 8 examines the changing technologies of audiovisual editing, from 16mm film to digital video editing. It shows how the potentials for filmmakers have altered, and also how the relations of power and responsibility in the cutting room have changed. Digital technologies have made it easier to cut material and to circulate it to more parties, especially the financiers or commissioning editors, allowing more people to influence the final film. A further consequence, explored in chapter 9, is the increasing speed of editing that has been enabled by digital editing packages.

Chapter 9 introduces the idea of Slow Film as a counter to the increased speed of cutting. The chapter explores the cutting speed of both fiction and news, and shows that the idea of montage, still thought by some today to be radical, was radical only in an earlier phase of filmmaking. Montage has become commonplace and has lost its revelatory power. Slow Film provides a more radical gesture in the current circumstances, and it has been adopted as a technique by a wide range of documentary filmers.

Chapter 10 inaugurates a sustained examination of contemporary viewing attitudes to match those of the chapters devoted to the processes of documentary filmmaking. Chapter 10 begins to explore the idea of the 'eventual viewer': a major component of the filmmaking process, present in the minds of both filmers and filmed. It shows that the contemporary audience has developed a critical awareness, which finds ready expression through the many forms of electronic communication that are now available. The meaning of any documentary is not sealed by the editing of it. This is merely the first stage of a process of negotiation, which exposes the many different interpretations that can be made of any documentary text.

Chapters 11 and 12 explore the bases of these different interpretations. Chapter 11 looks at the fears about photography that underlie many of the attitudes that we spontaneously adopt: an unease about how we ourselves appear in sound and image; concerns about the ability of photographs to take on a life of their own beyond our control; and fears about the issue of surveillance. All of these feed into the current questioning of documentary films. Chapter 12 examines the nature of the experience of watching itself. It uses the concept of 'witness' to explore the specific nature of audiovisual watching and listening. The chapter establishes the similarities and the crucial differences between being present at an event, and witnessing an event through the audiovisual. It shows how much Lasswell's famous definition of communication ('Who says What to Whom through Which channel With What effect?') needs revision in light of photography and the audiovisual.

Chapter 13 uses examples from written feedback about specific documentaries to highlight the specific nature of the modern, critical viewer's reactions to documentaries. It shows a vivid appreciation of the ethical problems of documentary

filming. It also begins to explore how modern perceptions of the documentary process can result in very different kinds of interpretation of the same film. Today's viewers may be enabled to make more sophisticated assessments, but this does not lead to any greater degree of unanimity about the meaning of what they are seeing.

The chapters contain specific case studies relating to the questions in hand. Not all of them relate directly to documentary films or programmes. Documentaries are common, and many that were important in their historical moment are extremely hard to access subsequently. So I have preferred to address the totality of documentary making, rather than too many specific examples that might well not be familiar to you, the reader. Most of the content of this book appears here for the first time. Chapters 3 and 12 draw to some extent on a number of published articles (Ellis 2009a, 2009b, 2010).

2

FROM RECONSTRUCTION TO OBSERVATION

A history of documentary 1895–1995

Documentary is an activity. It consists of filming without fiction. Documentary filmmakers take the world as it comes, or arrange the world so that it comes in particular ways, and then work on the resulting footage. Documentary is an organised activity of creation. It makes an object, a film, which then goes on to affect its viewers. Documentary is also a task. Its task is that of presenting reality, showing the world, explaining the world. Documentary has an ethical task laid upon it, bound up with the difficult question of whether or not truth can ever be shown. So documentary is both a physical activity and an ethical task. These two aspects are bound together in Grierson's definition of documentary as 'the creative treatment of actuality' (Grierson 1966). The implied tension between that which was actual or real, and that which is creative, has always caused controversy. If the supporters of any given documentary claim that it shows 'the truth', then the film itself will inevitably fall short of this claim. If any film tries to construct an argument painstakingly with all available evidence, then that argument can be proved wrong by someone, somewhere, to the satisfaction of themselves and perhaps others. If a filmmaker tries to create an emotional response in viewers to enable them to empathise with the subjects of the film, then this will also provoke accusations of manipulation. Nevertheless, documentaries continue to be made and watched; more and more so, if anything. Documentary and truth may be uneasy companions, but the problem seems to be on the side of truth rather than documentary. Truth is an absolute, unarguable for those who believe it. Documentaries provoke doubt, argument and dispute. Their status is always in play, never finalised. That is what makes them fascinating as documents.

Some documentaries, however, are less fascinating than others. The pervasive nature of documentary-type filming in our culture has produced distinctions between 'documentary' and other, more predictable forms of factual filming. Before the era of television, in the first half of the twentieth century, a distinction was drawn between

documentary and informational films. An informational film would typically use already-shot library material and perhaps some staged elements. It would seek to convey a necessary message. A documentary from the same period would seek to do more: to show a series of situations, to present an analysis, or to open viewers' eyes to a new way of seeing. Both would typically use reconstruction and extensive voice-over commentary. The distinction between the informational and the documentary lay in the complexity of the production process and the finished product. Documentary was harder to make; and sometimes harder to watch.

Such distinctions continue today. The television industry, which pays for much of today's documentary production, routinely makes distinctions between documentary, reality TV and factual programming. The BBC's commissioning editor for documentaries briskly tells the industry that 'we're open for business on all the channels for constructed formats, ob docs, presenter-led films and bold, fresh, innovative ideas that will make a real impact in a multichannel world' (Moore 2010). These distinctions are sometimes less clear to some individual viewers, but the principles behind them seem to be well known. Factual programming includes programming that stretches beyond anything that could normally be confused with documentary. It includes studio-based cookery programmes, programmes about antiques and home decoration, gardening and other consumption- or leisure-oriented subjects. Reality TV is a more recent category, tracing its development to the mid-1990s. Reality TV uses elements of documentary filmmaking, and especially the filming of 'ordinary people'. It reduces the unpredictability of such filming by extensive preparation and staging of events. This staging can take the form of constructing an artificial situation into which the participants are catapulted. This was the format of the *Big Brother* franchise, where participants were shut together in a house with 24-hour camera surveillance. The format introduced further production controls by setting the participants a series of tasks while they were in that environment, effectively creating a hybrid between documentary and gameshow. *Big Brother* caused much anxiety on its introduction; once the format was familiar, it lost its initial shock. Potential participants knew what to expect. This is a crucial distinction between documentary and reality TV. Reality TV is format-based. The genre produces similar programmes in long series, and participants know what is expected of them. Indeed, reality TV producers find that people propose themselves as subjects, presenting themselves as types and knowing what is expected of them. The format is known and predictable to audience and participants alike. Episodes are often driven forward by a knowing, often comic voice-over, which directs viewers' attention to particular elements in the scene, or even defines its content comprehensively. Reality TV formats contain a little reality that is stretched a long way in a format that is essentially a gameshow or even fiction. As a form of entertainment, reality TV has gained wide acceptance as a new element in popular culture, though it is not without its longueurs, as reviewers note:

> This is one of those reality shows that wastes a good 25% of screen-time in flashing forward to the best bits coming up later or recapping the best bits that

have already happened. Which is a shame because, amid the repetitions, there was some good content.

<div align="right">

(Jones 2010)

</div>

In contrast to reality TV, the documentary genre implies unpredictability and novelty. Documentaries are films and programmes that seek to find their form from their subjects, rather than to impose a form on what they film. They do, however, impose a style. The history of documentary since the middle of the twentieth century has been dominated by television, and by the search for a style of filmmaking that would be more truthful or honest than those that had gone before. Documentaries shared TV space with both fiction and news, and had to distinguish themselves from both. TV documentaries sought to emphasise their nature as fact rather than fiction, and as analytical insight rather than journalism. The period from 1950 to 1980 in particular is marked by a series of bold stylistic experiments in observational documentary, each claiming to express more human truth than its predecessors. So during this period the history of documentary was often written as a simple history of linear development. These accounts regard documentary as reaching something close to perfection in some of the films produced in whatever present moment the historian happens to inhabit. Such histories tell the story of various schools or tendencies, each reacting to the perceived inadequacies of their predecessors.

I prefer to see the history of documentary as three relatively distinct phases, each of which has a distinct and different set of requirements for an honest, revealing 'documentary'. Cinema documentaries before the arrival of television in the 1950s made extensive use of reconstruction. The period from the development of TV until the middle of the 1990s is a phase of observational forms, in which the truth function of the image was paramount. By the middle of the 1990s, a new scepticism about the truthfulness of the documentary image was beginning to assert itself. We now find ourselves in a third phase, where documentary is seen as the record of a series of interactions between the filmers, the filmed and their eventual viewers. Each phase is triggered by new technological and distribution possibilities (not by technology alone), and reshapes both filmmaking practices and audience expectations. These are expectations about the reality of documentary images. For instance, the practice of reconstruction was perfectly acceptable in the 1940s. However, by the 1970s it had become profoundly suspect and was practised, if at all, under tightly controlled circumstances. Then practices of reconstruction began to re-emerge. One area was that of the TV history documentary (a genre that became popular in the 1990s), partly as a result of Errol Morris's influential cinema documentary *The Thin Blue Line* (1988). Reconstruction developed a distinct, stylised aesthetic of its own (tight close-ups, slow motion, non-naturalistic lighting, etc.) to make its status absolutely explicit. So in the space of fifty years, reconstruction in factual film had moved from a well accepted standard practice in documentary to a specialised approach that had to signal its status very clearly. Such an account is relevant to the development of documentary in Europe and America, and other cultures closely connected with them. A different account is necessary for China, where the use of reconstruction lasted far longer, and

the social role of documentary was conceived in a different manner for a long period (Berry 2007; Robinson n.d.).

The key factor in the changing attitude to reconstruction, and indeed in the development of documentary in general, is a change in beliefs about how the real can be portrayed adequately. Photography is always compromised in its relationship with the real. A photo is never a perfect reproduction, the camera does not have an all-seeing eye, nor does film or digital capture reproduce every last detail in front of the lens. There is always more that could have been shown, more that was seen and felt that could have been captured. The relationship between the image and the real is one of adequacy. Images work when they are good enough.[1] Is it good enough to convince? Is it good enough for our purposes? But this is a shifting convention. What was once acceptable, even unremarkable, has now become arguable and even unacceptable. What was good enough for one generation and in one moment can quickly become inadequate for another. We no longer accept the shots of industrial workers going about their tasks that are typical of the British documentaries of the 1930s. They have lost their power of revelation. Today's audience will need to see more: the individual worker, the facial expressions, the marks of labour on their bodies. Above all, we want to hear their voices and to recognise them as concrete individuals. This is partly a matter of conventions of portrayal; but also a matter of the ability of the camera to portray adequately, to enter into the real and to return with material that satisfies our particular requirements for a good enough portrayal of it.

If this is true of documentary images, then it is even truer of documentary sound. Indeed, it seems that good enough sound, rather than good enough images, is the dominant requirement in bringing about a new phase of documentary. The key factor is what it becomes possible for us to hear rather than see. Right from their invention, cameras could capture the sights of everyday activity, but not the sounds of everyday speech. Cameras allow us to see people in 1896 waiting for trains, workers leaving their factories, crowds surging in the streets. But as to what they are saying, we have no idea. Even when speech came to such images, it did not do so as everyday speech. The introduction of film sound recording at the end of the 1920s did little more than allow the capture of carefully prepared dialogue, in documentary just as much as in fiction.[2] The elusive factor in the history of documentary has been naturalistic speech rather than naturalistic images. By paying attention to sound as well as image, the history of documentary can be reinterpreted as a series of phases with relatively fast moments of transition between them. These are motivated by developments both in the technology of recording and in documentary exhibition, that is, in the arrangements for seeing and hearing documentary material.

Adequate recording and reproduction of sound in cinemas emerged only at the end of the 1920s. In the early years of cinema, then, the lack of sound hampered the development of a cinematic documentary genre that would match that of cinematic fiction. Fiction films could develop quickly using the already familiar gestural language of popular theatre, supplemented by a tolerable number of explanatory intertitles. In Hollywood and European cinema, editing conventions developed based on a depiction of space from one side (as though seen by a spectator looking at a

stage) so that a drama could be based on significant looks between the characters. The detailed breakdown of scenes into shots required multiple takes and camera set-ups, but it effectively directed the viewer's attention within the scene. Writing of the Russian director Yevgeny Bauer's last film in 1917, David Bordwell states that 'it was in those years that filmmakers realised, however intuitively, that the power to see everything is meaningless unless at certain moments we notice only the most important thing' (Bordwell 2005: 22).

By the 1920s, skilled directors were able to create thrilling action and moving romance based on these conventions, without much detailed dialogue conveyed through intertitle captions. None of these devices was open to documentary. Documentary subjects could not use the same exaggerated gestures as cinema actors because they were rarely used in everyday life. The detailed editing of actions required more set-ups than were feasible. So the genre of documentary failed to develop beyond the short factual material shot by the first filmmakers. Documentary films are rare in the cinema that preceded the invention of synchronised sound. Where they exist, they involve a considerable amount of reconstruction, and are concerned with sensationalist topics that would ensure an audience, like Benjamin Christiansen's 1922 feature *Haxan: Witchcraft Through the Ages*. Rare examples exist of films that were made in the most remote regions of the world, which presented great technical challenges. Herbert Ponting's *With Captain Scott R.N. to the South Pole*, originally released in 1911, is extraordinary not because it tells any story, but simply because it was created as a moving image record. However, a decade later, it was no longer enough simply to present 'views', material shot with great difficulty in such remote locations. Reconstruction and fictionalisation were required if a film was to be commercially exploited. So when Robert Flaherty documented the life of the Canadian Inuit, he invented a story, cast his characters and asked them to act out the lifestyle of their forebears in *Nanook of the North* (1922).

Nanook of the North 'is considered one of the first great documentaries' (Aufderheide 2007: 2), yet it would scarcely qualify as a documentary today. It is a drama based on fact, a drama–documentary or a recreation. Yet at the time it was praised for its authenticity. In the documentary aesthetic of the period, there was no requirement that the cameras should capture events as they happened, especially if those events could not be anticipated or predicted in advance, or were too difficult to obtain. Waiting around for days to get the right shot, the quasi–religious belief of the wildlife filmmaker, belongs to a later phase in the history of documentary. For the documentary makers of the first half of the twentieth century, the aim was to provide photographs of events whose occurrence was sufficiently documented to convince both those filmmakers and their spectators that they had occurred in the way they were being retold. They aimed to create a screen recreation of documented events as faithfully as possible. If they could conveniently get the images from the event itself, then there was no particular necessity to go to the trouble of recreating them. So cameras were dispatched to places where predictable events were taking place. Early cinema has abundant footage of state ceremonials, festivities, pageants and celebrations. But even some of these predictable events lay beyond the reach of cameras, and then reconstruction was perfectly acceptable. For the *Coronation of Edward VII* in 1902,

cameras could not operate in Westminster Abbey because of the levels of available light. The director Georges Méliès and others saw no problem in recreating the events in a studio. Méliès worked closely with the palace authorities to ensure the accuracy of what he recreated ... or created, since he filmed in advance of the real event so the film could be in the cinemas as soon as the actual coronation had taken place (Kuehl 1999: 120).

Recreation of scenes for the camera in a documentary or even news was not the cardinal sin that it became by the early 1960s. Properly researched, supported by testimony and other reliable evidence, events could be reconstructed and the result called 'documentary'. This indicated that the film depended on documented fact. Brian Winston examines Humphrey Jennings' key British documentary of the Second World War, *Fires Were Started* (1943) and concludes:

> For us today, after four decades of observational 'fly-on-the-wall' style of Direct Cinema, all these preparations, re-workings, scripting and endlessly repeated takes render the film moot as a 'documentary'. Of course, for Jennings and his contemporaries, this was simply not an issue. The use of non-actors, actual firemen, and the legitimations of various types of prior witness were enough to mark the project as a documentary, re-enactments notwithstanding.
>
> *(Winston 1999: 58)*

Problems arise when footage produced in this first phase of documentary are re-used today as though they were real. In 1993, Roger Smither re-examined footage of British troops going 'over the top' in the trenches in the First World War (1914–18), footage used for many years without problems as 'rare footage of frontline fighting' (Smither 1993: 149). What Smither pointed out had not been noticed by many previous observers, but some of it now might strike a viewer as obvious. The camera is positioned where it would have been a clear target for anyone in the German trenches. In addition, this shot continues for a duration that later users have thought to be excessive; as a result, it was usually cut out. Towards the end of this 'overlong' duration, one of the 'corpses' lifts his head and clearly looks towards the camera for guidance from the director about what to do next. It was the combination of the two facts (camera position and fake death) that forced archival documentary makers and historians alike to re-evaluate much film footage that hitherto had been used as 'evidence'. However, Smither also points out that elements in the film had been seen as suspect soon after the First World War by those who had been closest to the events:

> *The Battle of the Somme* was screened on 4 May 1922 to a panel of experts who appear to have been unanimous in their suspicion of the 'attack' sequence. One of them, Colonel R.G. Finlayson, suggested 'any parts which are considered to be 'fakes' – such as the scene showing the troops actually going over the top – should be so labelled in the explanatory notes' although this excellent suggestion does not seem to have been acted on at the time.
>
> *(Smither 1993: 160)*

Smither also asserts that the filmmakers were simply following the values of the time:

> Maybe we should say the makers of the earlier film are guilty – not so much of fakery as of the lesser misdemeanour of 'improvement'. Improvement can take place both at the filming stage – with the cameraman encouraging participants to do more interesting things – and in the editing process, with scenes juxtaposed or dressed up with captions or music to provide an appearance more exciting than the reality.
>
> *(Smither 1993: 161)*

What enables such re-examinations of footage once taken to be documentary? It was once enough to say that it was good scholarship, which undoubtedly was the case with Smither. Yet there are now so many disputes about the evidential nature of particular photos and footage that even the most optimistic of media scholars would find them difficult to explain simply as the result of a recent increase in scholarly activity alone. There appears to be something more significant at stake here. It is now becoming clear that we are moving into a new phase in our relationship with the documenting nature of the documentary, and the evidential nature of the photographic. What was once good enough and even better than that (like the cases cited above) is now no longer even good enough.

The makers of *The Battle of the Somme* footage did nothing wrong by their own standards, and cheated none of their contemporaries. They were documenting, just as Flaherty in *Nanook of the North* in 1922 was documenting. The difficulties experienced by such filmmakers in obtaining shots of real events are not, however, due to technological difficulties. Film was a manageable medium, though it had to be treated with care as it was highly flammable. It had its limitations of speed and sensitivity, but these were restrictions that Flaherty could overcome in the Arctic. The main difficulties in getting shots of the real were economic. The process was expensive and the equipment relatively scarce, as were the skills in using it. Laboratories for the development of film negatives were located in a few centres, and filmmakers in remote places had to improvise as best they could. The financial risks of filming were greater when the technology was in its early phases, and the levels of organisation and skills required were greater. It was these questions, rather than the size of the cameras, which restricted the early documentary filmmakers. It is always surprising to see the small size of the original cameras used by the crews sent around the world by the Lumière brothers, or used by Edison in the USA and Paul in the UK. They are close in size to today's professional video cameras. So technology alone does not explain the documentary assumptions of the first half of the twentieth century. Instead, the working assumptions of the time did not put an absolute value on the image as truth: photographic evidence was a bonus for documentaries rather than its basis. Truth was located before the images, in the attested and documented realities that documentary filmmakers would set about faithfully to recreate. They might use the original participants, as Jennings did; or people who had seen the events for themselves, as Allakariallak, the Inuit who played Nanook, had seen his grandparents behaving.

This aesthetic of documented reconstruction continued into the era of sound cinema. The problems of film speed and sensitivity, skills, organisation and investment were one thing. Sound was quite another. It presented three problems: how to record it; how to synchronise ('sync') it with image; how to reproduce it so people in a large cinema could hear it adequately. These problems become particularly acute around speech. We notice minor problems of synchronisation most acutely when filmed people's lips move and the sound comes out delayed or ahead of their lip movements. We have particular problems in making out indistinct speech, where indistinct music or sound effects are quite tolerable. By the late 1920s, adequate solutions had been found to the three problems of sound, and it was launched into cinemas. But the available solutions were scarcely helpful to the recording of documentary sound. If sound was to be recorded, then cameras had to become much more bulky because of the need to cover up the noise that cameras make as teethed cogwheels pull celluloid film along, expose each frame, and then move up the next, twenty-four times a second. This creates a noisy clatter, which became a problem only when sound had to be recorded at the same time.

Yet sound presented more problems for documentary than simply keeping the camera quiet. The sound equipment itself was bulky. Recording onto tape still lay in the future; microphones were designed to capture close-by sound; sound mixing was limited by the loss of quality inherent in the analogue rerecording process; and the patterns and accents of everyday speech were unfamiliar. As a result, sound was not used as documentary evidence in this period. It remained a support for the images and a means of deepening them. Speech was declaratory rather than natural, dominated by the need to be heard clearly. However, music was used extensively and evocatively, especially in documentaries. The standard aesthetic emerged of documentaries with a clear voice-over and much music, both added in post-production to make up for the fact that location sound was almost impossible to capture. The 'voice of God' commentary, much derided later, enabled documentaries to become a more flexible form, freeing them from the problems of intertitles, allowing images to be explained or contextualised as they were being seen.

Ordinary speech remained rare, and appeared only experimentally in documentary work. Where speech was captured, it was usually carefully prepared and conformed to strict requirements of comprehensibility. In this, filmmakers were following the standard practice of radio. The BBC had been broadcasting for almost a decade by the time that sound arrived in the cinema, and its standard practice for radio 'talks' was one of scripting in advance, working up the spontaneous utterances of those who were to appear into a coherent and comprehensible piece, which they would then read. Hearing these talks now, they sound stilted. It was not, however, because people actually spoke like that; more that they spoke like that for radio. This was an aesthetic of sound based on comprehensibility and fluency rather than spontaneity of expression. Cinema documentaries adapted this aesthetic. Even the sudden irruption of ordinary speech in the 1935 British documentary *Housing Problems* was carefully controlled, and remained a much-commented rarity. To a significant degree, documentary speech remained on radio in this first phase, and even there was constrained

by requirements of universality. The real accents of people and their spontaneous self-expression in speech remained marginal, in light entertainment radio like *Down Your Way*, where Wilfred Pickles the presenter was always on hand to repeat what had been said in his comprehensible light (and even then, novel) Yorkshire accent (Scannell 1996: 38).

Sound enabled documentary to develop, and many of the most enduring films from the 1930s make adventurous use of sound design, from the poetry and music of *Night Mail* (H. Watt and B. Wright, 1936) to the satire of Buñuel's *Land Without Bread* (1933). But the documentary aesthetic of the 1920s to the 1940s was not an aesthetic that sought the truth in either image or sound. The truth, in this aesthetic, was located before the image, rather than in the image. Each documentary shot was underwritten by further documentation in the form of witness statements, authoritative accounts and thorough research. The image was, to a significant degree, guaranteed by the word. Such procedures have much in their favour. Many events become significant only after they have happened. We now exist in a culture that mourns the absence of film footage of many of its more significant events; or the grossly inadequate evidence of significant events accidentally captured on camera, like the assassination of President Kennedy. The TV cameras failed to capture the assassination, which took place during what was a routine public appearance, but it was captured on one amateur 8mm camera.[3] The desire to see the actual event is often frustrated by the unpredictability of events themselves, even in the current circumstances of ubiquitous camera devices. Yet we now regard reconstructions as an inadequate substitute. Indeed, one of the many problems that emerged for the regime of documentary that emerged with mass television and the new 16mm film technologies (both in the later 1950s) was the issue of historical recreation: all those hybrids called drama documentary and docudrama, signalled by stylistic markers or even captioned 'reconstruction'. They are simply doing what came naturally in the earlier phase of documentary: using images to document events whose reality is sufficiently authenticated, and which can, through the medium of film, receive further authentication and explication.

A variant of this approach to documentary was developed in the particular conditions of China in the 1950s and early 1960s. There, the communist government organised a considerable documentary effort aimed at showing the world as it could be, rather than as it was. Shooting was organised and scripted in advance to show exemplary activities, and outstanding individuals and groups at work. Activities were reconstructed, rather than captured as they happened. Indeed, to a significant extent they could be described as 'constructed' rather than reconstructed, as the link between the documented event and the filmed event was broken. It was replaced by an approach that constructed ideal versions of reality. The resulting films, referred to as 'special topic films' (*zhuantipian*), continued in cinema well into the 1980s, and are referred to dismissively as 'illustrated lectures' (Berry 2007). Towards the end of the 1980s, a New Documentary Film Movement emerged in China, working on video rather than film. The transition to a new form of documentary took place later than in the Western documentary tradition, and, moreover, took a different form as a result, basing itself on 'on-the-spot' or spontaneous realism (Robinson n.d.).

Second phase

The documentaries of the first phase, up to the early 1950s in the West, were made for cinema. By the 1950s, the new ubiquity of television and its insistence on daily news was a powerful pressure for change in documentary values. Television provided a window on the world, a new possibility of vision. As it developed as a medium, it brought into existence many more cameras; many more professionals dedicated to finding images, recording sounds, undertaking interviews, bringing 'the world' into the home. Lightweight technologies were developed, initially in film and then in video, to service this new and demanding medium. A new documentary practice developed, and new expectations of documentarity. The images and sounds themselves became the evidence of the reality of the events portrayed. The camera and the sound recorder together became the primary means of documenting events: 'speech need no longer be reserved for postproduction in a studio, far removed from the lives of those whose images grace the film' (Nichols 1991: 44). At the same time, events began to be arranged for the cameras, most immediately with sporting events. Media events emerged, public occasions whose power rested on their mediation through television, which invested often perfunctory or ritual events (a handshake between politicians; a royal wedding) with narratives and interpretive structures that enhanced them for the viewing public. Media events, as Dayan and Katz (1992) demonstrate, provide a different, more extensive and meaningful experience for TV viewers than perhaps they do even for the participants in those events.

It rapidly became obvious that this power of the camera to make events become significant was also a power to make events happen. Among filmmakers, a new set of terms developed to discuss the ethical implications of this. They began to talk of too much intervention, and to develop ideas of just letting things happen in front of the camera, of observing events rather than participating in them. Filmmakers invented new terms for what they were doing: cinema verité was a linguistic hybrid developed in the USA to describe a form of filming that avoided both intervention and explanation. For cinema verité, the spectator's voyage of discovery was close to that of the filmmakers, in that the essential ambiguity of events was allowed to come forward. In its pure form, it can be seen in the films of Leacock, Pennebaker and Wiseman.

With television came a new insistent gaze on everyday life (Turnock 2007). The ordinary and the domestic became the focus of attention. The many situation comedies of early TV were based around the home lives and ordinary feelings of fictional families. Panel games and other gameshows emphasised informal improvised speech and mundane exchanges (Ellis 2011). By the early 1960s, soap operas were well established, with their new emphasis on relationships and emotions. Through television, it seemed, camera and sound could access the complexity of life. Its news broadcasts developed a confidence and reach that had eluded cinema newsreels. Suddenly, it seemed that camera and sound could become witnesses of the present day, rather than selective remakers of it. Television provided documentary filmmakers with a new challenge: to observe complexity rather than to distil and

summarise. In addition, television put a new value on speech and on confession. This became the age of the interview.

The shift happened quickly. Only thirty years separate the wartime film *Ordinary People* (J. Lee and J.B. Holmes, 1941) from TV series like Craig Gilbert's *An American Family* (US, 1972) or Paul Watson's twelve-part *The Family* (BBC, 1974), but they seem to come from utterly different eras. The ordinary people of 1941 are swiftly sketched types who act their short lines of scripted dialogue. The tales of their lives dealing with air-raids are simple and heartwarming as they help each other out and trade rueful jokes. The closest the film comes to any conflict is the court case of a woman who owes too much rent, and even this is dealt with through the judge's conciliatory approach. But the ordinary people of the early 1970s are instantly recognisable. They are filmed in a style that has not changed fundamentally since. They are observed at home in all their complexity. We see the family disagreements, the failed conversations, the irritations and conflicts of the everyday. They confide to the camera; they resent the presence of the camera. They live and they love on their own terms with scarcely any narration to set them in context. They are not typical; they are the Louds or the Wilkins: specific people in their time and place.

The term often used about these series is 'fly on the wall' rather than cinema verité. This was a British term used to describe the effect of a small film crew spending a considerable time with their subjects. They hoped to become self-effacing, like a fly on the wall, allowing events to unfold without reference to the three or four people sitting in on domestic or professional events, undertaking their own private rituals of tending their equipment. This type of observational filmmaking allowed its audiences more explanation than cinema verité had done. Brief lines of commentary would introduce each film and would provide context in the bridges from one sequence to the next. However, commentary within sequences of action was not allowed. The evidential nature of the footage of events was intended by the filmmakers to be sufficiently clear. The job of the viewer was to make sense of it, directed by the way in which it was edited.

The problems with such footage, viewed from the vantage point of the present, are not particularly the result of the documentary aesthetic. They are rather to do with the inadequacy of sound recording technologies. The discreet radio microphones that are used nowadays did not exist. Sound was collected by a single monophonic microphone. The most difficult decision that a director had to make was what kind of microphone was to be suspended at the end of the soundperson's boom or 'fishing rod'. Technical choices had to be made in advance of the shoot, which would determine what could be recorded. Was the microphone to be highly directional, prioritising sound from a particular direction; or was it to have a wide range so as to pick up the unexpected? Here again, we find filmmakers stuck with the problem of anticipating events. Compared with their predecessors in the first half of the century, it was easier for the camera to be in the right place at the right time. The camera had a zoom lens that could quickly move in and out to concentrate on significant parts of the action, whether it be someone doing something, or the reactions of others. But sound zooming did not exist: a microphone had to be brought

closer to the source of the sound to emphasise it. A microphone does not select, as we unconsciously select from the sounds around us. It is not possible for sound recording to mimic this selectivity in the way that the use of a zoom lens can mimic (and improve on) the way we concentrate on particular details in our field of vision. In observational documentaries like *Dont Look Back* (D.A. Pennebaker, 1967), the sound remains muddy and it is often hard to distinguish any particular person's speech from the general hubbub.

In one sense, this makes the sound an excellent piece of documentary evidence. Everything is there: what the filmmakers think we should pay attention to along with the rest of what was being said or done. The problem is that the clatter of plates can drown the significant moment of a dinner table conversation, the ringing of a phone the crucial line of dialogue in the office, the noise of the traffic the murmurs of the pedestrians. And it is not possible to separate out one set of sounds from another, as they share the same spectrum. The enduring problem of acceptable and comprehensible sound shows that there is such a thing as too much documentary evidence. Good enough does not only mean a little more than inadequate; it can also mean less than too much. The question of the adequacy of documentary film as evidence is normally discussed when a film has provided its audiences with too little to convince them. Too much evidence conflated into a single soundtrack provides equally great difficulties.

By the mid-1970s in most of Europe and the USA, a new evidential adequacy had been created. A documentary was to be balanced in its presentation of material, yet a judicious amount of opinion could be mobilised so long as it was supported by the filmed evidence. Images and sounds were edited and selected so that they provided supporting evidence for a clear narration of events. The narration, ideally, could be carried by the editing of images themselves; usually, though, a degree of narration became necessary. Such narration, provided from outside the events shown on screen, was increasingly criticised as a 'voice of God'. However, when compared with the hectoring tones of films from the first half of the century, it appeared to be a relatively neutral voice of hindsight.

Technology played a role in creating this new phase of documentary production. This was also a period in which increasingly lightweight equipment provided new possibilities. Television began to use 16mm film, rather than cinema's 35mm, as its standard, and this meant that equipment became lighter weight. The desire to make cinema verité documentaries with this equipment led to a significant innovation: the adaptation of sound tape recorders so that they could sync exactly with the speed of the 16mm camera, but without the need for any direct wire connection between them. This innovation, called crystal sync, spread quickly during the 1960s and gave new flexibility for crews collecting sound and image from the real. It became possible to record ordinary speech as well as interviews. These developments are examined in more detail in chapter 4.

Today we are entering a third phase in the development of documentary. Again, technology has a role in bringing this about, through the increasing ease of use and cheapness of digital technologies, which blur the demarcation of the interview with a

more conversational style. Filmmakers have been able to come out from behind their equipment. And, as Michael Chanan notices:

> my collaborator, George Steinmetz, summed up by alluding to Marx's famous phrase about the French peasantry, 'since they cannot represent themselves, they must be represented', but here in Detroit 'they *want* to be represented'. This is clearly different from earlier times when people were mystified by the documentary camera and the rituals of the film crew, and then when they grew increasingly sceptical of their intentions. Today it would seem that the ubiquity of the video camera, and the dissemination of its imagery by satellite and the internet, is in process of demystifying the medium, at least to the point where people being filmed are no longer subdued by it, but ready to have their say.
>
> *(Chanan 2007: 253)*

There are many elements in this newly emerging phase of documentary production. It belongs to a moment when moving image and sound have become easier to access and to produce. Television enabled the shift towards the interview and the witnessing camera in the 1950s; now it is the possibility of distribution by cheap reproduction to DVD or through the internet that enables factual filming to reach viewers in new ways. Digital technology has reduced the costs of production and has made technology easier to use outside the professional contexts of cinema and TV. It has made it easier to shoot and to edit, for both professionals and general users. At the same time, the consumers of such material have changed, bringing their own experiences of filming and being filmed to their understanding of documentary footage. With this comes a scepticism about the truth claims of documentary on which the more observational style was based. We are entering a new phase of factuality, in which documentary is viewed as a series of encounters: between filmer and filmed; between filmer and their filmed material; and between eventual viewer and eventual film.

In a crucial essay for understanding this new turn in documentary, Michael Renov relates this new scepticism to the general scepticism about the modernist project of rational and exhaustive understanding of the world: 'in accord with modernism, the documentary idea has depended on preservation, durability, capture. In postmodernity, videotape, notable for its ubiquity, endless receptivity, and ephemerality, seems far less suited to documentary's aggressive assertiveness' (Renov 2004: 139). After a succinct examination of the theoretical underpinnings of this view, he examines a number of works in detail. He concludes that

> documentative work that invites radical doubt, ambivalence, and the embrace of contingency rather than certain knowledge should not be viewed as simply fashionable or facile in its scepticism. Its value exists both as a challenge and affirmation: provocative in its refusal of individualist truth, profoundly moral in its call for, and reliance on, individual moral responsibility.
>
> *(Renov 2004: 147)*

Renov was writing as the characteristics of the third phase of documentary were beginning to become clear, before the success of films such as *Capturing the Friedmans* (A. Jarecki, 2003), which carry this approach into the mainstream of documentary production. He was writing while filmmakers were realising the potential for a new approach to documentary, but before the extent of the changes in viewership were clear. After a decade of change in both the production and the reception of documentaries, it is possible to identify a third phase of documentary characterised by a more explicitly personal approach by filmmakers (Renov 2004; Bruzzi 2006), and new sophistication among viewers about the mechanics of documentary production.

3

NEW ATTITUDES TO DOCUMENTARY

The third phase of documentary emerged as the practices of observation began to be questioned. Observation or verité practices were underpinned by the claim that the camera could be more truthful if human intervention was reduced to a minimum. However, by the middle of the 1990s, widespread doubts were expressed about the truthfulness of the photographic image itself. The then-new digital technologies of image creation seemed to be changing the very nature of photography by increasing the potential for undetectable alterations and other human interventions. These concerns about digital imaging technologies emerged first in relation to still photography as digital technologies became pervasive in press photography and started to be available to non-professionals as well. The first digital still cameras (defined as cameras using a CCD image sensor and saving images digitally) emerged around 1991. They immediately caused anxieties around the evidential nature of the photographic image. During the development of photography over the nineteenth century, a whole mystique had grown up around the seemingly magical chemical processes of a film negative reacting to light. Photography seemed to evade, more or less, the capacity of human intervention in the moment of formation of the image. The original negative remained the original. And any subsequent manipulation of that image would leave a trace, or could be refuted by reference to the original negative. In the place of this quasi-magical chemical process, digital cameras seemed to offer an electronic process in which original and copy were identical, and subsequent alteration of the image could not be detected.

Writing in 1994, William J. Mitchell vividly expressed these fears:

> The growing circulation of the new graphic currency that digital imaging technology mints is relentlessly destabilizing the old photographic orthodoxy, denaturing the established rules of graphic communication, and disrupting the familiar practices of image production and exchange. This condition demands,

with increasing urgency, a fundamental critical reappraisal of the uses to which we put graphic artefacts, the values we therefore assign to them, and the ethical principles that guide our transactions with them.

(Mitchell 1994: 223)

The excessive 'manipulation' of photographs was a pervasive fear of the closing years of the twentieth century. The arrival of digital photography seemed to threaten the evidential status of photography in the eyes of both popular and academic commentators.[1] Cases of image manipulation were widely debated, citing both the routine use of 'retouching' practices, and some flagrant examples of falsified photographic evidence. Some of the rhetoric was extreme:

There are good reasons, however, for thinking that digital images are not really photographs. The causal process that defines photography underpins the treatment of photographs as evidence of what they depict. The possibility of precisely and systematically breaking that causal relation to the world makes digital imagery sufficiently different from traditional photography to suggest calling such a picture a 'photograph' is little short of intentional ambiguity.

(Friday 1997)

Digital image technologies seemed to challenge the status of photos as evidence, the 'causal process' that links the photograph to a moment as its visual imprint. Digital processes seemed to make it too easy to alter or improve the images, or 'manipulate' them.

In the end, though, photography was just too useful a tool to be abandoned in the face of such criticisms. The digital has not destroyed the evidential qualities of the photographic. It has, however, altered the way in which photographs are received as well as how they are produced. The popular consumption of visual images and, indeed, of digitally recorded moving images and sounds has adapted to these new digital circumstances. Photographic material is now subject to a double examination of its status as evidence. When it matters (which is often the case with documentary footage), the contemporary viewer will tend to examine images as evidence both of events and of an activity of image-creation. Images are subject to a double test of their qualities as evidence: first for what they show, and second for the activities which brought them into existence as images. How did they get those pictures? Is that a plausible angle? Was anything set up? Was anyone exploited? These are the kinds of questions that we now ask of images that seek or are given the status of evidence. We will even ask: should the photographer have been taking photographs rather than intervening in the events?

Challenging Photographic Evidence

The reality of Robert Capa's iconic picture *The Falling Soldier* (1936) has been in dispute for some time. Published in a French magazine in 1936, it was influential in creating sympathy for the Spanish Republican cause in the civil war. As an image of the moment of death, it is particularly disturbing, so it is

an obvious target for doubt. The kinds of doubt brought to bear on it show clearly how the criteria for disputing the reality of an image have changed. The first challenge to its authenticity came in the Philip Knightley's 1975 book *The First Casualty: From the Crimea to Vietnam; The War Correspondent as Hero, Propagandist, and Myth Maker.* Knightley was arguing that the 'first casualty' of any conflict is truth itself, so he was concerned to prove that the image was composed for propaganda purposes. He quoted a journalist who said that Capa had told him soon afterwards that the Republicans had staged the manoeuvres for him, including this 'death'. This was essentially one word against another: a method of refutation that relied on contemporary recall. Later, the subject of the photo was tentatively identified as an anarchist named Federico Borrell, known to have died at Cerro Muriano on 5 September 1936, which seemed to quell that controversy. In 2009, however, a new challenge was mounted, using a different method. The academic José Manuel Susperregui had painstakingly located the place where the photo was taken by distributing reproductions of the background visible in other photos of the same series. This, combined with Capa's known whereabouts during that time, identified the location as away from frontline fighting.[2] This challenge was based on inspecting the image itself, rather than the verbal discourses around it. It relied also on distributing many copies and recruiting help from local residents. Susperregui could assume that they had the necessary skills to compare a photo with the landscape scene before their eyes, and to report their deductions. Such a form of challenge to the evidential status of this photo has recently developed as a result of easily available digital image processing. Judgements about the adequacy of Capa's photo seem to change as new forms of evidence become possible.

The transformation of image recording wrought by digital technologies has been a complex process. The easy availability of digital photographic and recording devices has been as important in this as their revolutionary potential for image manipulation. The worried commentators of the 1990s concentrated on the malleability of photographs, and missed another aspect: the democratisation of photographic processes, which were also to be enabled by digital technologies. Digital technologies have provided easy and readily available ways of recording images and sound (cameras, mobile phones etc.); of editing them (Apple's Final Cut and other packages); and of disseminating them on the internet (YouTube, MySpace etc.). Not everyone does this, of course, but almost everyone knows someone who does. The shift is a cultural one, in which attitudes towards photography and filming have altered relatively quickly.

At the heart of this development is a sceptical public, knowledgeable about the practical and ethical issues surrounding photography and film. Contemporary publics know more about the processes behind image production because they have experienced them for themselves. Just as the computer has made a routine event out of the once exclusive craft skill of high-quality word processing and document creation, the

emergence of digital image technology has spread the potential for high-quality moving image recording and dissemination. Hitherto rare experiences have become common-place as a result of mass consumer digital technologies: particularly the experiences of filming, being filmed and seeing the results on a screen. Before the 1990s, such experiences were confined to the privileged few who worked within broadcasting or had the honour of appearing on TV; or within the relatively closed circuits of home filming on Super-8 film or VHS video. The division between the amateur and the professional pervaded every area of moving image production and dissemination. Now we need a new term to describe those who routinely produce such material, but without the aim of being a 'filmmaker': perhaps we should talk of someone as a 'filmer',[3] just as computing talks of 'users', making no binary distinction between the amateur and the professional. Nowadays we are both: our skill levels may differ, but it is impossible to be highly skilled in all areas: every professional is an amateur in another area.

It is necessary to use a new term, such as 'filmer', since mass consumer digital technologies have brought moving image experiences to very wide publics. Filming is used for all kinds of mundane purposes, at work, in leisure, and in all the areas between. Filming can now be used both by those in power and by those who oppose them. In London, during the spring of 2009, conflicts around the policing of the G20 summit in London involved both sides using recorded images to prove versions of the events. Surveillance by the police was matched by successful sousveillance by pro-testers, who demonstrated that a different angle revealed very different aspects of police behaviour.[4] All kinds of image-capture devices surround us, with consequences for our suspicions about photography itself, as chapter 11 explores. The occasional controversies around 'amateur' material posted on sites such as YouTube, or circu-lated by email, demonstrate how widespread the generation of moving images and recorded sound has become. They range from 'happy slapping' assaults on random passers-by to assaults on demonstrators by police; from pets doing cute things to footage of sexual activity; from students shooting footage of their new room for their parents to instructions on how to work a newly marketed piece of technology. The experiences of filming and being filmed, as well as that of distributing the resulting material, have become more casual and mundane than at any previous moment in the development of moving image culture. Every stage of the process has been made available through low-cost devices, often with surprisingly good picture quality (the sound, though, is quite another matter). Image capture goes on everywhere: in DIY stores and rock concerts, at traffic accidents and in classrooms. Image dissemination requires little more than an internet connection; image sharing is even simpler, as every camera has a digital display screen. Anyone who wants to can see what they have just shot, and show it around to others. The act of image capture and image projection can be performed using the same device, which was also the case when cinema was a new medium. The Lumière brothers' first cameras converted into a projector to show footage the same day that it was shot.

Digital cameras have also altered the relationship between filmer and filmed. A standard feature of digital moving image cameras is the flip-up or flip-out digital

display screen. This has altered the experience of producing images for all users, both 'amateur' and 'professional'. Images can be seen as they are being captured, and exactly as they would appear in playback. The digital screen has replaced the view-finder of analogue devices. Analogue viewfinders always provided an approximation, and were only accessible to one individual at a time, who jammed their eye to an eyepiece in order to see this approximation. The digital screen allows more than one person to see the image, allowing a more collective approach to film construction. It has also had an impact on the work of the lone (or almost lone) documentary film-maker by altering the relationship between the filmer and the persons being filmed. As many documentary filmmakers will attest, it is much easier to engage directly with a subject when eye contact can be maintained without the camera in the way. Without the need to use a camera eyepiece, a discreet check of the digital screen is all that is needed. The new intimacy and casual nature of contemporary documentaries attests to this: what we witness is more genuinely a one-to-one encounter between filmer and subject than has hitherto been possible. This experience has changed for those with professional intentions, and, crucially, their experience is now not sub-stantially different from that of anyone else with a digital image capture device. Filming has become a more casual process, more akin to an intimate conversation than the quasi-religious confessional endured by those interviewed by the multi-person crews needed to shoot with 16^{TM}mm and 1-inch video.

Digital technologies have altered factual filming relationships while making them familiar to a very broad public. The distinctions between amateur and professional remain in the area of actual film creation, however. There are fundamental differences both in the intentions behind any act of filming, and in the means of dissemination of the results. It remains a different class of activity to make a documentary for broadcast and to make a document for YouTube circulation. Different rules apply, and viewers have different expectations of the two media. TV documentaries are expected to be as truthful as possible within the accepted limits of the moment: the kind of highly opinionated material that can circulate on the internet is still not possible, or even desirable, on TV. The editorial practices of established TV broadcasters are jealously upheld, and are recognised as a distinctive brand or voice by the vast majority of viewers. Within the BBC, an editorial unit polices the boundaries between material that is generated within the professional environment and what, in BBC jargon, is known as 'user-generated content'. Before any user-generated content (footage of a news incident caught on a mobile phone, for example) is approved for broadcast, the editorial unit will inspect it thoroughly for signs that it might have been faked. The BBC does so because its brand relies on the trust viewers place in the footage it shows them; which is certainly not the case with YouTube. Trust is underpinned by professional values, which are commu-nicated to viewers and come to be expected. So, in normal practice, the distinction between amateur and professional intentions remains well defined. Attitudes to factual filming, however, have undergone a real revolution. Familiarity with the activity of film-ing and being filmed has bred a generalised suspicion or scepticism about factual footage. This scepticism frames the modern activity of viewing and interpreting documentary material, and fuels many of the debates about documentary and news footage.

Controversies around photography

Scepticism about the ethics of digital audiovisual representation were first expressed around press photography. With widespread use of digital photography has come widespread scepticism. Close inspection of images has become a commonplace activity, part of an increasing sophistication of attitudes towards the truth-claims of images, and to the processes by which they are produced and disseminated. These attitudes are our best defence against the activities of manipulation that were identified by the 1990s doomsayers. It is convenient here to mention some well known examples of controversies about still images, because these tend to be international as the circulation of press images is globalised. Most controversies about moving image material for broadcasting, outside news material, still tend to be limited to national contexts.

The publication of photos of torture of Iraqi prisoners by American troops at Abu Ghraib prison in 2003 is a key example. The photos had been taken by the torturers themselves, who shot each other posed in front of prisoners in different kinds of degrading positions. The soldiers were eventually condemned to prison sentences. The story is a macabre proof of the widespread use of digital imaging, and of the complicated relationship we have with it. The images were shocking both in their content, and in the fact that they had been taken by these soldiers. Their truthfulness was not in dispute; but the motives of the people who took them were the subject of much speculation. The question about why they took such photos became a part of the condemnation of the activities that they showed.

There are two processes underlying such reactions. First are the complex feelings about being confronted with horrifying images, images that contain too much specific information about events we would rather not know about. After the collapse of the New York World Trade Center on 11 September 2001, *The New York Daily News* was widely condemned for publishing Todd Maisel's photo of a severed hand, index finger pointing, lying on the tarmac (Girardin and Pirker 2008: 286–89), as were other papers for the picture of the so-called 'falling man'. This is revulsion at having to see, to witness through photography. The other aspect of this new sophistication about photography lies in the ever-present awareness that photos are the result of human activity as well as a mechanical process. Contemporary controversies about photos interrogate those who took the photos and how the photos were taken. Paparazzi photographers are often regarded as violating or invading the privacy of celebrities. Several were prosecuted for their activities around the 1997 death of Princess Diana in a road accident, which some deemed the paparazzi to have caused.[5] Celebrities have often been able to call on the support of the law to suppress them. In 2009, all photographers were forbidden by a British court from coming within 100 metres of the UK home of singer Amy Winehouse.[6]

Interrogation of the actions of news photographers, especially when photographing human suffering, sometimes has far-reaching consequences. In 1994, press photographer Kevin Carter committed suicide, two months after receiving the Pulitzer Prize for his photograph of a Sudanese child dying of hunger as a vulture looked on.

One press critic wrote: 'the man adjusting his lens to take just the right frame of suffering might just as well be a predator, another vulture on the scene' (Girardin and Pirker 2008: 249). But this was not the end of this particular story.

Starving of Sudan 1993 and 2008

In 1993, the professional photographer Kevin Carter took a photo that sealed his reputation and cost him his life. His picture of a starving Sudanese baby watched by a vulture is a classic news image in the sense that it condenses a whole situation into one image. It won Carter the Pulitzer Prize in April 1994. The award also unleashed a torrent of criticism of Carter's practice as a photographer. This criticism took a relatively new form, taking Carter to task for his objectivity as a photographer, along the lines of 'why didn't he do something to help rather than compose his shot and take the photo?' Less than six months later, Carter had killed himself, saying in his suicide note: 'I am haunted by the vivid memories of killings and corpses and anger and pain [...] of starving or wounded children, of trigger-happy madmen' (MacLeod 1994).

In November 2008, the Chinese artist Xu Zhen presented a work that commented on Carter's photograph and the furore that surrounded it. In a hot room in Beijing's Long March exhibition space, he presented a restaging of the scenario photographed by Carter, but in a way that put the gallery spectators themselves in Carter's position. Entry into the space was very much a *coup de theatre*, as gallery visitors suddenly emerged into this space from the cold air of the previous exhibit.

FIGURE 3.1 'The starving of Sudan' by Xu Zhen. Courtesy of Long March Space.

Many reacted by taking photos themselves; others were disturbed. '[The work] was repeatedly met with gasps and hands raised to cover mouths' (Don 2009). By removing the photographer Kevin Carter from the scene, Xu Zhen successfully pushes responsibility for the shock of witnessing the photographed scene back onto the viewer, where arguably it really belonged all along. Xu Zhen says in interview: 'the audience were in the same role as Kevin Carter. They went to the show, took out their cameras, shot pictures and I'm sure were very excited. Then afterwards they could pass judgment on me – "Oh, this artist is no good." And that parallels the fact that when Kevin Carter died, he was under a lot of pressure – condemned by the whole world; but the whole world does exactly the same thing that it condemns.' (Maerkle 2010)

Xu Zhen's work asks two questions. First, it simply confronts the viewer with the straightforward question: 'this is the scene, what do you do?' Or rather, since this is a reconstruction of a very well known photo in a gallery, the question becomes 'this was the scene, what would you have done?' The question becomes one of conjecture, but with one crucial difference. It does not allow – as the photo does – a response from a distanced witness which states that the photographer should have done something other than take a photo. The distance of the photo allows speculation about the ethical stance of the photographer in taking a photo rather than taking action. The reconstruction, with a live baby, removes much of that distance. Yet this was Beijing and not Sudan, so the distance is not completely erased.

Instead, it transforms the normal relationship of distanced witnessing that we have to a photograph. Xu Zhen's event sets up a new reflection on the ethics of seeing Carter's photography and by implication the many other such photographs that we come across. It forces us to confront the implications of witnessing such an event, even at a distance that prevents us from intervening. It says: 'here is the event, intervene if you can'. But intervention is still not possible. After all, this is a reputable world-class gallery, and it is inconceivable that this child is really starving and that vulture is really just waiting for its chance. If this exhibit really works, then it works to show us not only that we, too, have a responsibility in relation to that child in Carter's photograph, but also that we cannot simply absolve ourselves of that responsibility by pushing it back onto Carter, the photographer on the scene capturing the moment. Xu Zhen's exhibit shows that it is an evasion of our responsibilities as a citizen of the modern world simply to criticise Carter. The question 'why didn't he do something?' also relates to us. The exhibit focuses on the feelings of responsibility evoked by such images, and the process by which we try to shuffle them off.

If you, now, are feeling echoes of such feelings and are beginning to ask how the exhibition actually achieved its effect, then you are not alone. For the record, the vulture was mechanical and the child's mother, who lived in Canton, contracted with Xu Zhen for the child to appear and was present

throughout. The debate around the show, which was considerable, also demonstrated the same dynamic of shifting bad feelings back onto the artist responsible for creating them. As Lin Tianmiao confessed:

'Initially, I was quite saddened by the work *Starving of Sudan*. This had little to do with artistic or academic concerns. Rather the reaction resulted from the thought of the substantial impact that this half-month performance would have on the memory of the black child. In the future, would the child hate Chinese people? Hate Asian people? Hate her mother for having agreed to do this performance?'[7]

He then develops his comments: 'However, artistically speaking, I do like the work. [...] What's particularly "naughty" about Xu Zhen's work is the forced inclusion of the audience – just viewing the work gives the feeling as if you are taking part in the exploitation of that child, not to mention if you are taking pictures.'

Xu Zhen's work peels away the layers of feelings that are provoked by our position as the witnesses of powerful photos of current events. It also reveals the double-sided nature of the more critical stance adopted by today's sophisticated viewers. Speculation about the circumstances of photography – or, for that matter, filming – do not necessarily add to our understanding of the events portrayed. In the case of the public reaction to Kevin Carter's photo in 1993, they served to reduce the power of the photograph itself, even though they also helped promote a deeper understanding of the ethics of photography.

The contemporary sceptical attitude to photos relates to both the uncomfortable feelings that images can provoke, and an awareness that they are the result of human actions. In Kevin Carter's case, the two became inextricably entangled. There is a third element to the current scepticism: an interrogation of the truthfulness of photos. In 2004, the UK paper the *Daily Mirror* published photos which showed the torture of Iraqi prisoners by British troops. The paper had bought the pictures and the editor, Piers Morgan, believed them to be true. However, they were proved to be fakes by examination of details of the images themselves. Piers Morgan was dismissed as editor for his decision to run the photos (BBC 2004; Tryhorn and O'Carroll 2004). Similar controversies have taken place over the status of documentary sequences on British TV, reaching a moment of crisis in 1999 (Dovey 2000; Winston 2000; Ellis 2005).

Problems around the truth claims of photographs centre on their nature as evidence. They tend to deduce whether any fakery has taken place from detailed examination of the photographs and footage themselves. It is relatively easy to find examples of the public disputation of photographic material, fuelled by a competitive press eager to prove that rival publications have been hoodwinked. Such stories sell newspapers and promote the image of the print press as a relentless seeker after truth. Detailed evidence was produced for the two cases cited above (the 1999 documentary crisis and the 2004 *Daily Mirror* photos) in authoritative newspapers, which interrogated

details of the images. In the case of the *Daily Mirror* photos, it was proved that the type of vehicle in which the abuse was taking place was not part of the equipment used in Iraq. As for some of the footage in the faked documentary *The Connection*, it was shot in the director's hotel room rather than a 'secret location to which the crew were taken blindfold', as stated in the programme's commentary. In the cases of other programmes caught up in the controversy, the activity of filming was interrogated for its plausibility: was it really likely that a documentary crew would have been filming a couple when the wife suddenly woke in the middle of the night? And how much pressure had been put on interviewees to perform in particular ways?

Viewer scepticism involves an explicit questioning of photographic and documentary material. It relies on the particular combination of involvement and distance that is enjoyed by the viewer of audiovisual material: the position of witness. This is explored in detail in chapter 12, but a brief introduction is necessary before examining the characteristics of audiovisual production in more detail. The technical processes and human interactions of documentary production are all directed towards the experience of the eventual viewer, experiences familiar enough to all those involved in production (both filmers and filmed). Like any genre of filmmaking, documentary relies on a circuit of knowledge: the filmed imagine how they will look to the eventual audience; the eventual audience speculate about what happened between filmers and filmed in order to produce the interactions they witness.

Audiovisual hearing and seeing

The growing consciousness of the ethics of recording and photography is accompanied by an emerging appreciation that looking and listening is not at all simple. We know that image and reality are different things, so the old beliefs in the reality of the image are tempered by a growing understanding of what is involved in accessing and using recorded images and sounds. The current moment, with its proliferation of screens of all kinds, is the site of a growing awareness that the viewing relationship is not as simple as that of providing a window on the world or a 'panorama', as TV used to claim. Still less can we believe that our media are telling it like it is. In the consumption of recordings of real events, something is lost and something is gained. We are increasingly aware that this gives our moving images a double status. They are at once imprints of the real and constructed texts or documents (as implied by the word 'documentary').

The experience of watching these documents of the real is one of participating to some extent in three different experiences at the same time. The first is that of experiencing events directly, of being a part of what is going on. Recorded images and sounds certainly provide sense impressions that resemble those of someone actually present within an event; but equally, they deprive us of other sensory data which those present would use to understand their predicament. There is no sense of smell, of touch; no awareness of the temperature and humidity of the air; of the nature of the space as crowded and confined or empty and remote. We see and we hear, but we know that these senses alone can be deceptive. As viewers of a text, we may well

be able to work out some of these factors from internal evidence (beads of sweat, shivering, etc.), and we may even have them drawn to our attention. We cannot judge how important they may be to the way that events turn out, or to the truthfulness or otherwise of the characters. Beads of sweat on a person's brow could indicate the stress of lying; the stress of being forced to reveal something against his or her will; or lack of air conditioning. We experience through seeing and hearing, but at the cost of losing other elements of the experience.

The viewer of recorded images and sounds also experiences the position of a bystander at events. We watch and listen, but do not participate. The events we see are of interest, but do not directly involve us. We are not called upon to take any action. But, unlike the bystander at an event, we could not take any action even if we wanted to. Our separation is enforced and absolute. On the other hand, the position we are given is more than that of a simple bystander. A bystander is limited to one physical position. The viewer of filmed footage is given a privileged view compared with such a bystander. Cameras reframe events, microphones pick out particular material from the overall sound, cutting recombines fragmentary views into a synthetic whole. Through the screen, we become privileged bystanders at events, the point to which they seem to be addressed and the place where they end up making sense. Our privileged position comes at a cost: we are bystanders who cannot intervene. We cannot offer help, or comfort, or congratulations.

The third element of this distinctive audiovisual experience of events is that of the construction of those events for our consumption. The privileged bystanding enjoyed by the viewer of footage of the real is a construction. It is the result of a process of production that is increasingly well understood. Media organisations, preoccupied with branding in a crowded market, are increasingly explicit about their orientation and news values. Fact and commentary are more closely intertwined as a result, further encouraging viewer scepticism. News itself becomes the story as soon as any scandal breaks: attempts to suppress revelations or bad news often intensify the scandal. In short, we know that the footage we see comes from somewhere in particular. It has been gathered and assembled by individuals working in organisations with particular aims and characteristics. This is as true for clips on YouTube as it is for a BBC documentary or a film by Michael Moore. We do not simply see footage and hear sounds: we are addressed by them. We recognise the terms of that address as belonging to specific individuals and specific institutions. Usually there will be more than one set of terms in any one broadcast: we are addressed by a series of attempted communications by journalists, by broadcasters, and by the persuasive voices of others that they present within 'their' material. Any broadcast text is an assemblage of communicative attempts, not all of which are successful in their aim to communicate. As bystanders, after all, we can choose to ignore if we want.

The audiovisual experience is a distinct form of experience, sharing some characteristics of direct experience and bystanding, but also involving a privileged, synthetic view of events that is always the product of a particular organisation and the individuals working within (or against) it. The growing public knowledge of what it is like to photograph and be photographed encourages an awareness of the nature of the

viewing experience as well. The result is a rising scepticism about the audiovisual products we consume, and in particular those that claim factual or evidential status. This is the result of the spread of digital recording technologies and opportunities for digital viewing. Such scepticism was not necessarily anticipated by critics writing fewer than twenty years ago. Digital image production has not flooded the market with faked photos. It has, however, brought many other changes. It has produced a scepticism about the truth-claims of all and every image by a public who feel empowered to 'make up their own minds'. Equally, it has enabled many changes in the production of those images, some of which counter any overly sceptical conclusions by viewers.

Such is the nature of the third phase of documentary. The following chapters examine its various aspects in detail: the technologies involved in these new uses; the forms of personal interaction that are fundamental to the creation of documentaries; the attitudes that underpin this sceptical environment; and the differences of judgement and interpretation that result.

4

THE CHANGING TECHNOLOGIES OF DOCUMENTARY FILMMAKING

Documentary filmmakers are, in the main, technological opportunists. They seize on the technological developments that will allow them to achieve their particular purposes, whether they be less obtrusive filming or active engagements with their subjects. They sometimes achieve their results despite the technologies they use. So it would be wrong to see technology as defining documentary filmmaking. Nevertheless, it is necessary to understand a little about the implications of the move from film to video technology, and from analogue to digital technology. These have offered new possibilities to filmmakers, and they have altered the relationships involved in production, from the way interviews are conducted to the possibilities for engagement of those commissioning a project in the nature of the end result.

Does technology limit what can be filmed?

There is no such thing as one specific filmmaking technology; filmmaking involves a number of technologies that interact. The ability to record pictures and to record sound involves very different kinds of machine, both with their advantages and drawbacks. They are recombined in editing and in the production of the final print, tape, disk or file that is delivered to a consumer, often through further intermediates. The sound recording first used for the cinema (c. 1928–50), used the same basic medium as film: a 35mm strip of celluloid. This was exposed one frame at a time in the camera to record pictures. The same kind of celluloid strip was running through the sound recording apparatus at the same time, but this time a continuous strip of optical sound information was photographed onto it. These two strips of celluloid were edited and then the sound strip was combined with the picture for the release prints. The sound equipment relied on valve technology, so was very large. The camera could have remained quite compact if it were not for one problem: it made a noise as the film was pulled down for a brief moment to be exposed in front

of a lens, and then moved on. This intermittent motion of cogs produced a clattering sound that drowned out the sound. So the camera had to be soundproofed. Hence the equipment for sound cinema ended up, by a series of necessary compromises, as very bulky.

Technologies alone do not determine what a filmmaker can do, or what viewers may want to see. The cameras and sound equipment of the early period of synchronous sound cinema may have seemed impossibly bulky even at the time. However, this did not entirely prevent enterprising filmmakers from taking them into difficult situations if they needed a certain type of footage. The makers of *Housing Problems* in 1935 were famously able to film interviews with London slum-dwellers despite the fact that their cameras took up most of the space in the room, and the sound recording technology was in a large vehicle parked outside. More remarkably, as Michael Chanan points out, the Soviet Russian filmmaker Esfir Shub made the film *K-Sh-E, Komsomol, Chief of Electricity* in 1932, which depends completely on synchronised location-recorded sound (Chanan 2007: 121–22). She records the sounds of people working, interviews to camera (or with an eye-line that shows that some preferred to speak to a living person), and includes many speeches, among them a series at the opening of a hydroelectric dam at Dnieprostroi in the Ukraine, which is portrayed as a remote rural area.[1] Clearly, the forms of technology in themselves do not stop people using equipment in adventurous ways to create new forms of portrayal.

Rather, technology shapes what is normally done. And 'what is normally done' in turn shapes how the technology is developed, guiding inventors and manufacturers towards particular refinements rather than others. Much effort went into sound technology in the 1930s, and comparatively little into the development of faster (more sensitive) film stock. There seemed little need to do so, because sound films were made on studio stages with artificial light. Technology also has its own logic of development in addition to being guided by normal usage. Capacities can be built into equipment, only to remain unused in practice. Such was the fate of the GPS technology built into professional Sony digital cameras designed for news use around 2003. Theoretically, it allowed individual camera operators to record detailed data about their footage, eliminating some of the uncertainties about the source and accuracy of news footage as it circulated rapidly around the globe. In practice, use of this feature was not included in the workflow of news-gathering organisations, so it remained unexploited. So technology provides both more than and less than what is needed by filmmakers and their viewers. Technology offers potentials that can be taken up or neglected by users, its technological 'affordances' (Norman 1988), a combination of its actual and perceived properties. Nowadays almost everyone has pieces of technology with buttons the uses of which are completely mysterious. At the same time, users can push technologies to go beyond their tolerance and still get results, as Esfir Shub did with the sound technology at her disposal.

The technologies used in filming are inextricably related to the prevailing conventions of filmic depiction. Together, they produce an effect of reality, a depiction that almost everyone at a given moment will relate to spontaneously as real. It is never real, of course, but it is 'real enough'. As digitisation makes historical footage more

readily available, it is becoming clearer that the reality effect of moving image and sound has always been approximate rather than comprehensive. Writers who celebrated the astonishing reality of early moving images after 1895 were, after all, looking at black-and-white sequences with no recorded sound. The documentarians in the 1930s who were attempting the 'creative treatment of actuality' were working with large cameras and sound recording apparatus the size of a small bus. Colour film was becoming available to them but the results seemed unrealistic, not least because it revealed unwanted information about the real. Colour was perceived as spectacular rather than naturalistic (Neale 1985). Those who, in the 1960s, tried to produce a cinema verité with lightweight equipment and minimal intervention found that their soundtracks were often muddied and barely comprehensible. Those who have used lightweight digital technologies more recently to produce documentaries where cameras seem ubiquitous now employ extensive colour grading to unify their footage into a coherent visual regime. The reality effect is precisely that: an effect which is achieved with the available resources. It is a sampling of the real, but a sample that, at any particular moment in history, is a sufficient sample to convince a viewer that it is representing a real scene. In the 1930s and 1940s, black-and-white images were sufficient, and colour was seen as excessive or disorienting. In the 1960s, a non-selective soundtrack was the guarantee of the reality of the footage. Now, in the days of multiple tracks and radio mikes, reality is guaranteed by the clarity and audibility of each participant. Colour is taken as natural, whereas black and white is seen as a consciously artistic effect.

The reality of audiovisual representation is the sufficient sampling of the real. As Ivor Montagu defined it many years ago, 'A film is a series of motionless images projected onto a screen so fast as to create in the mind of anyone watching the screen the impression of continuous motion, such images being projected by a light shining through a corresponding series of images arranged on a continuous band of flexible material' (Montagu 1964: 16). The mechanism of the camera – as well as that of the cinema projector – uses a shutter which opens momentarily to expose a still frame, then closes while the next frame of the strip of film is pulled down. What the camera 'sees' is not continuous motion, but a series of very brief and separated glimpses. The camera eye is closed just as much as it is open during the process of filming. So the idea of the plenitude of the moving image (which underlies many epistemological speculations about the moving image) is something of a fantasy. Moving image and sound both sample from the real to create an artefact based on the wonderful illusion of real-seemingness to the 'mind of anyone watching'. Occasionally, films have explored the ways in which photography is based on a sampling of the real: Antonioni's *Blow-Up* (1966) centres on snatched photographs of two lovers in a park with details in the background which, when blown up, seem to reveal a murder. However, they are so indistinct that nothing can be made of them. In this case, the camera has seen what is in front of its lens, but has not sampled it sufficiently for the unusual degree of scrutiny this particular photo was made to undergo.

Digital technologies have made this relationship of sampling rather clearer. The calculations of megapixels, bit-rate and compression define the levels of sampling

involved in contemporary digital image practice. It is easy enough to zoom into our still images until they lose any meaningful resolution into a vision of anything real. The better the camera, the greater its megapixel sampling. Equally, digital image devices create 'documents' for us, emphasising the textual nature of the still and moving images that we make. The viewfinders of these devices show us the already-processed images, revealing the illusion in its moment of creation, rather than, as with film-based devices, the patterns of light still to be recorded onto film. Digital image-making, in all its forms, has made the ordinary user far more aware of the textual nature of the moving image and the selectivity that exists at its very heart.

Both filmers and viewers of documentary are subliminally (and sometimes consciously) aware that things and events escape the recording process because of the sampling that it involves. Developments in documentary filmmaking are driven by this awareness. This makes the relationship between filmers and their technologies an unstable and exciting one. However, major changes in filming technologies are not driven by the needs of documentary. First, it was entertainment cinema that drove innovation; then, from the 1950s, it was television. Within television, two genres of programming have been particularly important in demanding and exploiting new technologies: news and live sport. More recently, and especially since the development of digital technologies, the 'domestic', 'amateur' or 'pro-am' market has also been a major source of innovation in filming technologies. Documentary filmmakers are frequently the beneficiaries of developments in these areas, adapting new machinery to suit their needs.

Documentary technologies: a short history

The constant nagging sense of the inadequacy of the film recording process has produced a number of consistent needs from the typical documentary filmer. They want lightweight equipment that is easy to operate. They want to be ubiquitous and discreet. They want to be able to react to events without being hampered by cables or considerations of film stock. They want to shoot as much as possible without consideration of costs. They want sound that can be recorded as clearly as possible. They want to be able to operate with the minimum of crew, or even alone. Given such utopian demands, the actual equipment available will be pushed to its limits. Nevertheless, it still produces characteristic ways of working which, in turn, produce documentaries that are characteristic of their time. To understand the particular limitations and the newfound senses of freedom experienced by these filmmakers is to appreciate more fully their achievements in documenting their times.

From the standpoint of the digital present, it is difficult to appreciate how much the sheer cost of filming using celluloid film limited what was possible. The crucial questions for a documentary director were 'how many days of shooting?' and 'what is the ratio?' (the ratio between the amount of film negative available for the shoot and the length of the finished film). The usual ratio in British television in the 1980s varied between ten to one and twelve to one: between ten and twelve minutes of rushes for every minute of the finished programme. The number of shooting days

would be between ten and fourteen days, meaning that on average about an hour's worth of film would be exposed. Prestige projects would win longer shooting time and a higher ratio. This would have been the case for the classic films of the observational documentary movement of the 1960s: films such as *Primary* (Robert Drew, 1960) and *Dont Look Back* (D.A. Pennebaker, 1967). For many earlier filmmakers working in cinema, the ratio was much lower, leading to a characteristic style of wide shots taking in all of a situation, rather than a montage of details that added up to a whole. For the filmmakers of the 1930s and 1940s, the totality of these constraints made the whole enterprise of observational documentary an impossible dream. Events and people were simply too unpredictable; hence the widespread practice of documented reconstruction.

The filmmakers of the 1930s and 1940s were working with 35mm cinema technologies, designed for the highly controllable circumstances of film studios. They were pushing the technology available to them to its limits. Some worked with the 'amateur' technology of 16mm, but this had no capability for sound recording and was severely limited in the light sensitivity of its film stock. The television industry that grew exponentially after the end of the Second World War changed the demand for film stocks. The TV industry used film for its fiction series, which were low in budget when compared with their cinema movie contemporaries. 16mm technology would enable them to shoot quickly and at lower cost, so investment was poured into developing 16mm technology, both for fiction and for news. Television also changed the demand for documentaries. In the period between 1950 and 1960, documentary moved from having been a relatively marginal form of cinema activity into a new prominence as a central genre of the new medium of television.

During the same period, a revolution was taking place in the field of sound recording. Magnetic tape recording had been developed in Germany during the Second World War, with an immediate application in the field of monitoring radio signals and broadcasts. After the war this technology was brought to the USA, where it interested both the film and music industries, the singer Bing Crosby being a significant investor. Sound recording onto quarter-inch tape quickly became standard. Simultaneously, a Swiss-based company, Nagra, was developing a tape recorder that could be used in the field, principally by radio reporters (Nagra n.d.). The rapid development of transistors was taking place at the same time, enabling Nagra to introduce the Nagra III in 1958, a solid-state machine (i.e. not using fragile valves) which ran a 7-inch reel of sound tape. It quickly became a standard item in broadcast organisations after the Italian broadcaster RAI ordered 100 for its coverage of the 1960 Rome Olympics.[2]

By the late 1950s, documentary filmmakers had a new set of technologies to exploit as well as a new mass television audience to address. Television documentary production began to use versatile 16mm cameras with increasingly sensitive black-and-white film stock, and robust tape recorders. There were still significant limitations. The cameras did not yet have zoom lenses, relying instead on a turret of three lenses which had to be shifted by the operator. The cameras were not silent: there was still the clattering sound of the film running through the gate, though this could be

countered with a muffling cover. The first fully silent-running 'self-blimped' 16mm Arriflex was introduced only in 1965 (Arriflex n.d.).[3] The motors in the sound recorder and the camera had to move at exactly the same speed to ensure sound and image were in sync. This meant that the two machines had to be linked by a cable, until the introduction of crystal syncing some time in the mid-1960s. So it was possible at the beginning of the 1960s to go on location with an Arriflex camera that could be operated by a single cameraman, and a Nagra sound recorder that could be operated by one sound recordist. However, virtually no-one did this, as there were too many routine tasks that had to be carried out to support each of these machines and their operators.

For sound recording, microphones presented significant problems. There were no radio microphones that could be clipped to an individual's lapel with a small transistor hidden in their clothing (the kind of technology that is often visible on reality show contestants). Instead, documentary filming needed microphones suspended on a boom or 'fish pole'. It was very difficult for a sound recordist to operate a fish pole in addition to carrying the Nagra and monitoring the sound levels it was picking up. So a boom operator was normally required. As for the camera, it was heavy but could be shoulder mounted, or put on a lightweight tripod. Its problem, at least for observational filmmaking or interviews, was the length of film in its magazine. The standard 400-foot magazine ran for a few seconds more than eleven minutes. Then the magazine had to be changed, interrupting the camera operation. A clapper board or slate would be displayed briefly as the camera began to operate, to identify the new roll of film (production name, take, etc.) and to provide a clear point for the resyncing of rushes in the editing. The magazine that was taken off the camera had to be unloaded and reloaded before it could be used again. This operation had to be done in the dark, as any light would spoil the negative instantly. A skilled clapper/loader was needed to undertake this, operating by touch using a special cloth bag. Any dust or hair that accidentally wound up in the negative would ruin an entire eleven minutes of film. So the minimum crew was effectively four, plus the director, who was scarcely ever a cameraperson. Then a further crew member was needed to keep track of what was shot, and what roll of film and reel of tape it appeared on, since none of the material could be viewed until it had been developed in the professional laboratory. So six or seven people was the size of the crew required to operate this equipment successfully in a documentary situation, with the minimum of lighting. Denman Rooke describes the situation:

> For observational documentaries you had to have a pretty clear idea of what you wanted and made sure the sound man was rolling at the time. It took five seconds for the camera to start recording, but if you missed the action, you hoped to have it on audio. At £400 per 10 minute roll, it was a real event to turn over film and arguably a more considered technique than today, where you can shoot as much DV, but risk spending hours trying to find the right shot in post [production].

(*Wood 2008: 27*)

Nevertheless, it was suddenly becoming possible to go on location and follow action for the first time. A complex set of technologies had suddenly come together for documentary filmmakers who wanted to observe and present, along with the ideal platform for their work on TV. A new method of working began to evolve around these new technological possibilities combined with the desire of filmers to observe rather than to intervene. The crew could be largely self-effacing, with the direct interpersonal interaction with the filmed subjects delegated to one or two people: producers, directors, researchers. Part of the professionalism of the technical crew lay in reducing their interactions to a minimum. They would interact with the director and producing team through whispered conversations, hand signals and significant looks. So the crew functioned as a separate and self-contained entity, a self-contained world removed from the activity that surrounded them (which, nevertheless, was the object of their attention). Directors and producers moved between engagement with their subjects and interaction with the crew, inhabiting both worlds. The beginning of filming was marked by the withdrawal of the director into the world of the crew, often announced by the use of the clapperboard. The more the filming was intended to be observational, the more the director would try to limit their involvement with the subjects during the period of actual shooting. In some circumstances, most of the crew (clapper/loader, assistants, researchers, and perhaps even the sound recordist) would be withdrawn from the room.

For the subjects of filmmaking, this eased many of the interpersonal problems of interacting with such a large group of people. Sometimes subjects were told 'just pretend we aren't here', and the crew's discreet behaviour was designed to make this easier. This restricted the documentary subjects to an easier interpersonal negotiation with a single person, usually the director. Yet, for the filming, the director would often step back into the world of the crew, ostentatiously marking a difference, consulting with them on technical matters, getting involved with their rituals of magazine-changing, joining in with their unnatural silence and lack of reaction to the actions in front of the camera. This was a particular performance of the role of the director, designed to encourage 'natural' behaviour on the part of their subjects. It was a performance of distance from personal engagement coupled with intense concentration on what was being said and done. This performance stretched to the interview (see chapter 6), in which the director's reactions were channelled into an exaggerated form of body language, and the crew continued with their discreet impassivity. The change of magazine every nine or ten minutes, however, imposed a particular rhythm on the interview, requiring pauses and a change in the nature of the exchange, usually a return to the forms of interaction that surround or 'bracket' the interview. This often permitted directors to move back into the world of the interviewee (to resume bracketing activity) and engage in a more conversational exchange. Sometimes a director would ask the interviewee to repeat particular answers or remarks, giving some interviews from the period a slightly rehearsed feel.

Film continued to be the preferred medium for documentary filming for TV right through into the late 1990s. Documentary filmmakers preferred it because film technologies became ever lighter, the results were consistent, and the disciplines of

limited amounts of film stock were often useful. Until the 1990s, video was still cumbersome for shooting compared with film, and gave inferior results in many shooting situations. But editing was another matter (see chapter 5); a typical production route between the mid-1980s and the mid-1990s was to shoot on 16mm film and to edit using video, returning to film only to make a final print. The differences and relative advantages of film and video as a shooting medium were widely debated in the trade press of the period. This was a sign that video was becoming a robust-enough recording medium for difficult documentary and news work, and was beginning to provide significant advantages. However, it was only after the development of a fully digital filmmaking process at the beginning of the twenty-first century that 16mm film was relegated to the status of a rarely used medium for documentary.

Video had developed slowly as a medium that could be used by documentary filmmakers. Television itself was based on live video. No video recording capabilities existed in the first decade of mass television. Ampex introduced the first video recorder in 1956, and the BBC, after developing its own system, bought its first Ampex machine in 1958 for £80,000 (the equivalent of at least £500,000 at 2010 prices). It was the size of four fridges, and used a 2-inch tape (which was also expensive) and a considerable amount of power. All the technology necessary for editing was still to be developed. Time code was not introduced for another decade, and editing still waited for the development of sufficient affordable computing power, which did not arrive until the end of the 1960s. Until then, the slow-motion replay was the pinnacle of technical achievement using video. But there were some interesting developments nonetheless: in 1967, Sony introduced the Portapak, a lightweight camera that could record black-and-white images and synced sound onto a reel-to-reel tape. It was the beginning of an intriguing new possibility: the ability to record action of a long duration using a single machine running the cheap medium of tape. No editing was possible, but the Portapak took off for radical uses, being used by both artists (such as Andy Warhol) (Schneider and Korot 1976) and radical political groups (Hopkins 1973). Several technically minded artists began to experiment with forms of editing for this new medium, including John Hopkins and Sue Hall at London's Fantasy Factory.

In 1981, several technological developments made video into a medium of potential interest to documentary filmmakers. The first was the revolutionary move to enclose tapes in a cassette rather than to have them on an open reel-to-reel system. Cassettes had become available for consumer recording a few years before (VHS and Betamax), and were then developed for the professional market. Betamax evolved in 1981 into the BetaSP tape (later Digibeta), which became an industry standard format. Sony also introduced the BVW-1 camera, designed for news shooting, which recorded onto a cassette tape that was much smaller, lighter and easier to use than the 1-inch reel-to-reel tapes that were by then the professional standard. It could be used by one cameraman quite easily. It was light enough to be put on the shoulder for shooting, and carried an onboard microphone (or could have other sound sources plugged into it). Betacam came into common use for news reporting and news-type documentary work, despite engineering grumbles that the picture quality was not as

good as 1-inch tape. Picture quality was a serious concern. Video editing was still analogue, copying from one tape to another with a loss of picture and sound quality with each copy. Broadcast organisations were apt to refuse copies more than three generations away from the video original. By this point, the television industry had computer-driven tape editing. In 1981, editing possibilities were considerably enhanced with the introduction of Quantel's Paintbox, which offered digitised special effects, allowing video images to be layered on onto another (Caldwell 1995).

Tape had significant advantages over 16mm film for documentary work, but these were outweighed by its drawbacks. The advantages were the length of filming that it allowed; the ability to change cassettes quickly, with no risk of dust or hairs spoiling the footage; the ability to have picture and sound ready-synced on one tape; and greater light sensitivity, especially in dim lighting. But these were outweighed by the disadvantages: poorer picture quality; inability to deal with contrasting levels of light and dark in one shot; the rather inflexible editing process (particularly for sound); and the further loss of quality involved in analogue editing. Image quality and the problems of editing continued to be insuperable for analogue video. One problem was the technology of the camera itself. In the mid-1980s, all video and TV cameras were still using a tube technology that had a number of inherent problems. The introduction of the charged couple device (CCD) in the late 1980s inaugurated rapid improvements in video camera technology. The three glass tubes in a camera contributed considerably to its weight, so CCD enabled lighter-weight cameras. In 1985, Sony produced the Handycam using an analogue 8mm tape format. The Handycam was the first of the small video cameras that can be held in one hand, bringing new possibilities for documentary filmmakers and inaugurating the development of 'self-shooting' productions. Initially, the image quality was debatable to say the least. Editing remained a problem for home users, but by the end of the 1980s, TV documentary filmmakers quickly experimented with transferring their Hi-8 rushes to professional formats and editing from there. With the introduction of digital rather than analogue tapes in 1993, Hi-8 footage could be edited with no onward picture-quality loss. The resulting programmes were (reluctantly) accepted by broadcast engineers and commissioning editors for particular kinds of projects. These would include ambitious projects like the BBC's *Video Nation*, which first appeared on screen in 1994. 'The basic concept was to provide camcorders to a semi-representative selection of "the audience", to train these (approximately) 50 people and ask them to film fragments of their daily life. Mandy Rose, one of the co-producers summarised their ambition as follows: "the aim was an anthropology of Britain in the Nineties seen through the eyes of the people themselves"' (Carpentier 2003: 425). A key feature of this new production route for documentaries was the reduction in cost that it implied. The cost of an eleven minute roll of 16mm film was £400, including the necessary laboratory costs.[4] A thirty minute tape cost around £5. This was a significant liberation for directors in situations where it was preferable to shoot as much as possible, and to follow action. It also made it economical to shoot over much longer periods than had hitherto been possible, making studies of people in evolving situations much more common than before. However, the savings were not

absolute. Without some kind of notes from the shoot, a lot of time could be wasted finding the right shots from hour upon hour of footage. A shift had taken place. Fewer decisions about selection of actions for the eventual film were necessary during shooting; these decisions were delayed until the edit. The pressure on the director to make decisions during the shoot was reduced by this new technical opportunity.

Despite such developments, however, 16mm film remained the medium of choice for higher-budget documentary filmmaking. The 1996 series *The House*, about the Royal Opera House in London, was a complex observational series which was shot entirely on 16mm film. The camcorder or minicam had arrived, but it still suffered from many of the fundamental drawbacks of analogue video. The arrival of a fully digital tape-based camera changed that. Towards the end of 1995, both Sony and Panasonic introduced camcorders based on the same digital tape format, DVC. These were cameras addressed both to professional newsgathering and to domestic use. They could be adapted to record two mono soundtracks, rather than the stereo for which they were designed. Indeed, when they were first introduced they were bought in large numbers by musicians simply for their digital sound recording potential. After a few months, the problems of using these tapes in conjunction with professional video editing systems were solved, and a new technical combination was available for documentary filmmakers. In 1996, therefore, the digital video system that has now become familiar emerged for the first time. One person could easily use these small cameras, which were equipped with a zoom lens and able to record image and sound digitally for thirty minutes or more.

More recent developments have included 'solid-state' cameras that record onto digital memory chips rather than to tape, enabling direct input of rushes into a computer. There has been a considerable reduction in cost, not only in terms of the cheapness of digital recording as opposed to film, but in the equipment that is used as well. 'Technology is no substitute for a good story, but it does enable us to do things not previously possible: equipment that is non-invasive, works in low light, kit that you can afford to lose, kit you can remote control or mount on anything – it all allows us to shoot things in new ways' (Wood 2008: 57). In terms of shooting, the most significant later development was the flip-out screen, which finally freed the camera operator from having to look down a viewfinder. As the highly experienced observational cameraperson Joan Churchill commented:

> Now because of the smaller cameras with flip out screens, I am more present as a participant because I'm no longer hiding behind a big glass eye. I think my style of shooting has evolved and would be called 'experiential', a term my husband, Alan Barker, came up with. We see ourselves as being 'part of the circle' in whatever subculture we're following and really throwing the audience into a firsthand experience much as it unfolds for us, by a process of discovery.
>
> *(Fisher n.d.)*

The relationship between filmer and subjects has been reconfigured by these developments. Documentary no longer necessarily involves the technical rituals of the

16mm film crew and the movement of the director between the world of the crew and the world of the documentary subjects. Some prefer to work in this way, of course. The subtle gradations of separation produce a distinctive and often contemplative style of film. Others have grasped the new opportunities for intimacy that the equipment now affords them. There are fewer technical and budgetary considerations to distract a director's attention during shooting. Overall costs have reduced, so longer shooting times are possible. Directors can go out on their own, and can develop long-term relationships with their subjects. As Joan Churchill's comment implies, the filmer can be involved with what they are filming, rather than being an observer distanced by their professional equipment and role. Interviews can become much more like conversations, with the director glancing sometimes at the display on the flip-out screen to check the picture and sound. Documentarists have a greater flexibility in how they engage with people and situations. It also changes the exchange from the subject's point of view, but it does not necessarily reduce the uncertainties involved. The increase in intimacy and the more conversational nature of exchanges increases the sense of obligation felt towards the filmmaker. As a friendship grows, so the confessions can increase and the revelations will tumble out. However, most potential documentary subjects have seen enough to make them slightly wary of filming. So the more direct, one-to-one nature of this new technical set-up can allow subjects to negotiate a way of shooting that suits them better; or it can be simply confusing, with documentary subjects having few reference points in the delicate process of defining the filming process. It is almost certainly easier for a subject to ask for filming to stop, as this is a simple person-to-person request. It no longer involves 'losing face' in front of the silent film crew; a crew whose silence can be taken as implied disapproval.

Technological changes have enabled a new approach to documentary. They have informalised the documentary approach to events, but this has been valuable – or even possible – only in a social context in which most social exchanges have also become more informal. Quiz shows at the beginning of television in the UK reveal a society where people were reluctant to be known by their first name; contemporary informality means that use of the first name is taken for granted in today's game shows (Ellis 2011). Documentary, too, is informal, able to cross the boundaries between public and private at will. The informality of much documentary filmmaking does not, however, mean that filmers can avoid the necessity to take a change of perspective once filming is over. Film or video, analogue or digital, the post-production process is still one of turning events into texts.

5

PERFORMANCE AND SELF-REVELATION

'I assume,' wrote Erving Goffman, when trying to define his approach to the analysis of communication, 'that when individuals attend to any current situation, they face the question: "What is it that's going on here?"' (Goffman 1986: 8). Ask this question of documentary films, and immediately we find ourselves in difficulties. There are two distinct but profoundly interrelated 'things going on'. There is the film that we watch as an audience; and there was once a series of interactions between filmer and the filmed. Different things go on in each situation; the people in them act and interpret the actions of others in different ways. However, the two things depend on each other for their existence. There is no film without filming; and filming normally presupposes the eventual existence of a film. So an experienced interviewee speaks with half an eye on the conversation they are having with their interviewer, but also half an eye on the eventual use of their words in a film that will be shown to other people at another time. However natural the speech may seem to us when watching it later, the situation is distinct from other forms of conversation and witnessed speaking.

To ask 'What is it that's going on here?' is to look at documentary in a particular way. It is enabled by the development of the digitally enhanced audience for such films. If we are no longer transfixed by the question of whether such filming is 'true' or shows the 'facts' in an 'accurate' manner, then a situational analysis of documentary becomes possible. Goffman defines this as meaning 'a concern for what one individual can be alive to at a particular moment, this often involving a few other particular individuals and not necessarily restricted to the mutually monitored arena of a face-to-face gathering' (Goffman 1986: 8). A situational analysis, then, pays attention to the only reality that documentary can truly bear witness to: that of an interaction between individuals at a particular time, each individual bringing to that situation their own expectations and understandings of what is going on, and how that will define how they ought to, and want to, behave. The reality of documentary, as Bruzzi points

out, is 'performative' – 'Documentaries are a negotiation between filmmaker and reality and, at heart, a performance' (Bruzzi 2006: 186).

A second situation lies over this first situation of the actual filming. Viewers in multiple kinds of situations of their own will look at the footage in its edited form and react to the actions and interactions that they see. Digitally enhanced audiences bring their own understandings of 'what it was that was going on there' to their viewing of the filmed footage. They will be captivated by it, they will be moved by the things that happen and the things that are said, but at the same time they will know them to be the product of an interaction, rather than something caught unawares. It is perfectly possible to be moved and to be aware of the constructed nature of what it is that is provoking emotion: fiction would be impossible otherwise. And so it is with documentary. But the existence of this second situation of viewing brings a complication to the first situation of filming. The original filmers and most of their subjects will have been aware of their eventual audience and their probable attitudes to documentary, even as they strive to be as honest and direct as possible (or not, depending on their motives). So a situational analysis of documentary will have to take this into account as well.

Situation, frame and role: Goffman's theory

Goffman developed the notion of 'frames' to analyse the understandings that people bring to ordinary and extraordinary social situations. These understandings govern how individuals then act and react: how they understand what others are doing and asking of them; how they relate to those others; the kinds of actions they initiate; the kind of mood that they experience. Such framings are often automatic or unthought in their application. But they can be understood, as Goffman demonstrates in an extraordinary series of reflections on framings as diverse as everyday conversations; workplace relationships; gambling; deception by con men; TV wrestling matches; psychotherapeutic sessions; and the treatment of national flags after their use in rituals.

Integrated into this perspective is Goffman's earlier insight that any social situation involves a performance, an idea he developed in *The Presentation of Self in Everyday Life* twenty years before. His metaphor was drawn from the theatre. Looking at the very different behaviours of the staff of a remote hotel in Scotland, he analysed social exchanges into front stage and back stage. In the kitchen, he saw the informal behaviour from the staff's crofter culture; in the dining room, a 'British middle-class pattern' prevailed, affecting everything from verbal and body language to how the food was served on the plate (Goffman 1959: 116–18). From such observations, he developed the idea that behaviour is always moulded to suit the circumstances and expectations of the other:

> When one's activity occurs in the presence of other persons, some aspects of the activity are expressively accentuated and other aspects, which might discredit the fostered impression, are suppressed. It is clear that the accentuated facts make their appearance in what I have called a front region; it should be

just as clear that there may be another region – a 'back region' or 'backstage' – where the suppressed facts make an appearance.

(Goffman 1959: 111–12)

This division of activity or expression is no dishonest pretence; it lies at the heart of human interaction. Humans are social beings, so they have 'face' which is to be maintained. It matters what others think of us and what we think of them; we do not like to cause offence unnecessarily, nor do we like to be embarrassed or to look a fool in any circumstance (unless it is a deliberate ploy, as is the case with Nick Broomfield in many of his documentaries; see chapter 13). So our interactions involve elements of 'face work'. 'The mutually binding task of face maintenance in any social situation is the means whereby individual participants display their awareness of others. In so doing, they acknowledge that they are accountable to each other. This accountability is, in essence, a moral matter' (Scannell 2007: 151).

The full force of this moral dimension was brought out, not by Goffman, but by Harold Garfinkel in his *Studies in Ethnomethodology* (1967). Garfinkel carried out an experiment that is reminiscent of a major strand in contemporary comedy. He asked associates (mainly students) unexpectedly to disrupt ordinary conversations by asking for clarification of perfectly ordinary remarks. If someone said they were tired, the experimenter would ask in what way they were tired, following on relentlessly with requests for further clarifications. They found that the predominant reaction was anger: 'what do you mean, "what do I mean"?' The accounts read like a script for the sitcom *Curb Your Enthusiasm*. But these interactions did not take place in the frame of entertainment and the key of comedy, understood as such by all the participants. Instead

perfectly obvious utterances are treated as essentially strange [so that] conversation almost immediately becomes impossible [creating instead] a vicious spiral of vanishing meaning from which there is no way back. Thus what is at stake is the possibility of a meaningful world in the face of a radical scepticism that wilfully refuses to acknowledge and accept it as such.

(Scannell 2007: 155)

No wonder people became angry. Not only did the insistent questioning break the normal roles of domestic conversation, but, in doing so, it threatened commonly held assumptions about the nature of the world. The over-pedantic approach adopted by the experimenters (often at home) not only disrupted their normal ways of relating to those close to them; it also brought out the existence of that ensemble of taken-for-granted attitudes and actions which, together, form the horizon of our lived world. To behave appropriately is to acknowledge the power of the taken-for-granted in forming our world, and also the fact that it is a necessary underpinning of day-to-day behaviour. A conscious effort of analysis and criticism is required to step outside the taken-for-granted and to see it for what it is. Garfinkel demonstrates that such analysis cannot be too hastily imported into everyday life in a brutal way. It has to be framed

in particular ways in order to strip it of most of its aggression. So the unveiling of the inappropriate, annoying in the real, becomes the stock-in-trade of the stand-up comic, or the rhetoric of the radical social critic.

A history of self-revelation

The development of reality TV in the 1990s has divided cultural critics. As Graeme Turner argues:

> At one end there are those who see reality TV as a tasteless and cynical exploitation of ordinary people's interest in becoming famous, on the one hand, and the contemporary audience's regrettable fascination with witnessing spectacles of shame and humiliation on the other. At the opposite end, there are those who regard reality TV as a positively empowering development which has opened up the media to new participants
>
> *(Turner 2009: 34)*

Reality TV takes some of the features and techniques of documentary and marries them with entertainment and gameshow forms. It is generally regarded as a new development, but it is also part of the same long history of self-revelation that underpins much documentary filmmaking. Goffman observes that 'Life may not be an imitation of art, but ordinary conduct, in a sense, is an imitation of the proprieties, a gesture at the exemplary forms, and the primal realization of these ideals belongs more to make-believe than to reality' (Goffman 1986: 562). It may be 'make-believe' to believe that we can find individuals who embody the ideals of human behaviour, but it does not stop us from trying to find them. Nor, for that matter, does it stop us from finding the fatal flaws in anyone who seems to come close. Charles Ponce de Leon traces this emphasis back to the individualising tendencies of the democratic revolutions of two centuries ago in France and the USA. They 'sparked a new self-consciousness about appearances. This self-consciousness was not confined to dress, demeanour and choice of public association. It also affected how people presented and came to understand their life stories' (Ponce de Leon 2002: 19). The publication of the life stories of exemplary individuals became a major phenomenon during the nineteenth century. The books of Samuel Smiles and similar writers were bestsellers. Smiles' *Self-Help* sold 250,000 copies, arguing that the individual is responsible for his (always 'his') own fate. He believed that 'every human being has a great mission to perform, noble faculties to cultivate, a vast destiny to accomplish' (Smiles 1905: 133). He had, according to Asa Briggs, a 'remarkable ability to say something of interest and importance to generations of "ordinary" men and women' (Briggs 1958: 10). As the century continued, Ponce de Leon argues, the biographies of the famous came to emphasise the private life of these individuals:

now viewed not merely as the domain of the real self but as the realm where the subject was most likely to find fulfilment. Shifting attention to this realm enabled the press to construct portraits that were more interesting and relevant to the wide array of readers who made up the mass audience of the twentieth century [...] achievements served not as proof of a subject's virtuous character but as visible manifestations of his ability to express himself – the ultimate fantasy for people dwarfed by the size and complexity of the institutions that now dominated the public sphere and defined the nature of modernity.

(Ponce de Leon 2002: 40)

Ponce de Leon traces the emergence of celebrity journalism to the latter part of the nineteenth century – to the moment when popular journalism was born. The revelation of the private self, then, is a long-term trend in a Western society that promotes the value of the individual, and sees the individual (rather against the evidence of a complex, regulated and corporate society) as in control of their own person. Hence every individual faces a problem: how am I to behave, what are the most appropriate forms of behaviour, and how am I to be true to myself? The emphasis on ordinariness, rather than the lives of exemplary individuals, seems to date at least to the beginnings of TV in the 1950s. From the moment when the first gameshows invited 'ordinary people' to appear, a new tendency in the examination of exemplary behaviour was born. No longer was it necessary to read about people and their lives: TV viewers could see for themselves, and could see the details of personal interactions for the first time. How people moved and spoke became visible. Ordinary behaviour was on display, with all of its mistakes and hesitations. Documentaries tried to explore this further: it was one of the most elusive goals of cinema verité to discover how ordinary people went about their lives. People were invited to give accounts of themselves, to speak in their own words, to reveal themselves. Since the early 1960s, many television documentaries have tried to highlight the ordinary and the typical as part of their social mission. People could be exemplary in their ordinariness: indeed, as Turner argues, the ordinary is the subject of much contemporary curiosity. To supply the answer to these questions about self, about the nature of 'being ordinary', individuals have to reveal themselves in public, exposing their private behaviours for general inspection. Self-revelation has had a long history and is closely related to the exploration of the ideals of behaviour, and therefore of how any individual will fall short of those ideals in some way.

Though Goffman arrived at the idea of performance of self through a number of metaphors derived from theatrical performance, he makes a crucial set of distinctions between theatrical performance and real life. Actors in fiction offer themselves to be

looked at; if we were to look at a person in real life in the same way, we would be breaking the frame of the everyday face-to-face encounter. Our stare would be considered inappropriate and even offensive, and could lead to a fight. Actors, as they perform, are expected to be word perfect, and to take turns in speaking. The 'ums' and 'ers', the hesitations and slips, the interruptions and talking-over of everyday conversation are not permitted to anything like the same degree in a theatrical performance, even in a play that is ruthless in the pursuit of naturalism. Other participants in an everyday exchange will ignore these as something that does not merit attention, or even, if someone is clearly struggling to recall a word, that needs a friendly prompt. But in theatrical performance (and the delivery of formal speeches and the like), the inability to perform the lines prescribed is a major problem, and even minor hesitations or slips are highly noticeable to the audience. They can even 'break the illusion' by provoking unwanted responses of laughter or irritation. Something of this expectation rubs off on the people who appear in documentaries. Over-hesitant speakers tend to remain on the cutting room floor, or have their contributions 'invisibly' edited to make them seem more fluent.

However, there is one further distinction that remains paramount. Actors in the theatre are pretending to be other people, no matter how much of themselves they bring to a role. The people we meet outside fiction are fundamentally different, even though they, too, can be said to be performing in the manner expected of them by the situation (by not staring as they would in a theatre, or using inappropriate language, or shouting, mocking or insulting, or refusing to reply, or exhibiting any other disruptive behaviour). We expect to meet 'real' people, that is, individuals who are 'concrete organism[s] with distinctively identifying marks, a niche in life. [They are] the selfsame object[s] perduring over time and possessing the accumulating memory of that voyage. [They have] a biography. As part of this personal identity [they] claim a multitude of capacities or functions – occupational, domestic and so forth' (Goffman 1986: 128–29). Goffman examines many situations where this does not happen, using many stories of misunderstandings and of the deliberate deceptions of con men. In this way, he shows that the expectation of a biographical person behind the performing person is fundamental to the everyday working of the society in which we live. We expect people to behave appropriately: to conform to the frame in question. We are quick to react negatively to inappropriate behaviour of any kind. In the workplace, we run for the bullying police. In personal life, we avoid people we 'who make us feel uncomfortable' or who 'we don't like', often because we consider their speech and behaviour to be inappropriate. We assume there is a biographical person lying behind the frame-appropriate behaviour of those whom we meet.

Unlike the actor in a play, our everyday encounters involve performances of self, a display that involves identity and biography, mediated by the kind of 'face' that we have developed in our dealings with different social situations. Face is, in many ways, the expression of biography and experience. But however well developed a person's face may be, if their understanding of the framing of their current situation is off-key (Goffman 1986: 40–82), then they will still behave inappropriately, sometimes with disastrous consequences. Think of someone who mistakes a joking conversation as

serious, or takes a ritual question such as 'how are you' as the cue for a detailed recitation of your current woes. Framing mistakes are also hazardous, as they may well lead to the revelation of things which are shaming, embarrassing, troubling or even incriminating if revealed in that particular company, time and place. Few actors playing a fictional role ever had such problems; when they do, it is because their role becomes confused with their own personality and they are 'typecast'. For concrete individuals, however, it is another matter, as many inexperienced Facebook users have realised. The appropriate revelation to one's contemporaries and close friends may not go down so well with parents, stalkers or potential employers. The concept of 'face', which is implied in the naming of Facebook, is a difficult but essential one. It implies a self that is presented in a relatively public, interpersonal situation, and a person's face is something they usually learn to develop in early adulthood (often, that is, after they have developed a Facebook account). Facebook users now limit access to their detailed profile, photos, etc. to their 'friends'. However, the framing of 'friends' employed by Facebook is still problematic, at least at the time of writing. Many people include their parents and other relatives as 'friends', along with work colleagues and close personal friends. In most people's lives, different faces operate for each of these categories. The problems of privacy settings on Facebook dramatically demonstrate the power of framing in all kinds of encounters, not only those of face-to-face interaction.[1]

So how do we know the person behind the behaviour; and how, for that matter, do we reveal or conceal our 'real' selves in our everyday encounters? The answer may seem simple: there are moments when every person can choose to be sincere. But what if sincerity has its own framing rules? What if your moment of sincerity is taken by those to whom it is addressed as just another joke on your part, or as an embarrassing irruption into a conversation where it is unexpected, or (and this is the most devastating) as not sufficiently sincere, that is, as a sign of the level of self-delusion from which you suffer. Such judgements are routinely made on the people whom we witness in documentaries and reality TV shows. And so it is in our social interactions as well. As a result, sincerity is difficult to perform. Viewers of reality TV or documentary often express vivid judgements about the sincerity of individuals. Such judgements depend on particular criteria relating to the framing of sincerity. What was said was not right for the company or the moment in which it was said. So, very often, what was said, or the person doing the saying, is judged as somehow suspect. Such is the power of the framing of sincerity itself. It has to be appropriate.

After many examinations of what can go wrong in the framing of encounters of all kinds, Goffman reaches this conclusion:

> There is a relation between persons and role. But the relationship answers to the interactive system – to the frame – in which the role is performed and the self of the performer is glimpsed. Self, then, is not an entity half-concealed behind events, but a changeable formula for managing oneself during them. Just as the current situation [whatever it may be] prescribes the official guise behind which we will conceal ourselves, so it provides for where and how we

will show through, the culture itself prescribing what sort of entity we must believe ourselves to be in order to have something to show through in this manner.

(Goffman 1986: 573–74)

Sincerity and self-exposure also have their framing principles, even when they involve an excess of emotion. Goffman uses the striking term 'flooding out' to describe those moments when an individual's bodily functions, such as tears or laughter, cause them to 'capsize as an interactant' (Goffman 1986: 350). Such moments are excused if they simply interrupt a conversation, or even a theatrical performance (where it is known as 'corpsing'). However, where such 'flooding out' seems to be the result of the conversation, then it tends to be received as a communication in its own right: laughter asserts the comic nature of the conversation; tears attest to sincerity, or a stronger than usual reaction to what has been said. Again, harsh judgements can be made about a person dissolving into tears if those tears are taken as hypocritical, insincere or attention-seeking. The question of the framing of sincerity is crucial for an understanding of documentary. Contemporary viewers seem to value above all else the moments where the 'real' person peeps through in factual footage.

Goffman does not himself go very far in the analysis of documentary. Goffman's work implies a media perspective: he culls his many anecdotes from the press, and when he relies on TV news as a source, he has sharp things to say about its status as 'a special type of entertainment' (Goffman 1986: 452). Yet his habitual frame of reference for mediated encounters is the theatre rather than cinema or television, and fiction rather than documentary. He limits his consideration of documentary to the idea of replays of recordings or other 'technical redoings' (Goffman 1986: 68–72), perhaps because he is working in a culture where documentary is squeezed to the margins; perhaps because he is thinking primarily as an academic. However, a filmic metaphor is central to his writing at this time. He talks about 'strips' of experience that have 'tracks', which are attended to or neglected by participants, a 'raw batch of occurrences (of whatever status in reality) that one wants to draw attention to as a starting point for analysis' (Goffman 1986: 10). He pays little or no attention to those circumstances in which such strips are cut and combined into a distinctive new experience – which is the case with film and video. This, after all, was not his primary concern. He was interested in the framings of human behaviour and their impact on 'the organisation of experience', as he subtitles his book. The reorganisation of experience into an audiovisual text is another question, which is my concern here.

6

DOCUMENTARY FILMING AS PERSONAL INTERACTION

Goffman's ideas can easily be applied to documentary. One application has become a truism: of course, we say, people play versions of themselves appropriate to the documentary circumstances. This is often used to reject the insights offered by specific documentaries because the people are 'only performing'. But it follows from Goffman's theories that all that we ever encounter of people is 'only performance'; that it is impossible to engage the 'full self' in any particular encounter. There is always something more, something private, something which cannot be expressed in a particular moment, in a particular frame and keying of that frame. So people often surprise us: when we see an intimate friend in a public role, just as much as when we become intimate with someone whom we first met in a formal situation. Strategic self-presentation leads to an iterative 'information game', that is, 'a potentially infinite cycle of concealment, discovery, false revelation, and rediscovery' (Goffman 1959: 8).

However, the suspicion of 'performance' in documentary does have a grain of truth to it. Not that sincerity is somehow missing, but that we do not properly understand how the exchange we are witnessing was originally framed. If we do not understand how an exchange is framed (one we experience, or one we witness), then we are liable to misunderstand it. We will often misunderstand its keying (whether it is ironic or playful or flirtatious or intimidating), and we may even misunderstand the whole frame, taking accidentally captured, off-camera moments as if they had the same status for their participants as on-camera events. How well, really, does anyone understand the framings involved in a documentary experience? This is the enquiry of this book: what is it that is really going on in the framings of a documentary event, both when it is being filmed and when it is being watched? What does it feel like to be photographed and recorded, and what does it mean to watch the results?

The answer is far from simple. It has varied over the history of the documentary genre, and will continue to do so. The complexities are demonstrated by trying to understand the framings involved in the simple documentary interview, where an

individual is being asked questions about something that has happened to them. On the face of it, it is simplicity itself. We all tell stories about things that have happened to us; indeed, a remarkable amount of conversation consists of the recounting of relevant or entertaining past events (Goffman 1986: 496–511). However, to do so for documentary involves a set of framings rather different from those of everyday conversation with individuals whom we know slightly. To begin with, the rules are more familiar to one side than the other, which is not usually true of everyday conversation. For the interviewee, the interview is a relatively rare, or even unique, occurrence in their lives. For the professional interviewer, director and crew, it is a frequent and familiar form of exchange, though not without its risks. To begin with, then, there is a difference of knowledge and power in the exchange. The interviewee is often eager to please, or nervous, or suspicious, or elated.

Interviewees may even employ all the conventions of a more normal framing and settle down to an everyday conversation, ignoring the usual requirements of the interview format. In Raymond Depardon's *Profils Paysans: L'Approche* (2001), there is a moment when a couple are being filmed and the wife silently offers biscuits around as a hospitable gesture to Depardon and his sound recordist partner. This gesture disconcerts us as viewers, and may have disconcerted the filmers as well, as the proffered biscuits are not taken up. The gesture is entirely natural and would not be remarked on as part of any everyday visit to someone's home. In the film, it becomes noticeable because it breaks the interview frame that we all expect, and so becomes remarkable. When it is included in the final cut (which it need not have been), it serves to show the level of intimacy that Depardon had achieved with his subjects over a long period. Depardon had been a frequent and welcome visitor to this household for some time.

This encounter shows up the nature of the framing of the conventional documentary interview: it only appears to have been conversational. It also highlights the nature of many documentary encounters and interviews. The more intimate the interview or filming, the more likely it is to take place on the subject's 'home ground' rather than in a space controlled by the filmmaker, or in a more neutral space such as a workplace. To interview a subject in their home invokes all the framing of the host/guest relationship. In the case of Mme Challaye, this meant offering a defined form of hospitality. The invasion of someone's domestic space by a film crew is a familiar image. It subtly alters the dynamic of an interview (let alone of a longer filming encounter) by making the subject feel responsible for the success of the filming, as though they, as hosts, are being done a favour by the filmers, rather than the other way around. The rules of hospitality mean that you should make your guests feel comfortable and make their journey worthwhile. However, every documentary filmmaker has encountered contrary examples of situations in which the rules of hospitality are less ingrained, where their presence is felt as an intrusion or is resented by other members of the household. The bracketing procedures of pre-production research should eliminate this possibility, but there are sometimes surprises, even so.

The interview is a highly constrained and unusual exchange, 'bracketed' (Goffman 1986: 251) within less formal exchanges. Most interviews are conducted with a

certain amount of preparation. The minimum is a simple phone call that 'books' the interviewee and makes the necessary arrangements. This operates when both sides know what to expect: the interviewee is someone who can be relied on to deliver. They will set up expectations about the interview: the nature of the production, the topic, the reason for the choice of this particular interviewee, the location and date. More complex preparation can include being 'checked out' by a researcher; a preliminary conversation with the director; explicit conversations about ethical risks; or, if the interviewee is an academic, the request to submit something in writing to summarise your views. The conversation will be warm and friendly, usually involving a degree of flattery of the interviewee. This, in turn, may be taken literally or 'with a pinch of salt'. The process can sometimes be protracted. Designed by the filmers to clarify what might be involved in the exchange (or what they will get from it for their programme or film), such protracted negotiations set up expectations about the interview itself, tending to exaggerate its importance. This can provoke the interviewee into a request for payment if handled badly; or may flatter the interviewee even before the camera has made its appearance on the scene. This preliminary negotiation is the first level of bracketing of the interview itself.

The immediate bracketing of any interview lies in the less formal activity that surrounds the formal activity of the interview itself. These are usually off-camera, and so unavailable for scrutiny by eventual viewers of the film. The hallmark of Nick Broomfield's documentaries is to include a number of such moments, where they reveal more than the interviews themselves about the subjects. The interview itself is bracketed by a number of activities which are a little mystifying for many interviewees. The situation will normally involve more than one person, depending on the size of the crew being used and the technical challenges of the filming situation. Nowadays, there is often just one person in addition to the director/interviewer, someone whose function is primarily technical, unless the filmmaker has made a conscious decision to make the filming as informal and conversational as possible. Sometimes there can be an entire crew (camera, sound, lighting), and this was typical of earlier phases of documentary development. The presence of a technical crew complicates the exchange. They remain silent during the interview itself, and are relatively taciturn in the bracketing activities, while the interviewee is seated comfortably and lit satisfactorily. This activity is accompanied by light conversation with director or researcher on a topic other than that of the interview: travel problems or the weather being typical, a kind of exchange that is familiar from many other social settings. It is a relatively meaningless exchange, a ritual to establish common purpose and lack of aggression.

If a radio microphone is being used, however, the technician responsible for sound (who may also be the cameraperson) will have to invade the body space of the interviewee to fit the microphone. They will clip on the microphone near to their head, try to hide the cable under their outer clothing, and lodge the power and transmitter unit somewhere. This can be an unsettling moment and so will be accompanied by exaggerated courtesy. Formal instructions will also be given by the interviewer, which further emphasise the artificiality of the interview exchange:

'please can you include the question in your answer' or 'stop if you feel uncomfortable'. The start of the interview itself is marked by the ostentatious switching of the camera and sound to 'record' function, and the asking of the first question, often something like 'first, can you say just for the camera who you are and what you do?'. Such a neutral warm-up question (which itself can sometimes be used in a documentary) provides a fleeting moment in which the interviewee can try to define the scope and limits of the interview. We are all many people, according to the appropriate role for the circumstance: to answer 'member of the public' or 'cat lover' when 'university professor' is the required answer would be to redefine the situation and even, possibly, render the interview invalid.

Once the interview begins, the inexperienced interviewee is launched into a conversational exchange for which they will have no real precedent in their experience. The questions are put respectfully, and are pleasingly open, seemingly allowing full rein to the interviewee to define the answer as they wish. He or she is heard in conditions of unnatural silence. The usual sounds of agreement heard in conversation and even in settings of formal speeches are completely absent from the interview. Instead, the interviewer will indulge in extravagant body language: big grins, exaggerated head-nodding, a gaze of intense concentration as though the interviewee's every word means the difference between prime-time ratings success and late-night obscurity. Meanwhile, the rest of the crew say and do nothing. It is unnerving to almost anyone, with the significant exception of those who 'like the sound of their own voice' or are 'used to being listened to'. For most (and this includes university lecturers), this degree of rapt attention is extremely rare. So the interviewee will feel a strong temptation to go on talking, to fill the silence. The frame of normal conversation would require it. Everyone feels they have to fill the awkward silence with some kind of utterance, as to let a silence wear on is impolite. Deliberate silence after an interviewee has finished speaking, however, can be a technique to get more information or a more emotional response. This approach exploits the difference in framing being brought to the situation. The interviewee feels uncomfortable at seeming to neglect the necessary etiquette of normal conversation; the interviewer is experienced in interview framing. So the interviewer has a certain edge here.

Nevertheless, things can go wrong. The crew may be silent, but they are still active, and the interviewee may well read cues from what they are doing. The interviewee may catch in the corner of their eye the movement of the camera zoom lens being shifted to a closer framing: this can warn the subject that a more intimate moment is being anticipated. The crew may be self-effacing, but they are still a presence. In the circumstances of a simple interview with a seated subject, a crew can be relatively self-effacing, but this is the simplest of documentary encounters. In more demanding shooting situations, where more than one subject is involved, then all kinds of cues can be read from the most professional of crews. As Gideon Koppel put it in an interview:

> At one point I had four teenage girls standing in front of the camera who were all embarrassed, and the only time they could talk was when I asked them

direct questions. So I would ask them 'who's your favourite pop band?' and one of them would give a factual answer and stop talking. I noticed the sound guy moved the mike to anticipate the next person, so they started talking like robots. I actually took him aside and said 'don't ever when you are working with me anticipate the other person, because if you leave people in their silence, that silence might go on for a minute or two minutes but they'll start talking again'. That for me is when things start to get interesting, not when they respond to my question, but when they actually have to start confronting themselves in some way.[1]

Interviewers approach this situation in different ways, ways which define their 'professionalism'. Koppel's minimalist approach effectively invites people to give an account of themselves. The standard practice in television is still to ask relatively neutral and open questions, which seem to the interviewee to require answers full of explanation. Open questions include 'tell me about the time when ... ' or 'what did you think of this person?' or 'what do you object to about ... ?' Such questions are designed to be eliminated from the final programme. This technique allows for smooth intercutting of different interviewees, all of whom will eventually appear to be speaking to the viewer of the documentary through a relatively transparent pro-gramme form. When we watch such documentaries, the circumstances of the inter-view interaction are suppressed in favour of the informational content of the interviewee's speech. This utilitarian approach can bring into sharp relief those moments when there is an exchange between interviewer and interviewee, when the interview moves into a more interrogatory mode. Questions that take forms such as 'but I have been told a different version ... ' or 'what about this fact ... ?' or 'you said something different at another time' will tend to be included so that the inter-viewee's reaction can be studied and the dramatic intensity of the moment is emphasised. In more extended encounters, when the filmmaker is accompanying their subject over several days or weeks, the approach will be more conversational. New camera technologies have made this more possible. But the interviewer will remain a 'sympathetic ear' rather than an active participant in the conversation. Molly Dineen's problems with maintaining this position when following Geri Halliwell are clear from the eventual film, *Geri* (1999). In many conversational exchanges, Halliwell tries to involve Dineen as an active friend and helper. Dineen resists, and in doing so moves the filming towards a conclusion based on Halliwell's rejection of her.

Other filmmakers adopt a far more aggressive approach. The most extreme example is probably Michael Moore. Moore is the opposite of the sympathetic listener. His approach is to demand to be heard himself, leaving his 'interviewee' to negotiate a position in the exchange which often ends with a refusal, or what, in other situations, would seem like a failed interview. For Moore, however, failure is success: his point of view has triumphed over that of the powerful or the deluded. His erstwhile disciple Louis Theroux, however, sublimates his own point of view by adopting a *faux*-naïf approach, pretending to be a little stupid. Theroux asks people to explain themselves to him, while appearing to require just a little more clarification than would be

normal. The interviewee feels no threat from Theroux, and good manners require that his questions are answered in full. The presence of a film crew reinforces the interviewee's reluctance to appear bad mannered; in addition, they may feel a little sorry for Theroux. Indeed, they may begin to enjoy the situation of being able to talk at length about themselves, their beliefs and their work to someone who, however slow on the uptake, at least appears highly interested. Theroux subtly reframes his interview exchanges by adopting a role that requires a sacrifice of his own self-esteem. This is by no means easy, which is why many (including Michael Moore) would find the technique difficult, if not impossible. Indeed, many filmmakers are eager to eliminate their questions from their films because, when they listen in the cutting room, they are faintly embarrassed by what they hear. As journalist Rachel Cooke put it, 'when I listen to my interview tapes I, too, sound like a craven bubblehead. The difference is no one else has to listen to me. Thank goodness' (Cooke 2010).

The progress of any interview depends largely on the ability of the interviewee to hold to their definition of the interview, to hold to their framing rather than that of the interviewer. Someone being interviewed in a professional capacity is less likely to yield to the temptations of going too far, of 'flooding out', in Goffman's term. A politician or senior businessman has a whole set of professional practices to fall back on in the circumstances of an interview. They will tend to maintain the frame of the workplace exchange, which can involve a high degree of withholding of information or emotional intimacy. However, a whole profession of interview and public relations trainers is necessary to equip even these professionals with the necessary skills in maintaining their definition of the interview frame. It does not come easily or naturally to refuse a conversational frame when it seems to be offered by the person you are talking to. In the face of a trained professional, an interviewer will respond with an inquisitorial style, implicitly invoking the right of the presumed audiences of the interview to be told the truth. The encounter between ex-President Nixon and David Frost vividly demonstrates a competition between the claims of the calculated professional discourse and the inquisitorial journalistic discourse (see box pp. 59–61).

Without the frame of the professional workplace exchange to protect them, subjects who are being interviewed on more personal issues may well find that the framing of the interview slips from conversation to confession. The skilled interviewer will ask a particular kind of question: open-ended and brief. The interviewer will suppress their own impulse to 'hold up their end of the conversation'. He or she will not try to exchange personal information by bringing in information from their own life. Nor will the interviewer seek to impress or ingratiate him or herself with the interviewee. Even the questions will seek to absent the person, the biography, of the interviewer as much as possible. Instead, the questions will be invitations ('tell me about … ') or even exhortations ('how did that make you feel?'). Even in an age where therapeutic discourses and relationship advice abound, people don't normally ask each other such questions outside the domain of close friendships. For a relative stranger to ask you how you feel and then listen intently to the answer is very rare indeed. This can be the situation with a film crew. Several people may be listening in absolute silence. Uncannily, the relative stranger asking these sympathetic questions seems to know

many things about you, and is trying to make sure that they have your full account without disputing details. This is no longer a conversation: it has slipped into a confessional mode. The intimate interview format has all the framing of the confessional: the intent listening, the unnatural silence, the encouragement to speak more freely than was perhaps your initial intention. It is a moment of unexpected intimacy, which often brings tears. And after it is over, the subject will say that they feel better for having spoken out. Precisely because this is an unexpected moment of intimacy, however, it can have difficult results. The subject may regret what they have said, especially when they remember that a future audience was also involved in the exchange. Or again, they may feel that a bond has been forged with the interviewer, and they will want to repeat the experience of intimacy. They may, in short, think that they have found a new friend. If even the single interview can provoke such expectations, then the more extended shooting of a substantial documentary is very likely to do so. A substantial part of the documentary filmmaker's work, therefore, lies in managing the post-interview or post-filming expectations of their subjects, as chapter 7 explores.

The Frost/Nixon Interview

The temptation for any interviewee is to try to engage on a personal level with the professional who is interviewing them. Otherwise the situation is unnatural: you are speaking to someone who has an extensive knowledge of you and is intensely interested in your answers. But you do not know them. Most people would feel an urge to reciprocate in some way. The professional skill of the interviewer lies to a significant degree in intuitively recognising when and how this is likely to happen. A clear example occurs at the climactic point of David Frost's 1982 interview with disgraced former American President Richard Nixon. This is a well documented example of the process of an inquisitorial interview. Mounted as a lucrative venture for both parties,[2] it stretched to four 90-minute programmes in the USA, culled from some 28 hours of material produced over twelve days. The writer Peter Morgan fashioned this process into a play, which was then filmed as *Frost/Nixon*, directed by Ron Howard (2008).

The broadcast interviews show Nixon stonewalling for much of the time, answering Frost's detailed but deferential questions at great length. The film lays bare the mechanics behind the interviews. Frost's associates explicitly criticise his interview technique as being far too soft. The film shows Nixon's use of several standard tactics for unsettling the interviewer, such as asking Frost, just before the cameras roll, whether he had 'fornicated' the night before. For a seasoned politician, the ritual of the interview is all too familiar. He knows, and can easily refuse, the temptation to engage with Frost as anyone other than a fellow professional. So complete is Nixon's refusal to engage personally that the play and the film are compelled to invent a scene to dramatise the potential of such an engagement. A drunken Nixon phones Frost in the middle of the night trying to establish a rapport based on the

idea that they are both, in their own ways, persecuted outsiders. The scene may be invented, but it is created to reveal something of the interpersonal emotional dimension that grows even within the most difficult and confrontational of documentary interviews, especially if they involve more than one encounter. This invented scene shows Nixon's attempt to reach out on a personal level, beyond the confines of the public performances that he and Frost are conducting. It is a necessary invention because the moment when Nixon finally 'breaks' is so fleeting and subtle that it would be missed by almost every viewer of a fiction film.

Frost asks Nixon for an apology to the American people with a typically long-winded question:

> Would you go further than 'mistakes'? You've explained how you got caught up in this thing, you've explained your motives; I don't want to quibble any of that. But just coming to the sheer substance, would you go further than 'mistakes', the word that seems ... not enough for people to understand.

Nixon's reply clearly surprises Frost. Instead of another lengthy speech, Nixon asks a question in return: 'What word would you use to express ... ' and gestures back to Frost, inviting him to speak again. This is Frost's chance, Nixon's first moment of hesitation and reciprocity in a long series of exchanges. He is so flabbergasted that he almost throws the chance away.

> My goodness that's a ... I think there are three things, since you ask me, I would like to hear you say, I think the American people would like to hear you say. One is ... there was probably more than 'mistakes', there was wrongdoing, whether there was a crime or not, yes it may have been a crime [Nixon nods]. Secondly, I did ... and I'm saying this without questioning the motives, right? ... I did abuse the power I had as President, or not fulfilled the totality of the oath of office, that's the second thing, and thirdly ... I put the American people through two years of needless agony and I apologise for that.

Frost delivers these final few words much faster than the rest on a falling tone so that when he arrives at the word 'apologise' it slips out almost as though he, Frost, is unable to pronounce the word himself. He then continues: 'And I say that, you've explained your motives and I think those are the categories.' At this point, it appears that Nixon is about to speak, but Frost ploughs on with 'and I know how difficult it is for anyone and most of all you [Nixon smiles] and that people need to hear it and that unless you say it, you're going to be haunted for the rest of your life.'

Frost displays a high degree of empathy for Nixon here. He almost swallows the word 'apologise', acting out for Nixon his own difficulty in

pronouncing the word. He holds up Nixon's first attempt to answer, flattering him explicitly to show that he, Frost, knows that the answer Nixon should give will be difficult for him. Frost says the words 'unless you say it' in an almost flirtatious way. Frost here may be genuine, calculating, or just plain desperate to get something from Nixon beyond his long-winded stories and self-aggrandisement. Or, indeed, he may have sensed his moment and had sufficient reserves of empathy, even after several days of Nixon's self-aggrandisement and self-delusion, to see how to breach them. Whatever his reason, his question proves to be the correct strategy in response to Nixon's brief moment of doubt. Five minutes into his answer, Nixon finally comes up with a statement of his regrets which amounts to an apology to the American people. After telling the story of his final meeting with his entourage, where he said to them 'I just hope I haven't let you down', he continues

> Well I had. I let down my friends, I let down ... the country, I let down our system of government, the dreams of all those young people, that want to get into government because they thought it was all too corrupt and the rest. Most of all, I let down the opportunity that I would have had for two and a half more years for the great projects and programmes for building a lasting peace, which was my programme when we did our first interview in 1968, before I thought that I might even win that year ... I didn't tell you I didn't think I would win, but I wasn't sure ... yup, I let the American people down and I have to carry that burden with me for the rest of my life.

He continues for a few moments, but the apology is finally made. After talking for two hours a day for almost two weeks, Nixon's self-justificatory public performance broke down long enough for some further feelings to surface briefly, a whole fifteen minutes after Frost had uttered the word 'apology' for the first time in their epic exchange. The telling moment is the phrase immediately before the apology, referring to 'our first interview'. This is the germ of Peter Morgan's invented scene in the film. Here, Nixon finally acknowledges Frost as someone with whom he has a shared history. He volunteers the little truth about the 1968 interview to reach out on a personal rather than professional level. Perhaps, too, he is making amends for having given Frost such a difficult time during the previous days of interviewing.

The interview is a formal exchange, bracketed by a series of less formal exchanges that vary widely in nature. It may be the most basic of documentary situations, but it is nevertheless unnatural when compared with all other forms of conversation, and interviewees can find it difficult to adjust to this new framing. The professionals do not. However, there is a third party to the interview exchange, which complicates it

still further. The interview is not a conversation in the present so much as a message delivered to the future. Its intended audience is not the silent technicians or the nodding director; it is the eventual viewers of the finished film. They are the reason for the technical apparatus, the unnatural silence and the rest. So the eventual viewers are a defining presence, even though they are physically absent and not yet even constituted as a collectivity that could be called an audience. They can only be imagined by the participants in the interview, yet everyone there has them vividly in mind. The presence of this absent, not yet constituted audience defines the interview – and documentary filming in general – as absolutely different from any form of everyday exchange.

An experienced interviewee has half an eye on the conversation at hand, and half an eye on the audience to come. In recent years, this has become the case for many inexperienced interviewees as well. Within the interview there are also differing understandings. The interviewee is in a special sort of conversation with a filmmaker who also has half an eye on the future film, but from a different perspective. The interviewee wants to present her or himself in the best light to an eventual audience, and attempts to 'put themselves across' in a particular way. But the filmmaker has different intentions. The film is to include this interview, but only parts of it, and combined with all kinds of other material. It will communicate the 'vision' of the filmmaker, or at least their distinctive understanding of the subject of the film. Documentary, as we shall see in later chapters, consists of a number of levels of communication: the face-to-face communication of the special circumstances of filming, and the communicative attempts being made by both filmers and their subjects towards eventual viewers as yet unknown.

Even in the circumstances of a simple interview, the framing is complex, involving an unnatural conversation (because of the constraints of its future use) and two competing attempts to communicate with people who are not there at all, except in the imaginations of the filmmaker and the interviewee. Nevertheless, they are aware not only of the future existence of an audience, but also that these eventual witnesses to the resulting footage will see it within a radically different framing. That eventual audience will be like the theatre audiences referred to earlier. They are licensed to watch and listen but not to intervene – but they can criticise, reflect and even object as much as they like. Complicating matters further is the developing sophistication of these eventual witnesses. In the digital age, they bring their own experiences of cameras and recording to bear on their understanding of what they are seeing. They question the motives and the framings of the participants in the initial filmed encounter. So to ask of a documentary interview 'what is it that is going on here?' reveals many different framings, and assumptions about the framings brought by others that may well be erroneous. If this is true of a simple documentary, then how much more complex are the framings involved in a documentary that follows someone through a crucial change in their life, or sets their life in a context that compares their activities with those of others?

Such films involve a higher level of collaboration. The encounters will still be framed by the same considerations of hospitality and the rules of conversation, but

they will gain a further dimension of sustained involvement in a collective endeavour. The excitement and involvement with the actual shooting, a very unusual kind of activity for the filmed, may tend to elide the questions of what the finished film will be like, and what it will be like for people who see it (whoever they may be). They will see it as both a communicative activity and a creative activity in which they are engaged with this group of people who call themselves filmmakers. Some documentary subjects can begin to think of the filming as an activity in the present, rather than one whose purpose is communication in the future. The sense of collaboration in the present can reduce awareness of the imagined eventual audience. During that collaborative exchange, it is very difficult to think forward to what the eventual film will be like for both the filmmaker and their subjects. Such sustained documentary filmmaking can also move decisively into a confessional mode, and in doing so it can encourage feelings of emotional attachment to the filmmaker or interviewer on the part of the subject. It can also lead to regrets in hindsight about having 'given too much away'. This will typically take place after filming is over. Yet this is at the moment when the interests of filmmakers and their subjects begin to diverge markedly. The footage, for the filmmakers at least, ceases to be a 'conversation' and becomes 'material'. No wonder, then, that documentary is a difficult art.

7

EDITING, NARRATIVE AND SEPARATION

The participants in documentary filming, both crew and subjects, shape their behaviour in relation to an imagined eventual audience. They will have differing notions of how that eventual audience will perceive the documentary encounter, but their imagination of what that audience will be is a considerable consideration in the framing of their actions. They will be framing their actions in relation to an absent third party in the exchange, and will be engaged, to varying extents, in attempts at communication with that imagined eventual viewer. So during filming, both subjects and filmmakers have an imaginary film in their minds, the thing that will result from their present filming activity. Sometimes this is a clear and shared concept; sometimes two radically different visions can exist; sometimes one or both parties lose sight of their imagined eventual film to some extent because the immediate events being filmed become overwhelming. In the case of *The Boy Whose Skin Fell Off* (see box p. 65), it is clear that both the director, Patrick Collerton, and his subject, Jonny Kennedy, shared a clear vision of the film they were making and of its purpose. In the case of *Rough Aunties* (see box p. 75), it is equally clear that the relationship of trust built up by Kim Longinotto with her subjects led them to have few concerns about Longinotto's eventual film. To a significant extent, Longinotto enables them to 'ignore the camera', or rather to ignore any anxieties they might have about the eventual film. Instead, they concentrate on dealing with the traumatic events that took place during the filming.

The subjects of a documentary and its filmmakers have differing concerns after filming is over. Differences of interest in the filming project often emerge at this point. The filmmaker will want to make a statement, or to use the film to work out some concerns about its themes, or simply to satisfy some curiosity about their fellow human beings. The people they film may be flattered by the attention that they presume will be given to the eventual film, or even by the approach by the film-makers, which singles them out from others. They may wish to prove themselves by

performing for the camera, or they may relish the opportunity to 'put their point of view'. Or they may even use the process as a way of relieving the tedium of daily life. But in most cases, it is likely that the subjects will want to communicate in some way, in the same way as they have witnessed many others communicating with them through the TV and cinema screen. The people in documentaries very often want to communicate themselves, to offer themselves, their ideas and their lives as examples. The filmmakers, however, also want to communicate in a fundamentally different way. They want to show or to tell. They may want to use their subjects to enable a larger communication about the state of the world; or they may wish to communicate their views about their subjects. Both parties are engaged in constructing their own communicative attempts, and it is rare that they coincide.

Everyone has reasons for cooperating with filmmakers. These reasons, however confused or unarticulated, are concerned with their hopes and fears for the eventual film and their role in it. In the extreme case of a certain kind of confessional film, the intensity of the immediate filmmaking experience itself, the personal interaction with the filmmaker, will mean that the people on camera think little of the eventual film and what might be the consequences of exposing the confession to unknown viewers. Perhaps afterwards, they will have second thoughts. These second thoughts are very difficult for filmmakers to deal with, and they reveal the divergence of interests that takes place once filming is over. Legally, a person who has second thoughts about what they said or did in front of a professional filmmaker's camera will be unable to stop the footage appearing in the eventual film. They will have signed a release form that, in effect, allows the filmmaker and their financiers to do what they want with the footage. In practice, what happens depends on how the filmmaker chooses to negotiate the development of their relationship with their subjects after filming is over. Sometimes those subjects can become friends, especially if they are of the same social background and share a clear vision of the eventual film, which coincides with that of the filmmaker. In this case, they can become collaborators, and a delicate negotiation about the exclusion of certain shots or scenes might well take place. In other cases, the filmmaker will limit their further interaction with their subjects to a minimum. The subjects will be fortunate if they are allowed to see the film before it is transmitted, although some producers do allow this. Richard McKerrow, producer of series such as *The Baby Borrowers*; *Famous, Rich and Jobless*; and *Kidnapped by the Kids*, claims that he routinely shows the series to the subjects so that they can check for 'factual inaccuracies and suchlike'.[1]

The Boy Whose Skin Fell Off (Patrick Collerton, 2004)

A distorted body sits in a wheelchair. A woman addresses the camera from the rear of the room: 'I thought he could wear this waistcoat, but he said "don't use that, you could sell it on *eBay*"'. A man in medium close-up says 'I cried ... but I'm pleased he's gone'. A close shot of the body inaugurates, after a couple of seconds, a cheery voice-over: 'Welcome everyone. My name's Jonny Kennedy. I'm 36.' Cut to the woman who begins to speak and

the voice-over continues 'There's my mother ... and next to her is my brother.' Cut to the body, now in a coffin 'and that's me in the box. Have come back in spirit and I'll tell you the story of my life ... and my death.'

So begins a remarkable TV documentary, somewhat disguised under a sensationalist title. According to the director, Patrick Collerton, it was Jonny Kennedy who proposed the film.[2] Kennedy suffered from a rare genetic disorder, dystrophic epidermolysis bullosa, in which his skin did not attach properly to his body. Any knocks or friction ('such as constant wanking' as Kennedy remarks at one point) means that the skin has to regrow. The result is constant pain, which becomes excruciating when his whole-body dressings are changed once a week, as the film shows in some detail. Kennedy dedicated his adult life to campaigning for the charity sponsoring the search for a cure, and the film project is explicitly part of this campaigning. Collerton decided on a shooting style that was surprisingly classical: 'Together with cameraman Richard Ranken I decided to shoot everything on the tripod, including observational sequences. This way the camera is unobtrusive and allows Jonny and his supporting cast of characters to occupy centre stage. This is complemented by intimate mini-DV footage which shows the realities of Jonny's life' (Collerton 2004). The distanced style of a tripod-mounted camera (rather than the restlessness of a small, handheld DV camera) works because Kennedy understood the demands of filmmaking unusually clearly. He not only proposed the project, but was an active collaborator throughout, even though he knew he would not see it to completion. Collerton says 'Once in a situation, Jonny would perform. He was always trying to surprise me and I was always trying to surprise him' (Collerton 2005).

Yet this is no vanity project for this tragic figure. A third of the way into the film, Kennedy expresses his concerns about the project he has embarked on, in typical style: 'when I've done all the main filming I hope they're not just wanting me to go to bed and lie and die, and the cameraman's going "how are you feeling?"'. Immediately, this remark is followed by a scene in which he cannot continue with his account of how he reacted to his diagnosis of terminal cancer. Jonny's public persona gives way to a more private existence that he has chosen to reveal. This proves difficult for him, even though it is his choice and intention to do so. After a sequence in which he explains his spiritualist beliefs, we are shown a scene of his weekly change of dressings. Here, his composure for the camera again breaks down, but into something much more raw: 'Do something please,' he exclaims, 'don't just sit looking at us.' Yet this is all that we – and the filmmakers – can do.

Even with such a rare degree of collaboration, however, Collerton still experienced a definite shift in attitude from the shooting to the editing stages of the film. After literally watching and filming Jonny die, Collerton remembers edit decisions soon after that were 'technical but also very emotional'. Quite rightly, he's 'totally and utterly' proud of the final result. 'It's a huge thing and I will always be proud of it, but you also have to move on,'

he says (Collerton 2005). This attitude of separation, of seeing the film as material rather than an ongoing experience, is not unlike that of mourning. A year later, Collerton returned to add a short coda for a rescreening of the film. His mother reflects on the despair that Kennedy often expressed – though not much in the film – a sense of being a burden on those around him. She speculates 'and I wonder whether making this documentary was something that made him feel not as worthless as he [felt]'.

The official position of broadcasters that commission documentaries is that there is no requirement that the subjects of documentaries should be shown 'their' film before transmission, and indeed that this can create difficulties. The BBC's Editorial Guidelines state:

> The BBC does not offer the opportunity for contributors to see or hear programmes prior to transmission, save in exceptional circumstances. Any viewing or listening rights provided to contributors or facilitating organisations should not include a right to demand changes
>
> *(BBC 2010)*

The reason given is that:

> Care is needed to avoid compromising editorial integrity. This may be threatened by stipulations over what can and can't be recorded, the right to call a halt to recording, and – most notably – rights over the final edit. There is often temptation to believe that a programme will be made in a spirit of co-operation which will see both the BBC and the access-provider through any disagreements over content. This is often what happens in practice but it should not be relied upon – if the relationship breaks down, a badly worded agreement can lead to a loss of editorial control.
>
> *(BBC 2010)*

The reason for such a position is clear: filmmakers and broadcasters believe that many documentaries would never be seen if their subjects could veto their showing. Why should this be the case if, as even the BBC Guidelines admit, films are often made in a spirit of cooperation which enables disagreements to be resolved? The reason is that the interests and expectations of filmmakers and subjects begin to diverge once the activity of filming is over. The filmmaker has to undergo a process of separation from the events. The filmmaker has to view the film in a different way; their subjects do not. Filmmakers have to move on, quickly, to another stage. They are helped in this process of separation by the work of editors and by the interventions of their producers, commissioning editors or distributors. Filmmakers have to distance themselves from the events in order to make a coherent argument or narrative out of their footage. Documentary subjects remain involved in the events until the film is

completed and shown. For the filmed, the events are not yet over until they have seen how real audiences react to what happened when the cameras were present. Subjects are still concerned with their own face, their own image, and how they will communicate with the eventual viewers. And they also continue to live the lives that the filming has captured for a brief period. Things continue to happen to them after the filming is over. It is rare that filming is able to capture the entirety of events; most documentaries will end with some kind of coda that tells 'what happened next', a technique that even fiction has occasionally adopted. For subjects, the events are not complete, and the communication they attempted is left hanging in the air.

Filmmakers have an altogether different task. They have to make sense of the filmed events, present them as a comprehensible film and, usually, as a viewing experience that is emotionally satisfying (and 'satisfaction' here can include the profoundly disturbing). Filmmakers have to distance themselves from their subjects and the events they have filmed. However engaged and committed they were during the filming, they have to separate and regard their footage as 'material'. It becomes material to be used dispassionately in order to create a film, and this is the case whether that film is to be passionate or dispassionate. This process is familiar to filmmakers, but far less so to their subjects. After the sudden intimacy of a documentary shoot, some documentary subjects will tend to imagine what might be happening during the editing process. If their experience of shooting has left them with a desire for a continuing friendship with the director, then they may well try to make contact and enquire about the progress of the programme. This process is difficult for both parties to handle well. It is the source of many of the ethical conflicts that emerge once a documentary is shown to real (rather than imagined) audiences.

At the close of filming, the filmmaker becomes fully oriented towards the difficult process of making the products of shooting into a film. When a film is being made over a long period, or as part of a longer series or format, it is likely that this process will have already taken place parallel to the filming itself. A rough assembly by an editor or a series producer may well await the director at the end of filming. In the editing process, the material finds a new form as a text. It becomes an artefact addressed to potential consumers. What was said and done during filming is scanned for its nuances as well as what seemed to be happening at the time. It is combined with other material, which redefines what was said and done, giving it a new context, bringing forward concealed meanings, demonstrating consequences. Events become stories. Opinions become examples. Chance becomes fate. Boasting becomes hubris. In short, what happened becomes invested with meaning by the application of hindsight.

This is a process of textualisation. The filmed material is 'guided' into a form which it 'seems to invite' (as some editors would put it) or 'something close to what we were expecting' (as a commissioning editor would say). Such forms of description express the combination of two contradictory pressures experienced by filmmakers and their collaborators at this point. One pressure is the need to be true to the material, to try to be truthful and honest. This is a duty to the subjects of the filming and to the events themselves, and is a key consideration in documentary

filmmaking. The second pressure is the need to provide a structure and story to the material, which is a duty to the eventual audience as well as to the financiers of the film. The way in which each filmmaker reconciles these duties is judged by all concerned (subjects, critics, viewers, commissioners) in terms that are primarily ethical, and that are now used by viewers as well as by industry members, as explored in chapter 13.

Narrative

The process of editing is inevitably one of attributing meaning to events in hindsight: this is the art of storytelling from the real. Storytelling is a central feature of our culture, and documentary has absorbed this as much as any other cultural form. As the literary critic Frank Kermode argued in *The Sense of an Ending* (Kermode 2000), we use narratives to make sense of our world, and endings are necessary to narratives because they make sense of what has gone before. Documentary's mission to explain requires the construction of meanings from material gathered from non-fictional interactions or from documented events. This means providing a structure in which events do not merely follow each other, but lead one from another. The construction of narrative is the construction of a chain of consequences, which by definition can be done only with hindsight, in the knowledge of the end to the story. The ending will provide a sense of completion, however contingent. Many documentaries make clear that they cover just one moment in the life of their subjects; nonetheless, they still strive to provide some sense of narrative closure. Paul Ricoeur expressed the relationship between narrated events and the ending of a narrative by looking at the experience of reading a story:

> To follow a story […] is to understand the successive actions, thoughts, and feelings in question insofar as they present a certain directedness. By this I mean that we are pushed ahead by this development and that we reply to its impetus with expectations concerning the outcome and the completion of the entire process. In this sense, the story's conclusion is the pole of attraction of the entire development. But a narrative conclusion can be neither deduced nor predicted. There is no story if our attention is not moved along by a thousand contingencies. That is why a story has to be followed to its conclusion. So rather than being predictable, a conclusion must be acceptable.
>
> *(Ricoeur 1980: 174)*

Ricoeur expresses well the relationship between events and narrative that a filmmaker will have to achieve for an eventual viewer. Events are attributed an overall sense. There is a forward movement governed by the expectation of an ending which will 'make sense', but there are a 'thousand contingencies' along the way which complicate matters. An ending, therefore, must be 'acceptable', but it need be neither boringly predictable nor entirely satisfactory in tying up all the loose ends. This is particularly true of documentary, where loose ends are often the guarantee or sign

that the film has been manufactured from material that was gathered from reality rather than from some kind of fiction-making activity.

Narrative has another important function: it tells the viewer what to believe. Narrative is not only a structuring of events towards a conclusion, but also a structuring of judgement. Some characters are shown to be more truthful than others, and some to have a greater grasp of what is going on than others do. A narrative will tell us who to believe, including the narrator him/herself. In documentary, a number of voices are competing for attention, and many of the exchanges will have taken place with an eye to the eventual viewer. The narrative will organise the various communicative attempts involved, giving relative values to the statements and actions of different subjects, to the voice of the director, and even to the voices of the broadcasting institution itself. Narrative is the means by which this happens, and the editing process is where narrative is developed from shot material. So filmmakers diverge in their interests from their subjects at this point. It is up to the filmmaker to weigh up and place the communicative attempts of their subjects. Once the shooting is over, documentary subjects have completed their communications with the filmers, but their attempted communications with the eventual viewer are in suspended animation. They wait for the film itself to make that communication happen; but since their contributions and actions are being placed within a structure over which they usually have no control, this can be an anxious time. The filmmaker, meanwhile, is editing: they are structuring the film as their own attempt at communication.

Filmmakers have to narrativise the filmed events very soon after they have happened. The subjects of documentaries will rarely perceive their immediate past life as a narrative at the same speed. They will do so eventually; but the process by which 'stuff happening now' becomes 'things that once happened to me' normally takes some time. For the filmmaker, their subjects' lives have become material; but those subjects are still living those lives. For most subjects, then, the filmed events will be too recent to have been properly processed into personal narratives. Recent events take some time to acquire their eventual significance to those who have lived them. We all do it every time we recount our experiences to others. As Goffman asserts,

> often what talkers undertake to do is not to provide information to a recipient but to present dramas to an audience. Indeed it seems that we spend most of the time not engaged in giving information but in giving shows [...] Ordinarily when an individual says something, he is not saying it as a bald statement of fact on his own behalf. He is recounting. He is running through a strip of already determined events for the engagement of his listeners.
>
> *(Goffman 1986: 508)*

The fact of the filming makes it more difficult to absorb the filmed events into such a narrative structure of recounting. The fact of filming leaves the subjects of that filming with an unresolved story in their lives, and a suspended attempt at communication with the eventual viewer. When the filmmaker begins editing, the editing deals with events in the past. But for the subjects of the documentary, those events are not yet

over. It is an important event to have a film made about your happenings or important concerns. So for the subjects, those events are not yet over until the documentary is finished and shown. There is no closure for the subjects of documentary film until this has happened. They will delay making narrative sense of the events and their filming until they have seen 'how it turns out'. And in this, the imagined audience is an important factor. The subject's personal reputation and sense of self-worth is tied up in the film differently from the professional reputation of the film-maker. The subjects of a film will probably be concerned with how they will look to people they know. The people being filmed almost inevitably have one set of concerns that the filmmakers do not share. They will be seen and judged by people both known and unknown. They will be subject to comments from reviewers, family members and work colleagues. Filmmakers will not have the same experience of being judged on their appearance or atypical actions that happened to be caught on camera. Filmmakers are judged by their professional peers, and by their viewers, for how they perform as professionals; documentary subjects are judged for who they are, or who they try to be.

The role of the editor

Recordings and photographs, left to themselves, have uncertain meanings. To sort through a jumble of old photographs at a flea market is to realise that the motives that once called these photos into existence no longer have relevance or meaning. To see old film footage out of its original context is to search the frame and listen attentively for any point of reference that can organise its potential meanings. Self-evident meanings quickly evaporate as photos, and recordings travel beyond the immediate moment that led to their creation. Someone looking at a file of photos that they took perhaps a few months before may well be puzzled by the very existence of one or two images: 'I don't remember taking that' or 'who on Earth is this?'. This is not because the photos lack meaning; they lack a frame of reference. Recordings and photographs, on their own, suffer from an excess of potential meaning. What they often lack is any direction for the attention of the viewer. If only we knew why the recording was created and when; who the people are within its frame and why they were of interest; what their gestures might reveal; what the actions are; whether the spaces have changed or no longer exist. Then we might get a purchase on the material. This does not mean the viewer must be told that the footage means this and only this; far from it. The viewer simply needs an orientation within all the bewildering possible meanings, or in the face of the implacable indecipherability of the material. The physical frame needs an intellectual frame. This is particularly true of any archival footage that is to be integrated into a documentary, but the provision of a frame of interpretation is one of the key functions of the editing process. Once set on the particular trail of attention, a viewer can follow the complex assemblage of sounds, words, pictures and movements, gaining more precise and developed meanings from them. Either this, or they will decide that the particular text has little or no interest for them at that particular time.

Editing assembles sounds and images, organising them into a text of some kind so that particular lines of meaning can be followed. Recordings, those unique moments of unrepeatable reality, inevitably become material for this process. They are cut about, thrown away, altered, remixed, combined with other material, written over and colour graded. They are used in making larger meanings, a process of joining one moment to another, of juxtaposing one voice against another to create a larger view of some kind. Recordings are used to show and to explain, but showing and explaining are combined with a further action, that of drawing out the potential meaning. Daniel Dayan has emphasised that: 'to show something is not just to point it out. It is to demonstrate compassion, to express joy, to deliver a denunciation. The act of showing is a professional practice. It is also to do something, in the sense that J.L. Austin meant in describing some acts of speech as "performative" in *How to Do Things with Words*' (Dayan 2007: 8).[3]

One major divergence between filmmakers and subjects lies in their relative speed of narrativising the events which were filmed. The filmmaker has to find a narrative structure in the editing. The editing process is one that seeks to distil this retrospectively constructed meaning from the material that was shot. In this, the role of the film editor is crucial, as the editor comes to the footage without any previous engagement with the documentary subjects. The editor is usually the first person to encounter the filmed subjects as representations on a screen rather than as concrete people. This is a crucial shift of perspective, yet one that has to be negotiated warily. It is quite possible to mistake the meaning of particular rushes if no context is provided for them. Such incidents are relatively rare in professional documentary filmmaking because production is usually organised to eliminate such possibilities. However, producer Colin Luke cut together contributions from many filmmakers in Russia to make the thirteen-part series *Russian Wonderland* for BBC2 in 1995. As no-one who had been present at the shoot was with him in the cutting room, he misunderstood a crucial conversation and so ended up misrepresenting one of the characters. New production processes often throw up new editorial problems. Significantly, Luke was pioneering a new kind of production process, prefiguring the collective filmmaking arrangements that have begun to develop in online productions. The problems of context are even more acute when archival footage is being used. This footage is often made available with little or no contextual information. The careful researcher will try to deduce the status of what is being shown from evidence within the footage itself. All too often there is inadequate evidence, so the images are used as general illustrations of 'what things were like then', stripped of their specificity.

The editing process is one of interpreting the footage of shot events as potential material for a structured film. This process is governed by considerations of accuracy and truthfulness, and the editor is crucial in mediating between the director, who was present at the events, and the footage, which has to portray those events to an eventual audience. The editor Dai Vaughan has outlined this difficult process in a key piece of writing about documentary, which deserves to be quoted at length:

> The event is an argument between two people in a small office. The argument lasts for an hour and a half, out of which the camera is running for

approximately fifty minutes, panning between the two people and occasionally shifting position to favour one or the other. The attitudes of the characters emerge only slowly, with much repetition of key points, though with a gradual overall rise in the emotional temperature. The relevance of this sequence to the theme of the film does not justify allowing it more than about twelve minutes of screen time: but this, irksome though it may be, does no more than stress the inherent selectivity of cutting. The problems confronted by the editor therefore present themselves in the form of such questions as: Does this sequence, whilst avoiding undue repetition, reproduce the spiral nature of the interaction? Does it do justice to both positions whilst also conveying the subtleties of the psychological tactics in use on both sides? Does it respect the integrity of each participant, in the sense of not allowing a change of emotional state to appear unmotivated (so that anger, for example, might come across as mere petulance), or of presenting someone's line of argument in a form less rational – or even more rational than that which it took in the actual debate? And beneath these, of course, lie more fundamental questions. Are we trying to be fair to the people as individuals or to their strategies, or to the institution of whose ethos they are the temporary embodiment? Are we seeking to demonstrate the arguments used or to clarify the actual intellectual positions which these partly express but partly mask? Is the tedium of the event's repetitiousness a quality it may possess only for the observer uncommitted to either viewpoint – something which should be retained or avoided?

(Vaughan 1999: 70–71)

The example is probably drawn from an observational documentary of the 1970s, as the idea of a twelve-minute sequence of such material would be hardly imaginable in television today. Having explored the many considerations in reducing such rushes to a documentary account that will be as honest as possible, Vaughan then summarises his position as editor:

Throughout the process, the editor is engaged in a curious mental exercise: to attempt, from the rushes and from the testimony of those present, to form an intuitive impression of the event as if it were firsthand experience (granted that all such experience is itself partial and selective); and then, in settling upon the presumptive happening 'behind' the material, to use that material to say it.

(Vaughan 1999: 71)

Commissioning editors

Vaughan describes a process in which an editor confronts material and makes narrative sense out of it, in collaboration with a director who was present when the events happened. This was typical of the editing process when film was the principal medium for the making of documentaries. The sudden adoption of digital video in post-production of documentaries is outlined in chapter 8. This has had one major

consequence for the editing process: it means that many more people can look at the rushes and make comments to influence the shape of the final cut. Gone are the days when broadcasting executives had to visit film cutting rooms to view their productions as they evolved. Digital footage can be widely circulated within production companies, and the files can be forwarded to commissioning editors or executive producers in broadcast organisations as well as to distributors who may be involved in the financing. All can view; all can make their comments. For the filmer, this can be a harsh experience. It can lead to many conflicting views about how the film should be. It can also lead to the imposition of a particular structure upon the material, especially if it is intended as part of a larger TV series for a particularly forceful commissioning editor or executive producer. But it can also help a filmer make the transition to seeing the events as footage; to see the events from the outside.

Editing has become a more open and collective process, more debated and disputed within the professional production context. Editing is not only the moment at which filmmakers can define their own messages across the shot material. Editing is equally the moment in which the communicative attempts of the commissioning broadcasting organisation intervene in the final form of the project. The broadcaster may have conceived of the film project in the first place, or will at least have chosen it from the many ideas submitted. The idea will have been discussed and developed before it went into production. Nevertheless, the editing phase is the moment in which the commissioning organisation will seek to incorporate its distinctive values. The filmmaker will be encouraged (or even required) to adopt a certain tone, for example to frame the events into a narrative of conflict, crisis and resolution, rather than of negotiation and consensus-forming. The broadcaster's representatives will have concerns about grabbing an audience, and worries about clarity of message and the degree to which the film is expected to shock or entertain. These will often be expressed in terms of the branding of the series in which the film will appear, and the wider brand of the channel as a whole (Johnson forthcoming). Such concerns have become greater as competition has increased in broadcasting. As a result, the editing process is often the site of conflicts between the filmmaker and their financiers over the balance of voices within the film. Both will seek to express their particular views or ideas across the particular organisation of the filmed material into a text. It is rare that the subjects of a documentary have any involvement with this process at all. Their communicative attempts are the material for this process and rest incomplete until they reach the eventual viewers through the structure of the film.

Documentary, creativity and ethics

The editing process is one of deriving a film from material, a story from events, a text from filmed interactions, a comprehensible communication from the competing attempts at communication. This is hardly easy. Yet it is regarded as somehow less difficult than the creation of fiction. Documentary filmmakers do not have a very good reputation. When compared with their colleagues in fiction, they are not well paid and are seldom well praised. Their work receives less attention in reviews, and

finds its way into cinemas less often. On the face of it, this may be because a documentary is easier to make: it generally involves fewer resources and, after all, a documentary 'takes people as they come' and does not involve the elaborate make-believe of actors playing roles, specially constructed sets and the rest of it. Certainly, documentary is easy to make badly or routinely – more so than fiction. There is not the equivalent exercise of the imagination, the collective imagination of a fictional world and its doings. Documentary takes what is there, it seems, so involves fewer costs and less imaginative effort. However, the cost lies elsewhere, in the effort involved in each time developing anew a framing for the filming exchange, which may involve a certain duplicity in all parties to that exchange. And the imaginative effort is considerable in anticipating the reactions of a modern audience, with ideas of their own. The costs and the effort, therefore, are not inconsiderable, but they are less glamorous than those expended in the creation of fiction, and they are morally more suspect. Fiction may involve the most outrageous cheating and pretence, but it does not matter: we all appreciate the framing that fiction involves.

Because of the subtle differences of interest and of framing involved, documentary remains morally suspect. The makers of fiction do not face the same ethical problems routinely faced by the makers of documentary. They use the clean processes of imagination. Imaginary worlds are inhabited by imaginary people, who, unlike the subjects of documentary, will do what you want as their creator. The position of the documentary filmmaker is similar to that of a garbage disposal employee. They deal in bits of reality, but are contaminated by the collection of that material; it is a necessary activity, increasingly so in a complex modern society; but it is not very well paid in relation to those who work in the clean industries. Documentary is a profession that many find hard to sustain in the long term because of the difficult moral decisions involved. Documentary involves ethics: difficult judgements about the issues involved in the personal interactions around filmmaking. How much should a filmmaker indulge the mistaken beliefs of a particular subject about how they will appear in the eventual film? How much attention should be given to the second thoughts of subjects about what has been filmed? How open should a filmmaker be about their true intentions, especially when they are making an investigative film? Alongside these come another set of ethics, which, as Dai Vaughan's account shows, are concerned with honesty and accuracy in the process of rendering raw material into finished film.

Rough Aunties (Kim Longinotto, 2008)

Longinotto's style seems observational, but her filmmaking involves generating a high degree of collaboration with her subjects. *Rough Aunties* follows a group of women in Durban, South Africa, who work together against child abuse in a group named Bobbi Bear. The group, Mildred, Studla, Thuli, Jackie and Eureka, work alongside a single hard-pressed police officer to ensure justice is done for the vulnerable victims of abuse. The film follows them on raids; it shows them helping children give accounts of what has happened to them; it shows them trying to protect them, and succeeding; it shows them

campaigning. It begins with a child giving an account of being raped, and 'There are moments of raw, almost unwatchably painful emotion and distress' (Bradshaw 2010).

Because the five women who are Bobbi Bear are campaigners, they have had close involvement with the film's career. They were present at both Sundance and Amsterdam for festival screenings, using the events to plead for much-needed funding. There is a high degree of coincidence between the aims of the group and those of Longinotto as filmmaker, derived from a common history of feminist campaigning. Longinotto's company of the 1980s was named Twentieth Century Vixen; Jackie, the founder of Bobbi Bear, is shown more than once delivering impassioned speeches to groups of women. This common history, albeit lived in very different circumstances, produces unforced passages of self-revelation. Longinotto claims that she does not set up interviews, but 'If the people I'm filming speak directly to me in the natural course of events, it may feel good to have this in the film. I suppose I want the audience to feel that they are here where I am, seeing things through my eyes' (Weitz 2008). So both Mildred and Thuli tell their stories to camera not as interviews, but as remarkable monologues, with Mildred breaking off in an account of her cheating husband.

There is a further reason why there was an exceptional bond and coincidence of aim around this film. The filming itself was overtaken by events. The film would have been extraordinary and moving enough if it had simply shown the activities of Bobbi Bear. However, two tragedies struck the women in one short week. First, a member of Eureka's family was shot during a robbery at his home. He died after being transferred from one hospital to another because he did not have the money for the necessary operation. Then Studla's only son was drowned trying to cross a river whose shallows had been illegally dredged for sand. As Eureka remarks 'there has been too much death this week', the only reference, in this film without commentary, to this concentration of tragedy. After the funeral of Studla's son, Studla tells Eureka that she intends to come back to work on Monday. Eureka looks over to Longinotto's camera and says 'she's back', a brief remark that conveys both her relief that Studla will survive her loss, and the degree of involvement that Longinotto has with the group she is filming. *Rough Aunties* is a film in which much happens, maybe too much for some viewers. It succeeds emotionally, yet leaves almost all its narratives unresolved. Mildred leaves her husband and sets up a new home, but apart from that, the stories of the rape and abuse victims are left open. Longinotto's approach combines observation and commitment in a way that allows an unusual coincidence of purpose between filmmaker and subjects, without producing a film that preaches.

Ethical questions were once debated by documentary filmmakers in their professional lives, but remained a somewhat arcane set of anxieties to the wider world. With the

digitally enhanced audience, however, has come a widespread concern about the issues of making films from reality. The reason lies not only in the clash of framings that can take place in any documentary filming event. It lies also in the deep anxieties stirred up in such exchanges, anxieties that relate to being photographed, filmed and recorded, and also to watching and hearing the results of those processes. We can be uncomfortable in our dealings with anything that claims to capture realities, whether they are our own or those of others. These questions are the subject of chapters 10 to 13. First, the development of new editing technologies is examined, as these not only have altered the post-production process itself, but also have changed the aesthetics of documentary, introducing faster rhythms of cutting, and a reaction – the development of an aesthetic of the Slow Film.

8

THE CHANGING TECHNOLOGIES OF DOCUMENTARY EDITING

When a documentary filmmaker begins to edit, they move from the role of participant to that of witness. No matter what their particular engagement might be with the events they have filmed, they now have to see the footage through the eyes of the eventual viewers. During editing, filmers have to transform themselves into audio-visual witnesses – to see, hear and feel what lies in the footage and so to forget (or to put aside) what happened during the shoot. The technologies of editing help in this process. Just as the flip-out camera screen allows more personal interaction during the shoot, the double or multiple screen displays of the digital edit emphasise the processes of viewing from multiple positions and of abbreviating or expanding events. To edit is to construct a text out of the realities of the shoot. Editing technologies help filmers to reframe themselves, to adapt their point of view so that they can successfully create a meaningful textual experience for their eventual viewers. At the same time, editing technologies also shape the possibilities for those texts, imposing textual styles through the possibilities that they open up and close off. During the period 1970–2010, editing technologies have changed substantially, with consequent effects on the styles of editing that predominate. As chapter 9 shows, the speed of cutting has accelerated, leading to a need to re-evaluate some of the radical potentials once attributed to montage. First, it is necessary to outline the ways in which editing has changed, for both film and video, during this period.

In 1970, video was not a viable tool for documentary filmers beyond those who were experimenting with the new Sony Portapak cameras (see chapter 4). Film was the principal means of filming, and its editing process involved a number of distinct steps. The negative film that had run through the camera was returned to a laboratory for development, and a positive print was produced for use in editing. The sound was transferred from tape to a 16mm magnetic film base with a brown magnetic coating. Both had edge numbers printed on them every 20 frames (a little less than every second) so that they could be easily matched with their source. These were

delivered to the cutting room, where an assistant editor would perform the basic task of matching sound and image: syncing up the rushes. So here are two basic differences from digital practice: rushes could never be viewed in instant replay, and editing always involved more than one person.[1]

This film and sound was then viewed, physically cut, and glued back together (spliced) to produce a cutting copy. It was a slow, cumulative and flexible process: shots could be inserted or taken out down to the level of a single frame. Sequences could be built up gradually. However, it was difficult to backtrack to remake a sequence in a different way; and impossible to create more than one version of any sequence. The assistant editor would need to run a makeshift filing system to keep track of the footage, particularly the pieces of shot that had been cut out, but everything was recognisable by holding the footage up to the light. It was a system that enabled easy separation of image and sound; and a skilled editor could 'improve' the sound of a non-sync voice by slicing out the few seconds of hesitations. However, there were few facilities for improving the picture in the same way: every dissolve, or wipe, or other visual effect (known as an 'optical') had to be planned in the imagination and then ordered from the laboratory. Once the structure had been settled, the editor would concentrate on the sound, laying extra tracks of effects and music. With the final picture and sound edit decided, the cutting copy was dispatched to the laboratory, where the actual negative would be cut and spliced to create a master negative. Colour would be graded to ensure an overall look. The sound would be mixed separately and the two would be combined to produce a 'first answer print', paradoxically the final point at which any revisions could be made.

The culture of the film documentary cutting room was craft-oriented and collaborative within a firm hierarchy. The assistant was learning the trade and would, one day, become an editor. The director could be involved to various degrees, from detailed discussions of each step to simply arriving from time to time to assess progress and discuss the next steps. Detailed judgements and execution were the work of the skilled editor. This interaction, in which the director was 'hands-off', helped to distance the filmmaker from the shooting process, especially as it emphasised discussion. The physical handling of the cutting process was in the hands of the editor and assistant; the filmmaker had to verbalise, illustrate or otherwise make explicit how they wished to structure the film, and through this process the editor would usually become an active collaborator (Vaughan 1983). Decisions could be taken relatively slowly and iteratively, always depending on whether the production budget and schedule would allow. A typical hour-long 16mm film documentary for television would take about eight weeks to edit during the 1980s.

This process remained relatively unchanged for a remarkable length of time. Already in place in the mid-1950s, it continued as more or less standard practice for television documentary production until the mid-1990s, an extraordinarily long period of stability. By the beginning of the 2000s, digital editing had largely taken over in documentary production, a brutal process of change that required editors and assistants to learn new techniques almost overnight. An indication of the speed of this change can be seen from the introduction to the third edition of a popular handbook:

The first edition of *The Filmmaker's Handbook* was about film only [1984]. The second edition added video [1999]. In this third edition [2002], digital technologies are discussed as much or more than film. However, as the power and reach of digital media grow and costs fall, more and more filmmakers will turn to digital first. Even those who shoot film will make extensive use of digital tools in the course of production, postproduction and distribution.

(Ascher and Pincus 2002)

The digital revolution began as more productions used film for shooting and video for editing, a process that began in the late 1980s. High-quality video editing had been developed primarily for use within large broadcast organisations, for use on studio-shot programming, sports and news. It was industrial in its form and analogue in nature. This reflected the large-format tapes being used, the high cost of computing and information storage, and the slow speeds of image processing. In the early 1980s 'it would take a weekend to render a 15 second graphic sequence' (Wood 2008: 27), something that is now a trivial task on a laptop for someone with basic skills. This demonstrates the level of digital capability within the system at that time. Small islands of digital image processing were developing for specific applications during the 1980s, but the basis of video editing remained resolutely analogue. To edit meant to copy a selected shot from one tape to another tape, from rushes to master. Every act of copying reduced the quality of the image: analogue copying reduces the signal-to-noise ratio. For the broadcast standard 1-inch tapes, three generations of copying were enough to produce perceptible reductions in the quality of the image (more were possible with sound). Editing was relatively cumbersome, and could not necessarily get the pinpoint accuracy to a single frame that was a defining characteristic of film editing. The proposition for filmmakers was simple. Analogue tape editing would reduce the quality of the eventual image, and film would not.

In addition, the high capital cost of broadcast-standard video-editing equipment meant that editing was forced to take hours rather than weeks. The high-pressure environment of a video-edit suite, with equipment costing anything up to a million pounds, was not a place for the choosing of shots and the consideration of approach. The equivalent of the work of the film cutting room took place in the offline editing suite, using the far inferior technologies of cheap video editing on VHS or U-Matic tape. Mass-produced VHS editing arrived in 1983, allowing videomakers for the first time to view and assemble their rushes into a rough cut. The timecodes of each shot (displayed in vision) were then noted down (using pen and paper) to produce an edit decision list (EDL) for the online edit. It was laborious and scarcely frame-accurate; it gave no flexibility for sound editing; but it was the beginning of the adaptation of film cutting room practices to the world of video.

Many developments in wider technology were required before analogue editing could give way to digital editing. Indeed, those filmers who enthusiastically adopted the DVCam format for shooting did so with no clear route for its subsequent editing. It was, in 1995, a matter for improvisation with the various options then available. In the space of just five years, the options had been transformed by a convergence of

different developments, many in general computing capabilities. In the mid–1990s, tape was still the only affordable format for storage of programme masters, although formats were reducing in size from 1-inch and proliferating, especially after the introduction of the half-inch Digi-Beta tape in 1993. Microprocessors were beginning to make possible the digital storage and retrieval of moving images, but digital editing required what then seemed prodigious amounts of memory: 10GB for an hour-long programme. Offline editing could be done with considerable compression, however, so rushes could be digitised at a lower rate and stored in an offline edit. So in 1989, a number of companies showcased digital offline editing systems: Lightworks and Avid among them. These had considerable advantages over the existing analogue systems based on VHS tapes. They were frame-accurate and allowed sophisticated sound editing and some image effects. By 1995 or 1996, the resulting edit information could be imported to an online digital editing suite for an 'auto-conform' edit, a seemingly miraculous process which usually ended up with a number of flash frames to be corrected on the master tape.

A digitally based documentary production route was possible by the late 1990s, but there was one considerable barrier: the design of the user interface. The practices of editing developed in film cutting rooms and adapted for analogue offline editing needed to be rethought for the digital era. But there were no established protocols for how to imagine the digital editing process, or how to operate it. This was a period when the combination of a PC with a mouse was still unfamiliar to many. Internet access was hampered by slow download speeds so web pages were strictly text-based. The fundamentals of graphic design for computer users were just beginning to emerge: the Apple Mac had introduced the mouse and a graphic user interface in 1984; Windows 3 was released in 1990, making extensive use of icons for the first time. In effect, there were no obvious models for designing something that would enable editors to work by selecting from organised rushes to create a linear moving image and sound text. Fundamental design issues had to be resolved, such as how to maintain sound synchronisation whilst allowing the possibility of separating sound and image when required.

Lightworks offered an interesting solution: to confront the editor with an environment that was as familiar as possible. The company developed a version of the mouse which resembled the 'rock and roll' controller of the familiar Steenbeck editing table, and a software that reproduced the terminology of the film edit suite. This was done at some cost to the potential of digital: it reproduced the practice of cutting into film to produce a finished film, rather than the practice of loss-less copying of a segment of rushes into a draft version or versions. Competing software, such as Avid, developed a different approach, using the terminology of 'files' and orienting the interface around a timeline of the eventual film which could be expanded or contracted depending on the kind of display required. But the icons for the different functions; the way the interface was operated; even the kinds of processes envisaged: all these varied from software provider to software provider, all limited by the then potentials of the platform they were using (Apple or Microsoft). It was a highly confusing time for experienced film editors, especially in the area of documentary. Where camera

and sound operators had lived through an evolution of technology, editors were faced with a revolution. Working mainly as freelancers, they saw their traditional film-based ways of working being overturned by not one new way of working, but a whole series of less-than-adequate new methods, all requiring knowledge of their particular frames of reference. It was not until the mid-2000s that the general conventions of editing interface design were finally settled. By that time, many of the early pioneer equipment companies had been absorbed or had gone out of business. The first version of Apple's Final Cut (now a standard package) emerged only in 1999: a telling illustration of how protracted this standardisation process was.

Digital editing enabled new work practices. It simplified the editing process, allowing the editing of ordinary factual programmes and documentaries to become more complex. The simplicity of the physical process (once it had been learned) meant that traditional skills could be employed more fully: a sequence could have more cuts; sound could be deployed in a more adventurous way; image could be piled onto image, in series or even within one frame. Cutting speeds became faster (see chapter 9). Allied to the increased flexibility of lightweight cameras, with their ability to penetrate the real, digital editing provided a new flexibility in editing. It allowed for experiment. The incremental editing process of both film and analogue video required some time and patience to 'go back and do it differently'. Instead of having to commit to one possible cut of a sequence, digital editing allowed directors to say 'do it both ways and we'll see what it looks like'. Indeed, it increasingly allowed directors themselves to try things out. In the first years of the new millennium, it became commonplace for a filmer on location to look at their rushes on a laptop as soon as they had been shot, and to use Final Cut or a similar package to assemble rough sequences. For some, this was a liberation, allowing them to judge much more finely what footage they already had and what they still needed to shoot. For others, it was simply increased workload on already crowded shooting schedules.

Much of the creative potential of digital editing was swallowed by the shrinking working time allocated by producers. The increased speed of the digital process meant that overall budgets declined, and with them the length of time allocated to editing. Much of the creative dialogue of the old film cutting room disappeared as a director in the field prepared a first rough assembly and an editor working without an assistant quickly finessed this into a fine cut. 'Digital work flows', as they became known, had to be designed to rein in creativity and experiment in television, as well as to eliminate the disastrous mistakes that could occur when rushes circulated too widely within production companies and broadcasting organisations. The dangers are vividly demonstrated by the 'Queengate' scandal of 2007. In August 2007, the controller of BBC One, Peter Fincham, showed a clip from a forthcoming documentary series about the Queen to a press conference to launch the autumn schedule. The clip showed the Queen 'storming out' of a photo shoot with Annie Liebovitz, complaining about having to wear ceremonial robes. Unfortunately, the production company, RDF, had edited the footage for the press launch in the wrong order: the Queen had in fact been hurrying to the photo shoot and was complaining, quite reasonably given her haste, about the weight of the robes. Timelines had been

jumbled or misunderstood when someone (not the offline editor) had grabbed footage at short notice for the launch. As a result of this mistake, Peter Fincham resigned, the footage was taken away from RDF and recut, and RDF was blacklisted as a supplying company by the BBC (BBC 2007).

Digital, and then tapeless, production processes meant that the practice of editing became more integrated with the practice of shooting. The relationship between rushes and editing had evolved. The concern of many early adopters of digital video shooting was the amount that could be shot. Many producers were worried that filmmakers would come with hour upon hour of footage that then needed to be sorted out. It would need digitising and logging, only to be rejected wholesale for the minute or two of footage that would be used even in a rough assembly. The time involved seemed potentially infinite. This was indeed the case, until recently, when the ability to take a laptop on a shoot allowed directors or assistants to select from footage almost instantly. Delays between filming and seeing rushes were typical until the beginning of the millennium, and imposed on filmmakers a serial process of creation: first shoot, then edit. Digital processes erode that seriality, enabling shooting and editing to proceed in parallel. However, this does not reduce the need for a shift in framing on the part of the director, from involvement with the filmed subjects to the point of view of the audiovisual witness. Rather, it intensifies the stresses involved in doing so, since the viewing of rushes on the evening of the shoot requires a rapid shift of focus. This can be a strain, especially as digital filming often enables a more intimate interaction with documentary subjects.

The development of video editing since the 1980s has profoundly changed the possibilities for moving image and sound. Editing has become an easier process in several ways. It has become easier for more members of a production team to dabble in and to concern themselves with. Producers as well as directors can and do assemble rough cuts. Digital editing has enabled more collective working styles, even as it has eroded the small collaborative group of the traditional film cutting room. Editing has become easier in the sense that material can be seen, assessed and sorted very close in time and space to the moment in which it was shot. Editing has become easier in the sense that it is easier to perform any number of cuts to produce a film. This is different from the skill of assembling a rhythm and structure to a film, however. But the ease of digital editing has had one overall effect since the 1980s: cutting styles have become more rapid. Once a still image could be held on screen for up to five seconds before it seemed tedious; now the current limit is more like two seconds. It is tempting to see this acceleration as a passing fashion, a little like the fashionable page-turn or shatter effects that could be produced using the early digital TV effects boxes. These were ubiquitous in programmes and commercials alike for a year to two, and then became clichés. It is possible that the rapid cutting rhythms of contemporary factual television and many documentaries are the result of the same phenomenon: the overuse of a new technological potential. Certainly, as chapter 9 discusses, they force us to re-examine a long-held belief about filmic construction: that montage is in itself a radical gesture.

9

SLOW FILM

Both shooting (image acquisition) and editing (post-production) have undergone radical changes since the 1980s under the impact of successive forms of digital technology. These have changed professional working practices. They have made filmmaking more accessible beyond the confines of the broadcast and cinema industries, creating the new role of the filmer. They have profoundly changed the attitudes of citizens to the activities of filming and being filmed. They have provided new potentials to those who fund and make documentary and factual material for TV, cinema and other means of distribution. So it is logical that these changes will also have affected the regime of moving images and sounds itself. Chapter 4 shows how the relations between filmer and filmed have altered, reducing the elements of professional distancing and introducing a greater degree of personal interaction. This sometimes raises acute ethical issues, of which contemporary audiences are well aware, as chapter 13 shows.

The changes in post-production have also altered the potentialities of filmmakers. It has become easier to edit, and easier to construct complex combinations of sounds and images. The result seems to have been a general increase in the tempo of cutting, and a greater rapidity of montage. This is evident right across the audiovisual media, from entertainment films to news bulletins. The increased speed of cutting is not simply an increase in the rate at which one image succeeds another in a film. It has consequences: it intensifies the mobility of gaze which is provided for the viewer. It also raises questions about the historical assumption in film aesthetics that montage is associated with a radical way of seeing. When montage techniques have become standard, how is it possible to provide viewers with fresh ways of seeing?

Writers on fiction film in particular have identified a general speeding up of Hollywood entertainment films. Geoffrey King's *New Hollywood Cinema* compares the average shot length of spectacular films: *Spartacus* (1960) has an average length of 7.85 seconds; *Gladiator* (2000) 3.36 seconds; *The Fall of the Roman Empire* (1964) 8.72 seconds;

Armageddon (1998) 2.07 seconds (King 2002: 245–46). More generally, David Bordwell notes a general increase in the cutting rate since the 1960s:

> From the coming of sound up to about 1960, most Hollywood feature films contained between three hundred and seven hundred shots, yielding a range of average shot lengths (hereafter ASLs) falling between eight and eleven seconds. Since the 1960s, cutting rates have steadily accelerated, with typical 1970s ASLs running five to nine seconds and 1980s ASLs running three to eight seconds. The 1990s set a still faster pace, with several films containing more than two thousand shots and ASLs running from two to eight seconds.
>
> *(Bordwell 2005: 26)*

The increase in the rapidity of cutting is the most obvious and quantifiable aspect of an emerging new style in feature films. King's analysis extends to a change in the nature of the camerawork as well:

> *Spartacus* depends on scale for much of its spectacular impact. Sheer massed numbers are mobilized and choreographed to achieve this effect. Many of the 'big' spectacular shots are held for relatively long periods, inviting the viewer to examine at leisure the detail within the frame, a typical characteristic of 1950s and 1960s widescreen cinema. *Gladiator* depends to a far larger extent on the effects of montage-editing and rapid and unstable camera movement: effects that translate more effectively to the small screen.
>
> *(King 2002: 243)*

King points to the increasing importance of small screens (TVs, laptops, mobile devices) as a way of seeing feature films as a reason for this change. Bordwell extends his argument to discuss the existence of an 'intensified continuity' in contemporary Hollywood:

> an amplification and exaggeration of traditional methods of staging, shooting, and cutting [that has] changed our experience of following the story. Most obviously, the style aims to generate a keen moment-by-moment anticipation. Techniques that 1940s directors reserved for moments of shock and suspense are the stuff of normal scenes today. Close-ups and singles make the shots very legible. Rapid editing obliges the viewer to assemble many discrete pieces of information, and it sets a commanding pace: look away, and you might miss a key point. In the alternating close views, the racking focus, and the edgily drifting camera, the viewer is promised something significant, or at least new, at each instant. Television-friendly, the style tries to rivet the viewer to the screen. Here is another reason to call it intensified continuity: even ordinary scenes are heightened to compel attention and to sharpen emotional resonance.
>
> *(Bordwell 2006: 180)*

In an influential blog on Paul Greengrass's *The Bourne Ultimatum*, he claims:

> What Greengrass has done is to roughen up intensified continuity, making its conventions a little less easy to take in. Normally, for instance, rack-focus smoothly guides our attention from one plane to another. But in *The Bourne Ultimatum*, when Jason bursts into a corridor close to the camera, the camera tries but fails to rack focus on his pursuer darting off in the distance. The man never comes into sharp focus. Likewise, most directors fill their scenes with close-ups, and so does Greengrass, but he lets the main figure bounce around the frame or go blurry or slip briefly out of view. Essentially, intensified continuity is about using brief shots to maintain the audience's interest but also making each shot yield a single point, a bit of information. Got it? On to the next shot. Greengrass's camera technique makes the shot's point a little harder to get at first sight. Instead of a glance, he gives us a glimpse.
>
> *(David Bordwell's website on cinema.*
> *www.davidbordwell.net/blog/?p=1175)*

Greengrass is a director with a background in British TV current affairs documentary and factual reconstructions,[1] whose style is often labelled as 'documentary-like', an approach that Bordwell and others labelled 'upsetting [...] this summer's wildest excursion into Unsteadicam'.[2] Greengrass has introduced a style in which the camera is perpetually chasing after the action, giving the illusion of desperately trying to catch up, despite all the sophisticated techniques at its disposal. This approach became familiar in TV with the ground-breaking series *NYPD Blue* in the early 1980s (Ellis 2007: 99–106), one of an arsenal of distinctive visual styles employed by high-end TV entertainment at the time (Caldwell 1995). The so-called 'documentary style' of a director like Greengrass lies in frustrating one of the hallmarks of the intensified continuity style: the short shot whose information value is quickly extracted.

But Greengrass's style does not disrupt another key aspect of the intensified continuity style; if anything, it trades more intensively upon it. *The Bourne Ultimatum* maintains its suspense by producing the impression that events are moving so fast that even this new style of cinema can barely keep up. The intensified continuity style is possible only because cameras have gained an ability to move around within the scenes of fiction films. All kinds of expensive devices allow cameras to move: the Steadicam, which eliminates much of the random movement of a handheld camera; the remote-controlled boom, which allows cameras to swoop around within and above a scene; airborne cameras; miniature cameras that can be mounted inside objects; the cheap and therefore expendable cameras referred to in chapter 4. As Bordwell points out, the camera is constantly on the move in contemporary feature films, moving around within the action. The result is a ubiquity of the gaze, an intensification of audiovisual witness. Compared with the films of the 1940s, shot in their exquisitely classical style, we now have a cinema in which the camera can be everywhere all at once, and a cutting style that is able to switch view every couple of seconds. Any shot of a longer duration is likely to include a substantial amount of

camera movement. New Hollywood's fictions promote a sense of the ubiquity of the gaze which fits very well with our modern suspicion that 'cameras are everywhere'.

This ubiquity of the camera's gaze can also be found in news (see box). The editing of news programmes is sedate compared with that of a movie like *The Bourne Ultimatum*, but it has become regularised, with a more ruthless attitude to the reduction of interviews to a few key phrases. The comparison of news bulletins on the same UK channel from 1965 and 2001 shows that TV news has moved its perspective from an agency that 'receives reports' to one whose gaze can actively cover the world, being there as events unfold. The sense of ubiquity is supplied by the potential reach of the news organisation, able to bring in live footage from around the world, to construct a totalising global viewpoint on the important current stories. This is where the sharpest contrast lies with news from an earlier phase of television's history. Fast cutting and a sense of the ubiquitous reach of the camera are features of both contemporary news and new Hollywood entertainment cinema.

The news from 1964 and 2001: from local view to global overview

Britain's commercial news provider, ITN, has preserved a whole bulletin from 3 August 1965, enabling a detailed comparison with another bulletin of the same channel, ITV, from 3 March 2001.[3] The bulletins are similar in overall length and both lead with a breaking news story from the Far East. They differ in their time slots: the 1965 news was the main evening bulletin at 20:55; the 2001 example is the 18:30 early evening bulletin.

The 1965 *ITV News* bulletin contains more items (seventeen in all), all introduced by the single, closely framed newsreader, Peter Snow, who speaks a short headline to camera ('The campaign to shake up Britain's docks got off to a flying start today'; 'A murder hunt in Yorkshire', etc.). Many of the items are illustrated with short film sequences of about thirty seconds each. At an average shot length of about four seconds, these items have a faster cutting rhythm than the rest of the programme. Some items seem to have been included simply because pictures were available ('The leader of the opposition, Mr Heath, flew out of Lydd Airport in Kent today for a holiday in Europe'). The seventeen items simply follow one another: no list of programme contents is provided. The 2001 bulletin has twelve items and two newsreaders in a large studio space, delivering alternating sections of the main stories. In contrast to 1965, this bulletin begins and ends with a statement of the headlines, and returns after a commercial break with another set of headlines. Even the minor stories tend to assemble footage from a variety of sources. In 1964, all the stories after the lead drew their footage from single sources.

In 1965, the editors cutting the news footage for voicing-over tend to hold a shot with no camera movement for four seconds, and so do their counterparts in 2001. However, the 2001 bulletin gives an impression of a faster montage, for two reasons. First, it uses no long takes whatsoever. In 1964, a

single answer in an interview with government minister Ray Gunther runs for thirty-three seconds in fixed close-up. Nothing like this appears in 2001. The speech of politicians is either cut short, or punctuated by cutaways to other material. Second, the 2001 bulletin introduced material from a wider range of sources across the world. The contrast is clear in the respective lead stories.

In 1965, the headline report lasted for four minutes thirty-five seconds, covering the breakaway of Singapore from the federation of Malaysia. Peter Snow reads the story over stills for fifty-eight seconds, leading into a concise explanatory background item of filmed general views with a reporter's voice-over, which runs for just over a minute. This leads to a clip from a frank interview with Singapore's leader, Lee Kuan Yew, from a full eleven months before. This lasts forty-four seconds. After a brief roundup of reactions from countries in the region, read by Snow, the item concludes with an assessment of the likely consequences. This is provided not by an ITN correspondent, as would be the case now, but by a *Sunday Times* journalist, Anthony Holden, interviewed in the studio by ITN journalist Michael Nicholson for seventy seconds. The explanations stress British interests, particularly the importance of Singapore as a British military base, but in the context of a fight against communism in the region. It leads into a short film report from Vietnam to reinforce this editorial assumption. The overall viewpoint is clearly local: it is London's imperfect view of the world.

In 2001, the lead story is almost the same length (four minutes forty-two seconds) and again a dramatic political event in the Far East, but the story is constructed by cutting between correspondents in different regions. This provides the impression of an authoritative global overview. At the start of the George Bush Jnr presidency, a US spy plane has made a forced landing in China. A thirty-five-second introduction is read by both newsreaders taking turns, beginning 'in the past hour … '. The story is then told by the ITN correspondent in Beijing, Tom Bradby. His two-and-a-half minute report assembles snatched images of the plane itself, footage of a news conference given by the Chinese president, an interview with the US Ambassador in China, and footage from the USA of relatives of the pilots pinning yellow ribbons to a tree. From Beijing, Bradby continues with an assessment of the coverage by the Chinese media, including two vox pop interviews with well informed Chinese men, and ends with a piece to camera in Tiananmen Square. The lead newsreader, Dermot Murnaghan, says 'That's the view from China, now we can go live to our correspondent James Mates in Washington'. Mates engages in a live two-way dialogue with Murnaghan, which lasts for one-and-a-half minutes and includes footage of a press conference 'an hour ago' given by US Secretary of State Colin Powell. The overall impression is of a global crisis in which Britain is a bystander, delivered from a perspective that can collect together views at will across the globe.

Similar kinds of material are included in each of the lead items: a report of the current story in South East Asia, its background and its likely future

development and impact. The rate of cutting between shots has not changed appreciably but, significantly, by 2001 there is no tolerance for shots held for more than ten seconds. The 2001 montage is more ambitious and expects more discrimination from its viewers. The correspondents themselves provide opinions and speculations about the future. The impression of speed and range of material is greater because the material is globally sourced and, in part, live or from that day. It includes a far greater number and range of voices, interviews with ordinary people in China and USA, as well as officials. The view is a global one, organising a complex montage of material from many sources. No doubt the editors of the 1964 bulletin would have deemed it 'confusing' for the Beijing correspondent to introduce footage from the USA when the US correspondent was to appear in the same item. In 2001, when news footage is a global commodity, traded instantaneously, this is no longer a consideration. By 2001, news has become a montage of material, shifting rapidly from one view to another, one place to another, one kind of material to another. The modern news montage aims at a complete and kaleidoscopic view of the world.

Documentaries lie somewhere between news and fiction, and so participate in the general tendencies towards ubiquity of vision and fast cutting that characterise the regime of intensified continuity. Particularly since the arrival of inexpensive digital video editing at the beginning of the millennium, the general tendency in television documentaries has been to increase the cutting rate within scenes. Ubiquity of vision has been enabled by the availability of cheap, lightweight cameras requiring only one operator. In documentary, these have enabled filmers to move around within scenes, and for directors to employ more than one camera for greater coverage of events, to use remote controlled cameras, to shoot for more days, and to shoot more on each day than was ever affordable when shooting on film. The result, inevitably, is more footage, putting pressure on editors to concentrate material, abbreviating the action to eliminate the less significant moments. In documentary, too, the increased potential of cameras combines with the ease of editing to create a new style. Television documentaries no longer invite us to watch the gradual unrolling of a conversation, as Roger Graef did with such devastating results in *Police*, his 1982 series about the Thames Valley constabulary (Russell 2007: 146). Instead, television documentaries tend to present thin slivers of action, exemplified above all by the fast cutting rate of many 'reality' series, in which key scenes are reduced to a few lines of dialogue and selected shots to demonstrate the 'body language'. The everyday documentaries of contemporary television now offer a reality of fragments that are offered to the viewer to be added up to a whole.

Montage: a radical notion … in 1920

The speed and ambition of contemporary cutting is such that it is remarkable now to look back to a period when montage was hailed as an *avant garde* technique. Brecht's

radical aesthetic theories were based on a principle of montage, the idea of juxta-posing disparate viewpoints on a social process so as to make it strange. Crucial to Brecht's technique was surprise and discontinuity. He saw montage as providing the ability to move instantly from the general to the particular, from one scene to another, without necessarily demonstrating any connection. Montage therefore could provide a productive discontinuity, provoking the viewer to deduce the possible connections. Over the whole text of a play, such a series of jumps within and between scenes would, he theorised, develop a critical attitude towards the events and people portrayed. Montage techniques were widely used, for example in the political photomontages of John Heartfield. One of the originators of the method, Raoul Hausmann, wrote in 1931:

> The first form of photomontage was the shattering the surface by the multi-plication of points of view and a whirling interpenetration of many surfaces of imagery whose complexity goes far beyond that of futurist painting. In the meantime photomontage has passed through a certain evolution that one may call constructive. Everywhere the conception holds that the optical element is extremely varied and variable, given the nature of its structural and spatial oppositions. By its oppositions between rough and smooth, between the aerial view and the cinematic close-up, between perspective and the flat surface, photomontage offers the greatest technical variety – that is the most compelling elaboration of the dialectic of forms.
>
> *(Cullars 1998: 68)*

This gives a clear idea of the revolutionary nature of the possibilities of photo-montage. It gives a primary importance to the ability of the recording apparatus to enter into the materiality of life as well as to observe it from outside. Montage enables a creative juxtaposition between these disparate views, all of which are valid in themselves. It gives the viewer a mobility of gaze that allows connections to be made between different materials. In effect, montage intensifies the paradox that photos are both 'reality' and text by bringing forward the textual aspect in a specta-cular way. Montage prevents the potentially disruptive details of a particular shot from asserting themselves too much. Instead, the textual conjunction of different mate-rials insists on connections, contrast, parallels and divergences. Montage is therefore a highly productive way of using audiovisual material. As a revolutionary approach to the visual, it gave birth to a wider intellectual current in the turbulent early years of the twentieth century:

> In Europe it is as if the trenches of the Great War had brought about the decision to 'show by montage' (*montrer par montages*), that is by the dislocation and reconstitution of everything, right across aesthetics and the human sciences from the work of Georg Simmel and Sigmund Freud to Aby Warburg and Marc Bloch. Montage was both a method of understanding and a formal pro-cedure born out of the War, from the 'disorder of the world'. It defines our

perception of time after the first conflict off the 20th century: it became the modern method par excellence.

<div style="text-align: right">(Didi-Huberman 2009: 86)</div>

Film history is dominated by the contrast between two montage forms: the Hollywood and Soviet 'schools'. The classical style of Hollywood (which has evolved into intensified continuity identified by Bordwell) maintained spatial continuity so that the viewer knew more or less where their viewpoint was in every shot. This contrasted with the style developed by the more radical of directors working in the Soviet Union: Eisenstein, Vertov, Kuleshov. The Soviet school emphasised the conceptual and emotional connections possible between shots, rather than the need to orient the viewer in relation to the space of the action. Their discontinuities and juxtapositions were often more marked, and their pace of cutting could be frenetic by the standards of the time. They regarded montage as a radical gesture. Bordwell remarks on the continuing contrast between a montage style of spatial orientation and the more radical revelation of discontinuities:

> Faster cutting, however, did not lead Hollywood films towards the discontinuities of Soviet silent montage. […] The premises of spatial continuity still govern the way the scene is staged, shot and edited. Indeed the greater number of shots strengthens the reliance on classical continuity principles; because each shot is so brief, it needs to be more redundant in indicating who is where, who is speaking to whom, who has changed position, and so on.
>
> <div style="text-align: right">(Bordwell 2005: 36)</div>

This may be true of feature films, but elsewhere random juxtapositions and critical discontinuities are a standard feature of modern electronic and even print media. The maintenance of spatial continuity is less possible outside the controlled environments of the feature film set and TV studio, and without the production budgets that they command. Spatial discontinuity and random juxtapositions are features of many moving image forms, from music videos to promotional trails and even documentaries. Reality TV programmes often involve forms of montage that involve casual spatial discontinuities. There is nothing radical in such 'violations' of established editing conventions. The programmes rely instead on the fact that the overall spaces are familiar: domestic rooms or the familiar spaces of the constructed event environments. Even so, it is unlikely that a theory of the radical potential of montage would be developed in today's audiovisual environment.

The belief in the radically revelatory powers of montage belongs to a period when moving image and sound recording were still novel, and montage techniques still presented substantial technical difficulties. At the beginning of the following century, these technical difficulties have been reduced; the technologies of creation are becoming more commonplace; montages of still and moving images and sounds are the characteristic mode of presentation of such material. And, increasingly, our everyday encounters with these images intensify the montaging effect: we change channels;

we glance from one thing to another; we edit our own material; we revel in the chance juxtapositions of the internet. Montage has become routinised, as a key part of the understandings that allow modern citizens to orient themselves in the world.

Sontag noted the phenomenon of 'image-glut [which] keeps attention light, mobile, relatively indifferent to content. Image-flow precludes a privileged image. The whole point of television is that one can switch channels, that it is normal to switch channels: to become restless, bored. Consumers droop. They need to be restimulated, jump-started, again and again. Content is no more than one of these stimulants. A more reflective engagement with content would require a certain intensity of awareness – just what is weakened by the expectations brought to images disseminated by the media ... ' (Sontag 2010: 131).

The boredom that Sontag asserts is the result of a lack of overarching patterns of meaning. Significantly, she identifies television and the feeling that 'there must be something on another channel' as lying behind this. There is an expectation of meaning, but fragments that are encountered do not add up to anything. The citizen of the modern world is surrounded by more or less factual material, organised into montages. Much of this material is inescapable and encountered casually: in public advertising displays, screens at the workplace, TV in the background, internet advertising, flipping through magazines, recorded sounds spreading out into public spaces. They provide a continuing sense of a world in which we all exist, a multitude of parallel moments that are actualised in our own. This was the initial shock provided by montaged moving images; the only difference is that we have become thoroughly used to it. The montaged material that we encounter everywhere is no longer shocking. It has become routinised, necessarily so in order that we can make best use of it.

The texts in everyday use belong to larger routines of meaning. News is one example: it ties together disparate fragments of new or ongoing stories into an overall text that declares 'This has just happened'. The scenes of a soap opera follow each other in a similar way, yet it is clear that they are fictional. The genres of news and soap opera provide a routine that orients the viewer's attentions and expectations to particular ways of understanding the material offered. These factual genres are routinised textual structures, able to produce instantly recognisable and broadly similar programmes in large numbers. These predictable forms are highly necessary in a culture that is awash with audiovisual information of all kinds. It allows a daily or weekly orientation, enough reality, but not too much, perhaps, to enable everyday functioning. They provide a way of dealing with things, of knowing something about them but not being unduly disturbed by them. These habitual forms are one part of a larger process, which I have called elsewhere 'working through': a longer process of repeated encounters with material drawn from reality into differing kinds of textual systems (Ellis 2000a). The ubiquity of audiovisual material in our daily lives is the basis of this process. It introduces a random element into any citizen's encounter with sound and image alongside the more structured encounters that result from being attracted to longer, more documentary-based forms.

Slow Film: the modern radical gesture

Montage was a radical gesture because it introduced a new way of seeing, freed from the constraints of physical space. Like any radical gesture, it belonged to a moment in time: when it comes to enabling different forms of seeing, there are no timeless principles. Today's radical gesture would be a calculated refusal of montage. As Bordwell says: 'What has gone almost completely unexplored [in contemporary Hollywood] is the unbudging long take. [...] Today perhaps the most radical thing you can do in Hollywood is put your camera on a tripod, set it at a fair distance from the action, and let the whole scene play out' (Bordwell 2005: 29). In a feature film, this would prevent the camera from entering the action, and would prevent the editing from analysing and retotalising it. The viewer would, in effect, be invited to inspect the spectacle and to find their way within it, with their attention attracted by sound, colour and movement cues from within the action. The ubiquity of the camera would be replaced by the scanning eye of the viewer. As Geoffrey King hinted, this is an approach that would work best with the monumental images of widescreen cinema rather than the smaller screens on which moving images are increasingly viewed.

In a documentary, such a strategy would have rather different effects. The ubiquitous camera of the feature film is always there for the right detail (even if barely, as in Greengrass's *The Bourne Ultimatum*). Feature film directors know what is about to happen in their productions, so their cameras can anticipate the action. If they miss it, or it is not good enough, then a retake is routine. Documentary filmers have no such certainty. Their cameras are always just keeping up with unpredictable events. Reality TV is, in effect, a means of organising events to avoid a large amount of this unpredictability. But for documentary, the ubiquitous camera of the feature film is an impossibility. All that a documentary filmer can hope for is an adequate coverage of events, with the occasional moment of 'magic'. This occurs when the camera is indeed capturing just the right shot of an action that is perfectly sincere and at the same time perfectly decipherable by the eventual viewer. For most directors, these are rare moments. So a documentary cannot rely on the same strategies as the feature film.

A documentary shooting strategy cannot be securely based on the assumption that the eventual film will consist of a fast montage of short shots whose informational value is clear. Those reality TV shows that try to approximate to the fast editing of the feature film do so by using ruthlessly directive commentaries. The voice-over will set up the meaning of the next sequence in advance; it will intervene with direct editorial comments on what a participant has said; and tell the viewer what to look at and what conclusions to draw from it. Unlike the feature film camera, the documentary camera is tied to a place or a person; it is not ubiquitous. Its place is a human one rather than omniscient. In the modern documentary, the camera is closely identified with the filmer and so with the filmer's interaction with their subjects. The documentary camera cannot gain the same ubiquity as that enjoyed by the feature film camera. Documentaries also are not able to make their footage perfectly explicit in the way that a well designed feature film can.

Yet documentaries are always specific: they are about these people, this place, this moment, this issue. Documentaries depend on particularity, on getting to know people, places, situations and dilemmas. They will present viewers with actions that seem unfathomable, and words whose status is uncertain. Documentary exploits the implications of gesture and speech, the unsaid rather than the said. These will gain their significance only in retrospect, when events have taken their course, and the filmer is watching in post-production. The aesthetic of reality TV solves this problem by putting great weight on the ability of the montage to direct the attention and ideas of the eventual viewer. Documentary can easily do the same. But a radical approach seems to be emerging, which throws the viewer's attention back onto the events that took place, rather than the filmmaker's subsequent construction of meaning from them. This approach relies on adjusting the eventual viewer's attitude to the images and sound. It relies on a calculated refusal of the ubiquity of vision provided by mobile cameras and fast montage. I propose to call it Slow Film, to ally it with other 'slow' movements, principally the Slow Food movement developed from the initial work of Carlo Petrini in Italy in 1986.

Slow Film

The idealistic 'Slow Food Manifesto', written by Folco Portinari in 1989, argues against the perceived ubiquity of fast food.

> Our century, which began and has developed under the insignia of industrial civilization, first invented the machine and then took it as its life model. We are enslaved by speed and have all succumbed to the same insidious virus: *Fast Life*, which disrupts our habits, pervades the privacy of our homes and forces us to eat Fast Foods. To be worthy of the name, *Homo Sapiens* should rid himself of speed before it reduces him to a species in danger of extinction. A firm defence of quiet material pleasure is the only way to oppose the universal folly of *Fast Life*. May suitable doses of guaranteed sensual pleasure and slow, long-lasting enjoyment preserve us from the contagion of the multitude who mistake frenzy for efficiency. Our defence should begin at the table with *Slow Food*. Let us rediscover the flavours and savours of regional cooking and banish the degrading effects of *Fast Food*.
>
> *(Portinari n.d.)*[4]

Developing from this initial polemic, the movement now has two emphases. First, it insists that the enjoyment of food lies in taking time to consume it, in savouring its flavours rather than using it simply as fuel. Second, it insists on the particularity of the food to be enjoyed. It emphasises the local and specific against standardisation. It is on the side of small producers and local differences. Slow Film has the same characteristics. It insists that time should be taken, that the evidence should be weighed up by the viewer, and that instant reactions are to be distrusted. Slow Film also insists on the individuality of its subjects and their situations. It does not seek to reduce them to

types or to generalise from their plight. But a viewer might well draw such conclusions once they have been through the process of encounter that the Slow Film will yield to them.

One example of such a process can be found in *L'Approche*, Raymond Depardon's first film in his trilogy *Profils paysans*. It includes a remarkable sequence which is prefaced by a short factual commentary by the director:

> We are in Haut-Loire. It is 8am. We are with Paul Argaud, 55 [...]. I have known Paul Argaud for more than ten years, but this is the first time he has invited me into his kitchen. Until now, I have stayed outside when I have talked with him.

This might lead a viewer to expect a revelation of some kind. However, what takes place in the next sequence scarcely lives up to this expectation. Argaud pours hot milk into a bowl and settles down to his breakfast, dipping bread into the bowl of hot chocolate. The shot lasts for just over three minutes, in which Argaud does nothing except eat, concentrating on his food and occasionally looking up to his left. Following this shot is a briefer one of 30 seconds, for which the camera has been moved (seemingly in real time) to frame the view towards which Argaud has been glancing up. Across the disorder of his kitchen we see the window, but not what he sees beyond it. Argaud finishes the last few scraps of food, and moves out of frame. The sequence ends a few seconds later. It seems as though nothing has happened at all.

However, we have seen and heard something fundamental, but we do not realise its significance until later. Argaud has indeed given Depardon and his viewers a profound insight into the reality of his life. We know that he lives on his own since the death of his parents, and lives close to subsistence on his land. As Depardon's film develops, we realise that Argaud is becoming ever more reclusive. He lives a life of silence among his animals, towards which he may be looking through the window. He becomes more silent, more withdrawn from any human contact. In retrospect, then, the meaning and value of this sequence becomes clear. But as we watch, we are looking for a wider meaning, searching closely for any clues in Argaud's behaviour and in the objects that surround him. This is one aspect of Slow Film: it does not necessarily reveal the significance of what it shows immediately. Instead, it concentrates on the absolute particularity and individuality of person, place and moment, leaving significance to emerge gradually.

Another film about peasant life – but a world away, in China – demonstrates a second aspect of Slow Film. Feng Yan's 2007 film *Bing'ai* is the result of almost a decade's filming in an area that was soon to be flooded by the controversial Three Gorges dam project on the Yangtze River. It centres on one woman, Zhang Bingai, who struggles in vain to gain an adequate resettlement for herself and her family in the proposed area 120 kilometres away. She oscillates between negotiations with the authorities and canny attempts to gain something for herself from using soon-to-be-flooded land vacated by her neighbours. Many of them have also failed to be properly

resettled, but, unlike Zhang Bingai, have left for the cities. Feng Yan describes the gestation of her film:

> As Bingai talked unhesitatingly to the camera in between her busy farm work and heated negotiations with officials, I understood how all her past choices and actions were based on her own life experiences. As I was editing *Bing'ai*, I came to realize that parallels emerged between her history and current situation entirely in the order in which the scenes were shot. A life's richness and complexity goes far beyond our imagination. This coincidence made me lament over my silly and unnecessary efforts to try to 'compose' the film.
>
> *(Feng n.d.)*

Again, in this film, the significance of what we see emerges gradually. But unlike Paul Argaud, Zhang Bingai talks, frankly and engagingly, once Feng Yan has gained her trust. During a shot that lasts over three minutes, she sits by the river and tells the story of her wedding day, how she married with no affection for her husband, and how this subsequently developed. Another three-minute shot frames her in her doorway as she sews, and begins to talk, slowly at first and then fluently, about the many abortions she has gone through, including one at six months. There is no editing within these shots; the pauses are hers rather than the result of post-production. We watch the simple act of telling and so develop, slowly, an understanding of the speaker as well as what she says. These are, as Feng Yan says, the experiences that guide her current decisions.

The Slow Film approach is not necessarily confined to film about rural life, nor to film that respects the integrity of the interview exchange. Patrick Keiller's 1994 film *London* has hardly any synchronised dialogue. It consists of shots of London and a voice-over which recounts a fictional journey of discovery. It is stuffed with details and obscure knowledge about the city. One sequence deals with an encounter in the central district, near Elephant and Castle, with a couple who have lived in a pre-fabricated house since it was put up in 1965. In most films, an interview would follow. Keiller simply incorporates their observations into the continuing flow of the voice-over narration. This works closely with the shots without camera movement, all of which are held longer than their information value would warrant in most films. We see first the house in its garden, with a forbidding wall of tall buildings behind it, and we glimpse a woman working in the garden with a rake, with the shot lasting for nine seconds. The second shot of eight seconds' duration is closer, looking across a garden fence, but with no human figure. As the voice-over recounts the anonymous couple's account of the hostel building behind their prefab, we see the featureless walls and windows of this building (or, at least, what we assume to be this building). This is held for longer, twelve seconds, despite having little information value. The sequence then ends on an even longer shot of fifteen seconds, returning to a different framing of the garden: this time, a woman in long shot is working, partially obscured by bushes. The sequence of images works closely with the voice-over, although there is nothing that guarantees that the woman working in the

garden is the same as the person whose account is being retold. The construction of the film as a whole would lead us to think it is. The remarkable feature of this sequence is not only its refusal of much of the paraphernalia of documentary (interview, captions, substantiating the specificity of the building, etc.), it is also the fact that the duration of the shots increases as the sequence goes on. We see the same kinds of things, but the film insists that we look at them more closely for a second and even a third time. This is a city film that insists on the need to look again, and does so through a distinctive form of cutting together its shots.

Slow Film deals with one of the lurking suspicions that many have regarding contemporary documentary: the suspicion of selection. In its refusal of fast montage, it is able to stress the uniqueness and the specificity of each filmed moment. It shows what some feel that they do not get to see; it leaves in the 'dead moments' that are often left out – moments that are often the preparation for important actions or statements, and often enhance our understanding of those actions when they happen. It also allows the viewer to notice the incidental things that might have significance for that viewer, and provide a means for their better understanding of what is being shown. Slow Film insists on the specificity of each person and each situation, allying itself with a key trend in modern art exemplified by the site-specific work of artists such as Andy Goldsworthy and Richard Serra. This is art that relates to the 'thingness' of things, rather than the hidden connections between things. Slow Film also offers a specific kind of integrity: the integrity of a unified shot. In its refusal of fast montage, Slow Film begins to provide an answer to one of the most common criticisms of contemporary documentaries: the accusation that they have 'left out' vital details, or have distorted the viewer's conception of events and people by too much elision. Such responses are now common, and are a symptom of the development of new attitudes to viewing documentaries, which is a key aspect of the third phase of documentary.

10

THE EVENTUAL VIEWER

We watch documentaries because they provide us with information and a way of knowing the lives of other people without making their acquaintance directly. We watch documentaries to see events up close, but simultaneously at a safe distance. We are able to watch the most intimate or outrageous actions of others without suffering any kind of threat to our own safety; without any need to intervene to influence a dangerous or unjust situation; without the need to respond directly to objectionable views. We can see things happen, but without feeling, as a bystander would, that we should intervene in some way or hurry away to a safer place. There is no possibility of interpersonal exchanges with the people we see on our screens. Even if we are moved to help, we cannot. The eventual viewers of documentaries watch them from a secure position, outside the action, yet able to see and hear closely and in detail.

We watch documentaries because they seem to offer proof. We believe them to show us people and situations as they are. They give us a key insight into the lives, beliefs and practices of people who share our world. They offer us something that we do not – or cannot – see every day. Documentaries take us out of the lives we know and offer us other ways of living, sometimes strange, sometimes unwelcome, but always enlightening. They take us to places and situations that can enrage us or make us feel profoundly uncomfortable. Fiction can do this too, of course. But a fiction, however moving or persuasive, is always a fiction. It proves nothing. Fictions are invented by people in the hope of persuading their viewers that they ring true. Documentary rests on the claim that it has reduced invention to a necessary minimum. Documentaries claim to show what already exists, and we watch them because they can bring us into contact with aspects of our world that might otherwise escape our attention. Documentary can cut through the complexities of issues to show us what it feels like to be an individual experiencing them directly. It can broaden out from individuals to examine the network of forces within which they are caught. Documentaries are able to ask questions and to challenge attitudes precisely because

they can claim to be real and to offer proof of their contentions. Documentaries can make us angry or they can offer us reassurance; they can moralise and try to recruit us to their point of view. But they always do so because they claim that their footage proves the truth of what they are saying.

We, the eventual viewers, arrive at documentaries once they are finished. They are addressed to us in various ways. As Jacob Smith asks of sound recordings, 'is the media consumer an audience member, a ratified participant in an intimate one-to-one exchange, an overhearer, or an eavesdropper? This ambiguity can be felt in the slipperiness of the terms used to describe the media auditor – are we talking about isolated listeners or a unified mass audience?' (Smith 2008: 244). Any viewer of a documentary, in whatever situation of viewing, has to find their way through the differently pitched communicative attempts of documentary subjects, of filmmakers and of their commissioning organisations. The contributions of all these parties have been through a process of production which eventually produced a text, which has negotiated the differences of address that Smith outlines. The viewer (or listener) starts from that finished text, at the other end of the process. Yet we are all too aware that the process of textual construction has taken place, and, because we watch documentaries to find proof, we will interrogate what we see in light of our knowledge and feelings about the processes of production. Today's eventual viewer knows what it feels like to film and be filmed, so we often experience a sense of ambivalence, best expressed by the actor Michael Caine when refusing to appear on Piers Morgan's *Life Stories:* 'I love watching your show for all the reasons I don't want to be on it' (Morgan 2010: 7).

The documentary viewers of today occupy a subtle place. Addressed by all kinds of attempted communications, their emotions are engaged, yet they are in a position of security and distance that allows judgement (Chapman 2009: 134–55). The digital environment has brought about a greater awareness of all of these aspects of the viewer's position, along with a heightened awareness of the reality/textuality paradox. Within our self-aware media environment, there are practically no naive viewers or naive documentary participants. Everyone has something to say, not least about documentaries themselves. Documentaries have always created controversy, but now it is different. Documentaries are now discussed by viewers who have a considerable degree of skill and experience in evaluating what they are seeing and how they are reacting to it. And those discussions, which once would have been confined to immediate reactions in front of the screen, are now concretised into feedback and public debate by the many forums that feed civil society, from phone-ins to blogs, from official websites to graffiti, from emails to SMS texts. A reaction that once could only have taken the form of a spontaneous expletive directed to an impassive screen at home can now become an instantaneous rant on a range of electronic communications devices. It can then be picked up and amplified in other media, either by direct quotation or – more usually – by recycling into the writings of journalists, the comments of radio presenters, usage in more authoritative blogs, or repetition by the broadcasting organisation itself in one of its own outlets.

Documentaries no longer exist within themselves, as self-contained texts. They are now subject to a two-way traffic of interpretation which makes the cacophony of

communicative attempts even more tricky to negotiate (and poignant to experience) than it was before. This activity takes place around the films and programmes, but also beyond them. It is an extratextual activity in that sense, even though some of the activity takes place 'close to' the text in linked websites, or is included in DVD extras, as is the case with *Capturing the Friedmans* (Austin 2007: ch. 4). For some kinds of factual programming, such as the *Big Brother* series, extratextual activity assumes an importance equal to, if not greater than, that of the actual programmes, so that there is no point in trying to understand the phenomenon of *Big Brother* without seeing it is an extensive text across a number of media (Tincknell and Raghuram 2004). In this case, viewer activity has explicitly become the point of the programme, but this is now a routine phenomenon for both broadcast and cinema documentaries. Documentaries now have another dimension of communicative attempts to add to those of their subjects, their filmmakers and their commissioning organisations. Now the eventual viewers join in with their attempts at communication.

There has always been an active audience, of course. One of the challenges for cinema in its mass audience heyday was to make sure that all sections of the audience quietened down enough to allow the film to make itself understood (Hansen 1991; Ellis 2000b). Recently, we have experienced two changes: the increased availability of audience ideas through new forms of feedback and communication; and the development of a media literacy, partly as the result of the availability of consumer digital production devices. This has made it easier for filmmakers, their financiers, broadcasters and distributors to understand and evaluate audience feedback. It has also made it possible to respond almost immediately. There has been a shift in the basic genre relationship, in which common ideas about what 'documentary' might be circulate between the individual filmmakers, the broadcasting (or other) institution that uses the label to define whole classes of product, and the audience who bring expectations to bear on anything that is claimed to be (or that they think to be) a documentary. This 'triangle of expectation' (Neale 2000: 7–48; Mittell 2004: 1–27), with filmmaker, audience and institution as its three points, is still an essential way of understanding how generic definitions such as 'documentary' perform an essential role in organising media activity.

The relationship has changed because viewers now have sophisticated ideas about what filmmakers and institutions are doing and have done. The whole process has become far more self-aware as a result. Audience expectations are more explicit, more complex, more heard. Viewers bring to bear ideas about how documentaries are produced and should be produced. This awareness – even if mistaken – of how documentaries are made determines how they are seen and understood. Filmmakers attempt to anticipate these ideas by sowing clues about the way that the film was made, the relationship between subjects and director, and their own ethical uncertainties. Broadcasting institutions try to manage controversies, and are acutely aware of the issue of trust that underpins the claims to proof or truthfulness in 'their' documentaries. It is a struggle for understanding and for trust across the cacophony of often misheard voices, all involved in their distinctive attempts to communicate.

Critical awareness

The critical awareness of the eventual viewer relates to both the filming and the editing process. Today's viewers are fully aware of the paradox that films are the product both of real situations and of a sophisticated process of textual organisation: the reality/textuality paradox. Today's viewers know that, even as they look to the footage for proof, they also need that footage to be arranged into a meaningful whole. We desire selectivity and structure, but we also distrust it as having introduced forms of distortion or bias. The textual arrangements of footage drawn from various sources and places create the distance necessary for acting as a viewer, moving from one view to another, from one fragment of attempted communication to another, from one story to another. This creates the mobility of viewpoint that is central to the contemporary experience of the audiovisual, but it also introduces the potential for doubt, scepticism and denial.

Documentaries present us with a synthetic view, drawn together from the best available pieces of visual and auditory evidence. Documentary is distinct from news footage because it is capable of bringing together footage from a wider range of sources and over the whole span of a story, and is constructed into texts without the imperative of being ready for that day's news. We watch documentary to see what has happened (rather than what is happening), and in doing so, to be able to see for ourselves. As with fiction, documentaries give their viewers a mobility of vision which gives another level of security: that of not being tied to one character, of being able to discover and to know more than any of the characters within the documentary. The double security of the documentary viewer is a security of distance and knowledge. This enables – if not requires – an activity of judgement on the part of the viewer. The evidence is assembled for our inspection. The footage is at once real and textual, and is therefore open to both emotional empathy and critical judgement. Every documentary attempts to set up a hierarchy of voices, valuing some rather than others, questioning the motives of some of its characters or the evidential value of some of its images. Yet, in the end, it is up to the viewer to accept or reject that hierarchy, and to try and judge for themselves the truthfulness of characters and stories. Many filmmakers, having assembled the evidence, will leave lingering elements of doubt. Some, like Andrew Jarecki with *Capturing the Friedmans*, will make doubt and ambiguity the central concern of the film.

We are aware as viewers that the potential meanings in footage have been mobilised (or muted) with some aim in mind, to reveal something about the world, to stir the emotions, to draw the attention, to argue a point. Using footage both draws out and attributes meanings in a reciprocal process of negotiation with its viewers. A line of commentary may point out particular features of a shot, but a viewer is still free to look at something else, a passer-by in the background, for example. Commentary may sometimes anticipate what the following scene will show, predicting the actions that we are about to see. Such devices aim to reveal the nuances of behaviour in their subjects, but many viewers will notice other features instead. The commentary may try to emphasise what a row between a couple says about their relationship, but for

many the subject of the row might be more interesting. It might reveal how little money each earns, who they compare themselves with, a difference in their expectations about the future, or more general information about their social conditions. Over the course of a programme, this process will generate minor differences of interpretation, and sometimes it may create more major divergences. So it is a foolhardy individual who assumes that their particular reading is shared by others. The differences of interpretation are usually resolved in the multitude of everyday discussions that take place around factual footage, what we saw on the news, the latest reality TV material or a recent documentary. This is a major feature of the new active viewership for documentaries: an active debate about what the meaning of the texts might be, and the nature of the original shooting and editing interactions that lay behind them. While viewers need the textual organisation of footage so that they can understand what is going on, they are sceptical about the nature of this organisation. They will see things and quite legitimately interpret them for themselves, producing variant understandings that can develop into doubts or disputes about the overall organisation of the film text.

Emotional identification

The documentary viewer may witness from a position of security, but this does not mean a lack of emotional involvement. On the contrary, the knowledge that the characters in a documentary exist beyond the film – unlike the characters of fiction – lends an extra level of emotional involvement. We recognise and feel with their feelings, we feel empathy: experiencing something of the emotions of another without confusing them with our own. We empathise with the characters of a documentary, but since we are somewhat detached, and often in a position of greater knowledge than any of the characters, this empathy is often complicated by other emotions. If a character has a sudden emotional outburst, we may well perceive him or her as selfish in relation to the characters on the receiving end. While feeling for this character's evident distress, we equally feel impatient on behalf of those other characters, even if they themselves take the outburst entirely at face value. As distanced witnesses, our emotions are engaged, we feel empathically with one or more characters, but we experience other emotions as well. Documentaries often involve complex emotional involvements for their viewers, sometimes even despite the directions implicit in commentary material. There is always the risk that the viewer's sympathies will be aroused by the evident sincerity of a particular character, especially where the viewer shares something of that character's problems or characteristics. In such cases, an emotional conflict begins for the viewer, which cannot be contained by the experience of the programme itself. It will lead to many different kinds interpretation and of 'audience action'.

Our emotional engagements are real and complex. We feel with the characters, but not like the characters. Our feelings are always leavened by the knowledge that we are being addressed, and we can feel that documentary subjects are appealing to us to respond to them in a fairly explicit way. As documentary viewers, we are

addressed by the footage that we witness. Documentaries are not accidental com-
munications, but are intentional ones. With very few exceptions, documentary
characters speak knowing that they will be heard, and they act knowing that they
will be seen. Filmmakers record knowing that their recordings will be viewed. The
documentary viewer is the point of these communications; both filmmaker and
characters are trying to communicate with the unknown viewer. Documentary
material should therefore be seen as a series of attempted communications: commu-
nications that are attempted but are by no means successful. Each cut from one
person to another, from one action to another, brings a new complex of attempted
communication. Viewers have to judge how what they witness now fits with – or
conflicts with – what they witnessed before. They have to judge what was meant by
the cut, why it came at that particular point in the outgoing and the incoming scene.
They have to interpret the actions of the characters who they are getting to know.
They have to hear what is said and reach a conclusion, however provisional, about its
trustworthiness. And sometimes they have to wipe away a tear or stop themselves
laughing too much. Documentary viewers receive attempts at communication within
the film and try to make sense of them. But the communicative attempts within the
film are just one dimension of the process.

For there are other attempts at communication being made at the same time: the
documentary comes to its viewers through a broadcasting organisation or a dis-
tributor. These organisations also have their messages to convey, and their known or
presumed reasons for providing finance and access to markets. A BBC commission
or screening will endow a documentary with a level of truthfulness which is
guaranteed by the editorial processes of that organisation: the BBC attempts to
communicate its claims to truthfulness through every documentary it screens. The
BBC will also attempt to communicate a series of public service values across what it
screens, which will include a sense of the cultural value of what it shows. These
communicative attempts become particularly evident when they fail, when the
truthfulness or cultural value of one or several BBC documentaries is challenged, for
example.

Documentary viewers experience a wide range of attempted communications
through each film that they witness. The films are made for them by agencies which
have their communicative intents. Viewers come to them, usually voluntarily,
expecting to receive, despite all the reservations that can intellectually be had about
the word, some kind of communication. Any audiovisual text comes with a dense set
of expectations and promises. Any audiovisual text equally, through its mobility of
vision, will provide the witnessing individual with multiple instances of address,
instances of attempted communication. Attempted communication is, in part, the
result of the nature of the viewing process itself: it goes with the selection of shots,
voices and points of view and their synthesis into a single text by the work of film-
makers. But it extends beyond this as well. It includes the activity of the providing
organisation as a communicator. It includes the lone viewer's awareness that others
are, or will be, watching, to whom these attempted communications are also
addressed. Documentaries are almost always forms of public communication, and so

also attempt to communicate something about the nature of the publics to which they are addressed, even if it is simply a series of assumptions about their viewers. Viewers will often frame their views in terms of what 'other people' might think, showing that they, too, are aware of attempted communications around the public nature of the documentary.

Emotional engagement with the subjects of documentary comes with its own set of doubts. Since we know we are being addressed, our spontaneous feelings of empathy are leavened by an awareness that we are being appealed to, both by those subjects and by the individuals and organisations that have brought us the film. Individual viewers deal with these contradictory pulls in their own ways. These feelings come alongside the differences of interpretation, which come with the distrust of the necessary textual organisation of footage. So the contemporary documentary viewer has much to deal with. And beneath these conflicts of emotion and understanding lie one further set of doubts: about the status of recorded moving image and sound as any kind of record.

Doubts

The early twentieth-century discovery of the radical potential of texts constructed through the principles of montage largely relies on the reality effect of moving images. If the daring juxtapositions of montage are to be effective, then the status of each image as the imprint of a reality has to be taken for granted. However, this also is no longer the case. The ubiquity of montaged images and the near-universal experiences of photographing and being photographed have produced a culture of doubt about photographs and recordings. We know them to be the result of an extended process of production. The reality effect of moving image recordings is too fragile to be taken at face value. Nowadays, there is always some nagging doubt about the status of the footage and how it came about. There often seems to be some kind of conflict between reality and textuality, between the illusion and the fact of the human work that went into producing it. The most routine piece of news footage is capable of inciting such doubts, and the more the textual structure draws out meanings inherent in the material, the more these doubts tend to impose themselves. The process of watching a documentary, where the text deliberately bases itself on the realities of the footage, is often the particular focus of these doubts.

Documentary films constantly struggle to establish their trustworthiness and truthfulness. Documentaries base their claims of proof on the ability of the photographic process to depict what is before it. Yet these proofs are brought to us only through a process of depiction that involves all kinds of human intervention. We are aware of this as a principle, but in practice it is enormously difficult to judge exactly what went on, and whether it was justified. We examine the images closely, since they can often provide proof of the levels of human intervention if we look at them closely enough. Yet, all too often, the images do not give a simple answer, or simply provoke fresh doubts. Filmmakers are aware of this, of course, as are the broadcasters and other information suppliers for whom they work. So they try to anticipate objections as far

as possible in making their films, and try to promote themselves as trustworthy in order to guarantee that their films are seen that way too. But still the doubts remain.

Disputing undercover documentaries

In 1999, the BBC showed an episode of the series *MacIntyre Undercover* in which the reporter Donal MacIntyre had pretended to be a Chelsea football fan interested in getting involved in the organised violent gang fights that were then taking place around Chelsea matches. The crucial moment in the film comes when one of the leaders confesses to a vicious assault on a policeman. The confession was recorded on a hidden camera in MacIntyre's car as he drives them to a possible fight at an away match. The footage is irrefutable: he is clearly seen and heard boasting about this attack. Yet all kinds of questions can be asked. Did MacIntyre's presence provoke the confession? Did his expensive car impress the man so that he felt it necessary to boast? In short, even though the film is perfectly clear about how it was made, is the proof invalidated by aspects of the making of the film? Did MacIntyre, in the usual way we say these things, 'lead him on'? In this particular case, the balance of the evidence provided by the film and by the editorial processes of the BBC is that there was no undue provocation.

However, other programmes in the series were the subject of lengthy court cases which hinged on the representative nature of MacIntyre's evidence. Disguised as a fashion photographer, he had shown a number of abuses of under-age models employed particularly by one agency, Elite. Despite the resignation of two of its executives, the agency took legal action to dispute MacIntyre's allegations of under-age sex and drug-taking. Elite eventually withdrew its claims and reached an out-of-court settlement with the BBC. In the same period, MacIntyre was himself suing for libel, this time against the Kent police, who had alleged that another film in the series had been 'misleading'. MacIntyre had filmed the physical abuse suffered by the elderly residents of a care home in Gillingham, Kent. The home was subsequently closed by Kent Social Services, but a police investigation produced no prosecutions. Kent police then claimed that, as MacIntyre's footage was highly selective, no general pattern of abuse was shown that would justify prosecuting the 'carers'. This was a challenge to the documentary procedures employed by MacIntyre and underwritten by the BBC, so MacIntyre sued for 'damage to his reputation' and the Kent police eventually apologised, paying his legal costs of some £650,000 as well as damages, in October 2002.

Digital image technologies have intensified scrutiny of the 'thereness' of the photographic. Digital material is so malleable, so the argument goes, that it is impossible for us to know any more whether what we are seeing is drawn from reality or is merely a drawing. Fiction films have shown us impossible worlds and superhuman

feats thanks to digital image processing. We are used to created worlds like that of *The Matrix*, or the panoramic recreations of battlefields in films like *The Lord of the Rings* trilogy and *Flags of Our Fathers*. Documentary itself has participated in this digital creativity, allowing us to walk with dinosaurs or to see inside the human heart. There is a widespread perception that the photographic itself is under threat from these new processes. We know of the digital retouching of glamour photographs that can render Kate Winslet thin[1] or Beyoncé Knowles white.[2] We therefore assume that any photograph can be extensively altered.

Do these contemporary levels of doubt totally undermine the reality effect of moving images? If this were the case, then the whole documentary project would be impossible. Any evidential claims for moving image material would be subject to a more fundamental objection than those of selection and over-intervention, which have been levelled at filmmakers such as Donal MacIntyre. This is the position some critics took when first confronted by the awesome power of digital procedures (Fetveit 1999). However, the situation is rather more fluid, and it is more a matter of a new turn in the vivid history of understanding of the audiovisual: of audiovisual literacy. Recent doubts about image manipulation have not undermined the status of the photographic, but instead have led to new kinds of arguments about the trustworthiness and truth of those images.

It may be that, in the end, we need acceptably accurate and trustworthy moving image material far too much to allow a new technology to deprive us of it. Spontaneous new uses of digital technology often rest on using it to show things as they appear. Moving image and sound is just too useful a technology to be undermined by one particular potential that it offers: the ability to create images from scratch or to intervene creatively within them. So we are reaching a new accommodation with the photographic in the digital age. There are two ways in which this is happening. The first is the result of the new levels of availability of the technologies of sound and image recording and creation. The second is the development of new ways of dealing with the reality/textuality paradox.

In our technologically saturated cultures, almost everyone has now enjoyed the experience of taking numerous photos, of being filmed and seeing themselves on screen. So we are all experts now, knowing what it feels like to be on the receiving end of the camera lens. As we know what it feels like to be filmed, we can more easily form an opinion about what went into the production of the documentary material that we see. We take our own experiences of 'home video', surveillance footage and workplace video training, and extrapolate our feelings into those of the people we see on our screens. We feel that we can see when people are uncomfortable or embarrassed, or led to say more than they intended. We also know what it feels like to do the filming. We know what it feels like to point the camera. We know how people respond, which is often unexpected and sometimes hostile, even when we know them. We know how the view on the little screen of the viewfinder differs from the view in front of our eyes. We know how the edge of the frame cuts out our peripheral vision. We know how the sound recording picks up things we missed and also seems different, more indiscriminate, than the sounds that we think

we heard. We know more about the selection and combination of material, so feel we can judge when cutting has been judicious and where it has distorted what was originally said or done. We bring this emerging awareness of the practices of production to our understanding of the documentaries that we view.

Thanks to new forums of communication, the eventual viewer of documentaries can now also be a participant in the activity of meaning around documentaries. Viewers can now add their own communications to those contained in any documentary. Critical activity has no doubt gone on whenever factual footage has been watched. However, doubts and differences of interpretation are now public, as a thriving extratextual activity. This seems to have two characteristics. First, it is a crucial part of the process of reaching a new accommodation with the treachery of the evidential, the reality/textuality paradox. Much discussion now seems to focus on the truthfulness of footage and the sincerity of participants. The second emphasis is the process of trying to reduce ambiguity, and particularly emotional ambiguity. It is directed towards asserting or discussing the significance of actions and words and how to react to them, or how to deal with reactions to them. This emotional ambiguity is, of course, resolved, but outside the text. We think about it, talk about it, come to a conclusion of some kind, or dismiss the whole thing as a passing show of no great consequence. The extratextual resolves the ambiguity of the textual, as empirical researchers such as Helen Wood are beginning to understand by looking at conversations with and around TV material that take place as programmes unroll, as well as after watching (Wood 2009). With documentaries, these exchanges often take the form of ethical discussions, about the nature of the filming as exploitative, or what is perceived as 'playing up for the cameras', or the bias of the director. These ethical discussions mirror those that take place within the profession of documentary filmmaking. They are based on a number of half-expressed attitudes to photography and sound recording, and on the specific experience of watching moving images, the experience of audiovisual witness. Before examining some specific examples of ethical debates around documentaries, the bases of modern viewing attitudes must be explored.

11

AMBIVALENT FEELINGS ABOUT PHOTOGRAPHY AND RECORDING

Photography stirs up ambivalent feelings. Its ability to freeze moments and to return them to us is a piece of everyday magic. As photography has become easier and more pervasive, it has become more useful in our mundane pursuits: many people use the camera on their mobile phones as a visual notebook. Yet photography still retains its magical qualities, allowing us to see again, and also to see differently. Photography both preserves and reveals, opening up the moments that it freezes to an inspection that was not possible at the time. In looking again at what was photographed, away from the pressures of the moment, we can see much more than we could at the time. This is photography's magic, and it is a magic that both charms and disturbs. We are happy enough, nowadays, to take photos, but we can also be less than happy when photos are taken of us. The single moment of the photograph can often feel 'wrong'. It captures an 'unfortunate' expression, perhaps, or an unwanted gesture. The lighting can conjure up bags under the eyes or a washed-out skin tone. The framing can produce unhappy coincidences like the lampshade that looks as though it is growing out of the top of a head. Photos can record moments or even relationships that we later want to forget, even to the point of cutting up prints to eliminate the offending person. Photography still carries its risks, despite being universally available for more than a century. Cameras are used every day for everyday purposes, but photography still produces a sense of unease behind all its evident convenience and life-affirming power.

If photography excites ambivalence, then moving images do so even more. Scenes taken from life, sounds snatched from the air, both cause all kinds of contradictory feelings. Moving images of ourselves still take us by surprise. They show a different, public self, one who may be more assured than we feel, more accomplished than we believe ourselves to be. We see how well we respond emotionally and intellectually, how naturally we interact with others. But these same recordings reveal gestures and expressions that we never realised we had. We blink violently, or seem to twist and

turn when we felt we were keeping still. Our recorded voice sounds different from the familiar one that resounds in our head. The speech that we imagined was fluent and witty is revealed to be hesitant, halting and even appallingly miscalculated. When people see moving images of themselves for the first time, they are taken aback by the strangeness of their familiar selves. Embarrassment is present as much as, if not more than, the celebration of self. It is something that we can get used to quite quickly, but the ambivalence remains submerged, prompting a desire to perform 'better' or 'more naturally'.

An initial ambivalence in the face of recordings of ourselves will set in motion a process of trying to reconcile how we appear and how we like to see ourselves. Once a person becomes conscious of their own behaviour as something that is perceived by others, they try to reconcile their behaviour with the imagination – or idealisation – of themselves that they carry around inside themselves. Recordings of our behaviour alter that process, allowing us to see ourselves as others do: to see ourselves from the outside. Neither this imagined self nor the onscreen self emerges unchanged from this process. It is not simply a process of 'measuring up', but one of negotiation. This process seeks to reconcile an imagined self with a perceived self that is revealed by the magic of photographic preservation and representation. We can seek help in this process of reconciliation in various forms, 'media training' to 'behaviour mod-ification', and sometimes this help is forced upon individuals. The reconciliation process works on the disparities between imagined self-presentation and recorded self-presentation.

Photos and recordings are objects that mimic the perceptual process of seeing and hearing. They seem to extend natural seeing and hearing – the everyday visual and aural perception that happens without any intermediary – into other contexts. The magic of photography and recording lies in this apparent extension of natural powers. Much of the enduring ambivalence felt in relation to photographs and recordings is the result of this process. Photos and moving images seem to give us back the sights and sounds of a particular moment, but are able to do so in other spaces and times, for other witnesses. They capture moments, and can replay them at any subsequent moment, and to any individual who cares to look or listen. Natural seeing and hearing is therefore extended in time, in space, and in scope. It enables repetition and detailed examination of the recorded moment, allowing us to decipher the interac-tions and make out the muffled sounds. Recording enables new kinds of looking, ones not accessible to an observer at the time. Photography and recording allows inspection and extended gazing. This usage provokes huge ambivalence. We carry photos of loved ones, which we can gaze at even after they are dead. Yet, at the same time, this extended gazing can be used for entirely other, more unwelcome purposes: by police, by voyeurs.

Photos and recordings become objects that can be used in the future for as long as they last. Much of the ambivalence we feel about these recordings relates to their future career as objects, which cannot be predicted when they are originally produced. Photos can go on being used even when their original subjects are unknown, and even when the context or meaning of the actions depicted in them is also forgotten

FIGURE 11.1 Photos in circulation

(Frosh 2003). Greetings cards and picture libraries are full of such images, often in black and white, portraying individuals from the first half of the twentieth century engaged in surreal activities. Who are those two men with mammoth glasses of beer wiping their foreheads outside a café? Why did those nuns allow themselves to be photographed smoking?

The more that these inscrutable and anonymous images circulate, the more they feed our ambivalence about the life of our own photos when they separate from our keeping. A friend's grandmother, who grew up in the first age of mass photography, destroyed all the photos in her family album just before she died, aged ninety-five, because she had seen similar albums for sale in a local junk shop. She presumably could not bear the idea that the people who she remembered through the photos would be reduced to simple commodities. Photos and recordings are objects that can circulate and find new users, and those users will have their own motives.

Few people would destroy their family albums today. Indeed, they probably have more images than they can possibly view or deal with. They may have found that many of their colour photos are already degenerating physically, and that digital images get lost somehow in the continual shift of data from one computer to another. The sheer numbers of images now in circulation means that we tend to treat them more casually. Yet, though attitudes to our images have changed and will continue to change, our ambivalence remains. Many a teenager regrets posting a risqué image on Facebook, which is then seen by their parents, who may well use the

forum simply as an easy means of keeping in touch; many more may regret being tagged in photos posted by others. Photography is both a good and a bad thing, to be celebrated but also to be treated with respect, sometimes bordering on fear.

Still photography seizes just one fragment of a moment, less than the blink of an eye. Moving image and sound, by comparison, captures far more of the person, and so excites greater feelings of ambivalence. Moreover, still photography has been in the hands of the ordinary citizen since Kodak popularised it in the 1890s. We are just getting familiar with the equivalent spread of moving image and sound-recording devices. In effect, the widespread use of video is far more recent than that of still imaging, dating from the introduction of the Handycam in the mid-1980s (see chapter 4). Until that moment, the creation of moving image and sound had effectively been in the hands of the professionals, the privileged, and the dedicated 'enthusiasts'.

The proliferation of simple sound and image recording devices (especially the multi-purpose mobile phone) gives the majority of people in the developed world the ability to record each other as easily as they photograph each other. Many have experienced themselves as a recorded phenomenon, and have reconciled to some extent their ambivalent feelings about this new experience. We know what it feels like to point a camera and to have it pointed at us. This allows us to speculate about what might have happened in the professional filming of footage that we watch in TV documentaries. We can project our own ambivalent feelings into the discomforts of the people we see on screen. However, this awareness is very recent. At the beginning of the 1980s, the opportunity to appear on TV was more restricted than it is now; non-professional videotape technologies were in their infancy; and 'amateur' film was commonly shot silent. The everyday opportunities to be filmed or recorded simply did not exist. So it is reasonable to infer that a shift is happening in how we deal with moving image and sound recordings on film, video and digital recording devices. Our ambivalences about filming and being filmed are becoming more complex as the processes become more familiar.

Caught unawares

The fear of being caught unawares was a major feature of the early years of both television and popular photography. In the late nineteenth century, the British and American press discovered a new menace in the streets: the 'Kodaker', who took photos without their subjects' knowledge and then used them for their own purposes. According to Robert E. Mensel, there were accounts of entire rooms in New York City papered with illicitly taken photographs of women in the street. The cameras were described as 'deadly weapons' and 'deadly little boxes'. The click of their shutters was 'ominous' and 'dreadful'. An English comedian described the Kodak as 'an instrument of torture [...] which is driving the world mad' (Mensel 1991: 29). The camera industry itself actively encouraged such activities by creating a range of miniature cameras, known as 'detective cameras', hidden in common items of male clothing.

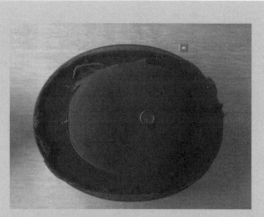

FIGURE 11.2 Photographic hat, 1895

FIGURE 11.3 Photographic cravat, 1890

Women were the major targets for photographic attention, as photography allowed men to take away and contemplate images of the women whom they could see in public spaces. According to *Amateur Photographer* magazine in 1894, 'several decent young men' formed a Vigilance Association 'for the purpose of thrashing the cads with cameras' who take pictures of ladies at the seaside (Anon. 1894). One photographer used photomontage to stick the heads of 'fashionable women' onto photos of naked bodies (Mensel 1991: 35). Illicitly taken images of attractive women were also used commercially, exploiting the fresh and unposed quality of the image taken unawares. Such photos were widely sold. In 1899, Abigail Roberson a teenager from

Rochester, New York (ironically, the home of the Kodak company) found that an image of herself, taken without her knowledge, was being used as a flour company's trademark. The court case that she brought eventually established many of the guidelines for photographic privacy in the USA (Mensel 1991: 36–40).

Mensel states, perceptively, that the level of public panic at the idea of photos capturing people unawares 'so remarkable to our modern sensibilities, arose from a complex interaction between contemporary suspicions about the "reality" of photographs and uncertainty about the limitations of the technology on the one hand, and contemporary bourgeois notions that unguarded facial expressions were reflections of deep and sincere feeling. The possibility that "reality" was captured in a photograph was enormously unsettling to late Victorian Americans' (Mensel 1991: 29).

The discomfort of being caught unawares also figured prominently in the early years of television, but in a culture that had experienced half a century of acclimatisation to the problems of still images, it took a different form. The hidden camera show derived entertainment from watching people react to situations that challenge their habitual politeness and consideration in their encounters with strangers. Allen Funt's *Candid Camera* first appeared on American TV in 1948–67 (Loomis 2004), and a similar format ran on ITV in the UK between 1960 and 1965. Both captured the reactions of members of the public confronted by implausible stunts or impossible behaviour. In Britain, Jonathan Routh waylaid the unsuspecting with talking pillarboxes, and once arrived at a garage in a car that had no engine, to the bemusement of the mechanics. The results were presented, with the permission of those involved, as comedy entertainment, exploiting the reactions of those caught unawares. The results were entertaining to a large degree because those watching were imagining how uncomfortable they might have felt in the same situation, and how they might have reacted. The heyday of the format was the early years of television, while the medium established the limits of what it might get away with. For many years thereafter, the format was revived occasionally as an item in Saturday evening variety shows such as *Game for a Laugh* and *Noel's House Party*.

Unlike the Kodakers panic of half a century before, the *Candid Camera* format required the permission of its victims before the footage was shown. The moment of revealing the existence of the hoax and the hidden camera was often the culmination of the sequence (Smith 2008: 181–99). However, permission was sometimes withheld. According to press reports, the boxer Sid Richardson gave Routh a black eye after his entrapment was revealed to him, helpfully confirming that the discomfort of his victims was all too real. Both *Candid Camera* and the Kodakers panic reveal a deep-seated anxiety about being caught unawares by a camera, about what might be revealed about ourselves, our bodies or our behaviours, when we are not actively arranging them for the camera's view.

Surveillance

Our ambivalences about filming and being filmed are currently felt acutely because they are a part of a wider concern about 'being watched'. The digital revolution has given us easy sound and image recording by transforming the process into one of digital data collection and storage. The previous analogue world of photography, filming and taping meant that transferring recordings from one form of storage (tape, film, paper) to another was difficult, if not impossible. Digital image and sound data, however, can be stored in the same way as other information, and can be searched along with data from radically different sources, subject to the right software being available. Compared with previous forms of data collection and organisation, digital has many advantages. Data can be quickly organised for one purpose and just as easily reorganised for another; and can be combined with other digital data to reveal hidden patterns of meaning. This process excites the same ambivalence as photography and recording. It is at once liberating and threatening. It has produced huge advances in medical diagnoses; it gives us instant access to our cash from machines around the world; it allows us to find the cheapest or most suitable deals in the electronic marketplace. It can even allow anxious parents to trace their errant teenage children through GPS functions on their mobile phones, or to keep an eye on the babysitter through the so-called Nannycam. This latter example vividly demonstrates some of the pitfalls of this technology. That which is useful from one perspective can be downright threatening from another.

Digital imaging technologies and data processing have produced unprecedented opportunities for workplace surveillance, as any call-centre worker will testify. The data are not only visual, though it is the idea of the 'surveillance camera' which is the particular focus for contemporary anxieties. Every digital transaction leaves its trace, whether it is a computer key stroke or a phone call. The information thus generated is sold on to organisations with their own commercial aims without our explicit consent. This could permit a devastating efficiency to repressive political regimes.

This creates a justifiable concern about the 'surveillance society', where every action of every individual can be not only tracked but also understood. The data concerned do not have to be accumulated in any one place: the network society is based on vast information flows that search different databases in order to sift patterns of behaviour. Neither is it a matter of exclusively state surveillance, as more data are held on our activities by the commercial organisations with whom we interact daily than by any state organisation. As David Lyon asserts: 'surveillance is a distinctive product of the modern world. Indeed, surveillance helps to constitute the world as modern' (Lyon 2003: 161). The early years of the twenty-first century have seen an increase in the use of surveillance, and of public approval of some of it, in the wake of the attack on the World Trade Center on 11 September 2001. Both in Britain and America, surveillance initiatives multiplied in the years after the attack in order to 'prevent terrorism'. Some critics have identified this as leading to a 'culture of control', with the result that 'our civic culture becomes increasingly less tolerant and inclusive, increasingly less capable of trust' (Garland 2001: 195).

Photography lies at the heart of concerns about surveillance. We feel we are being watched and caught unawares. These are concerns about being visible, and having

FIGURE 11.4 Banksy, Rathbone Place, London W1, 2009

our images recorded. For many people, the most intrusive and visible aspect of surveillance is the presence of the surveillance camera in public spaces and workplaces: the closed-circuit television camera (CCTV). As the House of Lords Constitution Committee report put it drily 'most experts appear to agree that the UK leads the world in its use of CCTV' (Lords Constitution Committee para. 70), with the exact number of such cameras being unknown, but 'recent estimates have put the figure at over 4 million' (Lords Constitution Committee para 70). In the UK, at least, it seems that the ordinary citizen is indeed being watched. There are cameras perched up high in public spaces, in the corners of rooms, and in train carriages and buses. The footage from these cameras is familiar to us. It forms part of TV programmes, and cameras on London buses show their images on a live screen on the top deck.

The Lords Committee presents a useful survey of the recent state of knowledge about public attitudes to this surveillance, finding that many popular beliefs about the usefulness of these cameras are supported more by faith than by evidence. There seems to be a considerable degree of support for the installation of cameras because their presence will 'deter crime', though there is growing doubt about whether this is indeed the case. However, there is evidence from a number of polls that a clear majority of people are concerned about the use to which data about them will be put, including the footage from these cameras. There seem to be comparatively few such polls. A US poll in 2007 (with a relatively small sample) did put the question of CCTV and the use of footage from it. It found that 58 per cent supported the use of surveillance cameras to 'stop or catch terrorists and other criminals', but at the same time 55 per cent were very or somewhat concerned that this technology was being used by government to get private information about them. This figure rises to 75 per cent when the same question is asked about private companies using it to get private information.[1]

This is, at first sight, a strange state of affairs. Recordings are relatively difficult data to deal with when compared with organised databases such as car ownership and driving licences, the British police's jealously guarded DNA database, or the mountains of data on consumer behaviour generated by credit cards, supermarket loyalty cards, etc. Video and sound recordings are hard to analyse. When they are used in court cases, the evidence of the cameras must be sifted by people viewing them more or less in real time. The technologies of facial recognition are untrustworthy, even when presented with a high-quality image of a face full-on, which is not the typical image created by a surveillance camera. Speech-recognition technologies are by no means guaranteed to make sense of more than 95 per cent of any utterance, falling down particularly on the words that convey crucial information: names, specialised vocabulary, and colloquial words and phrases. However, even given all of this, the prevailing image of the surveillance society is one of a society dominated by cameras and microphones – of a society in which we are being watched.

'Being watched' evokes particular anxieties. It is more immediately bound up with questions of personal identity and freedom, it seems, than is the use of data from all the forms of electronic identity in which the modern citizen participates. Perhaps this is because video surveillance seems to extend natural hearing and seeing, whereas these other forms of data seem to extend the intellective activities of writing and calculation. We feel that these are more under our control, that there is less risk of being caught unawares. Video surveillance raises exactly this anxiety: that the myriad cameras will capture how we behave when we think we are not being watched; and, further, that this footage will be put to some kind of use that may damage our reputation in some way. Video surveillance is the focus of the two great modern anxieties about photography: the issue of the distinction between private and the public, and that of the potential use of material by other parties.

Privacy

Privacy is seen as a key right in contemporary society. Article 8 of the Human Rights Act 1998 in the UK, based on the existing European Union Convention on Human Rights, states that:

1 Everyone has the right to respect for his private and family life, his home and his correspondence.

2 There shall be no interference by a public authority with the exercise of this right except such as is in accordance with the law and is necessary in a democratic society in the interests of national security, public safety or the economic well-being of the country, for the prevention of disorder or crime, for the protection of health or morals, or for the protection of the rights and freedoms of others.

This repeats a long-established legal principle which sees privacy, family and home as inextricably linked. Further, it sees privacy as something to be enjoyed when it does not have a negative impact on the lives of those around us. So the second paragraph contains a relatively long list of those areas where wider society has the right to impinge upon the privacy of individuals. Someone who is plotting a murder cannot complain of 'invasion of privacy' if their home is searched or their phone is tapped. However – and this is crucial in issues of privacy – it is normally the case that an invasion of privacy has to take place to prove that a suspected private intention is real. Outside agencies may believe that individuals may have the private intention to commit an antisocial act, but they cannot prove it until they have already violated their privacy.

The Human Rights Act also acknowledges that privacy is unique to the individual: it makes a distinction between 'family life' and 'private life'. So there is more than one kind of privacy at stake in modern society. There can be things that we want to share with some family members and not others, or even to keep secret from all. There are layers of privacy even within a family, as was shown in the documentary *Capturing the Friedmans*, which made extensive use of home video footage. Similarly, there are forms of public privacy. What people reveal about themselves in public is a crucial part of establishing themselves in relation to others with whom they work, with whom they undertake all kinds of ordinary civic activities, from shopping to political actions. In different public arenas, a person will choose to 'make public' different aspects of themselves. People chatting to their hairdresser, in the hearing of others, may tell stories about themselves that they would prefer work colleagues did not know. The way that people negotiate the issue of their own privacy is often seen as a key aspect of their public character. Too much self-revelation means that someone is seen as 'having no limits' or as 'too much of a blabbermouth', giving out 'too much information'. Consequently, they are seen as someone in whom others will not confide, as they do not seem to value their own privacy. Too little self-revelation, on the other hand, means that someone is seen as 'reticent' or 'secretive', and even 'uninteresting'.

The layers of privacy that the modern citizen maintains define spheres of appropriateness. In November 1995, the ITN newsreader Julia Somerville was arrested along with her husband as both were suspected of producing child pornography, under a law passed in 1987. They were held overnight for questioning, and released the next morning without charge. They had simply taken photos of their seven-year-old daughter in the bath. In this, now vanished, pre-digital era of photography, they

had done as almost everyone did. They took the reel of negatives to their local chemist shop, acting as agents for a developing and printing laboratory. A worker at the laboratory had spotted the photos, thought them suspicious, and alerted the police, who then waited for the photos to be collected. As child law specialist Alan Levy QC said, somewhat disapprovingly, 'If you are taking naked pictures of a seven-year-old, which seems older than usual, you are playing with fire – not because you are necessarily doing anything indecent, but because it might be construed that way' (Fowler 1995). This example demonstrates that photographs taken in one private context can create problems when they pass into a different, also private, realm. These photos were never circulated or published, and were not intended for any such use. They simply passed through a private economic exchange between customer and service supplier, and were destined only for the private context of the home. However, these are two different levels of privacy, governed by different considerations. The photos temporarily crossed the boundary between the most private of realms, as the home is regarded, into another, also private, realm where the law was able to act in the wider public interest. Privacy is a complex right, dependent on context, and when private photographs as objects move between different contexts, problems sometimes result (Frosh 2001).

Privacy is treated almost like a possession. It can be 'given away' or 'given up'; it can be taken away. Privacy is often concerned with information (hence the stress in the Human Rights Act on 'correspondence') which, once given out, cannot easily be retracted (Marx 2001). People often forget the confidential information that you have confided in them, but you can never be sure. Still less can you be sure when the information is held in some kind of archive or database. Privacy often relates to the showing or telling of aspects of someone's life of which they are ashamed, or which reveals them as having committed acts which they now regret. So there now exists in British law the 'spent conviction', which allows a person to keep secret the fact that they once committed a crime after they have served the whole of the sentence passed by the court.[2] This right to privacy about acts that once affected others does occasionally pose problems. When archives of news footage are made public, the privacy of many individuals may be breached, as old news programmes contain a remarkable amount of material about criminals whose convictions are now spent.

Privacy extends beyond the giving and getting of information about individuals. The right to privacy is normally understood as the right to do what you want, as long as it does not affect other people or the wider interest. Hence the freedom to practise freely a religion of choice exists in many societies: mainly those societies where religion no longer plays any significant role in the affairs of state. Privacy is something of a default position, a natural state of affairs unless the wider public interest is affected. This right exists because it needs to be defended. It is a right that requires 'respect'. Privacy is not merely 'observed', it is 'respected', a much stronger and more active term. To observe someone's privacy simply means to keep a distance. To respect someone's privacy implies more consideration of the other person, even to the extent of holding back from actions that might be desirable. Respecting the privacy of someone means restraining a natural curiosity, or even turning a blind eye. This respect implies discretion and a moderation of curiosity about others.

Curiosity

Humans are usually curious about each other, and consequently are aware that others are curious about them. The conventions around privacy attempt to set limits on such curiosities. We would like to control what people know about us, rather than leave it to the vagaries of whatever they are able to find out. Curiosity about the behaviour of others is a necessary attribute. It helps people to understand the conventions of mutual society: of how to behave in a way that others find acceptable, if not desirable. However, excessive curiosity is threatening. This becomes a problem with the greater mobility and anonymity of contemporary urban culture. Urban existence brings with it a vast number of daily encounters with people about whom we know little or nothing. An attitude of 'civil inattention' (Goffman 1971) becomes necessary just as a means of negotiating our individual ways through crowded streets and public transport. Urban living also brings with it a large number of more definite encounters with strangers, and these require some kind of provisional understanding about who they might be, and what they might – and might not – find acceptable in the approaches of others. So curiosity about the norms, expectations and behaviours of others becomes all the more necessary. Modern media provide the principal means of accessing this vital information. However, they do so at the potential cost of invading the privacy of those others. The role of the celebrity has developed as a pragmatic response to this problem. The price of fame (or notoriety) is generally deemed to be a consequent reduction in the right to privacy. Celebrities live in an environment where the public 'right to know' threatens to overwhelm their 'right to privacy'. The material rewards that come with celebrity are often seen as an adequate reward for this loss of personal privacy. However, individual celebrities go to law to establish limits to these rather open-ended arrangements, and they have limited success. Some countries, such as France and Norway, have enacted legislation that requires publications to seek celebrities' permission before using their images, but this does not seem to be done routinely. Instead, the personality concerned is forced to seek redress, judging from the frequent apologies in celebrity magazines.

Paparazzi photography invades privacy by its use of long lenses and long periods of stalking, that is, waiting to catch the celebrity unawares. It is an excessive practice of surveillance whose aim is not to see, but to record, and then to spread the recorded images as widely as is commercially advantageous. Paparazzi photography is a clear breach of the respect of privacy that private citizens would expect for themselves. It is a double breach, not only because it creates the nuisance of having a crowd of photographers hanging around, but principally because it aims to create photos: recorded information which is designed to be used in particular ways.

This is the key issue. The fact of recording is at the heart of concerns about surveillance cameras and privacy. Most surveillance cameras exist in spaces where individuals are already subject to the gaze of others: in the workplace, in public spaces. But photography extends this gaze into recording. Photography offers what the lens sees up to scrutiny by other people, in other places and at other times. This cuts across the layers of privacy that people maintain around themselves. The results of such

photography can put a family moment into the general public sphere, revealing the intimate behaviour of the most reserved of public figures, for instance. It can show dubious workplace behaviour to the family. It can show 'off-duty' moments in the street to workplace colleagues. Our concerns about surveillance cameras focus around these possibilities, which are inherent in photography and recording. Photography and recording can cut across our personal distinctions between our various public and private domains. Surveillance cameras are currently the particular focus for these fears because they are so far beyond our control. They are unavoidable in public spaces, even if we know they are there. We have no right to refuse permission for our image to be recorded. They are always on, intensifying anxieties about being caught unawares. And we have no idea what use will be made of their footage, so we have no idea whether our privacy will be respected.

Usage

Photos are not very good at holding their meaning. They require explanation, identification and relocation into an explanatory format of some kind. Surveillance footage carries no indication of who the subjects of the images might be, unlike paparazzi images, where the identity of the subjects is the key factor. Surveillance footage is useful only in a few instances when it captures images of an exceptional event such as a crime, or of a particular individual who can subsequently be identified (a celebrity, someone on their way to commit a crime, an employee not doing their job, etc.). In many cases, surveillance footage is never even viewed by any human being, and is destroyed after a period of a few weeks. Surveillance footage is not really meaningful until it is put to use in some kind of explanatory framework that makes sense of the footage, by identifying either the actions or people within the frame. The footage requires a context that will reconstruct its meaning retrospectively. In effect, surveillance footage is the clearest example of a general characteristic of recordings. All recordings gain their meaning retrospectively, when they are edited into some kind of text and presented in a defined context. Even a simple family photograph receives this treatment when it is included in the family collection (which is often little more than a disorganised heap), and is looked at or shown in the context of other such photos. Tourists who happened to point their cameras at the New York World Trade Center's twin towers on 11 September 2001 had no idea that their footage would become iconic news images; neither did Abraham Zapruder, when he filmed President Kennedy's cavalcade in Dallas on 22 November 1962. Both were recordings begun for a specific private purpose, but they have since gained quite another meaning, and have been used ever since in very different public contexts (Bruzzi 2006: 15–46). Surveillance footage is a clear example of this process of retrospective attribution of meaning because it is created with the most general of intentions in mind (compared with material shot for a planned documentary project), and carries very few indicators of its subject matter beyond 'it happened in front of this camera'. So it is exceptionally meaningless footage – until it is used.

The meaninglessness of surveillance footage is only apparent. Like all factual footage, it could be used for a bewildering variety of uses. With a sneering commentary on a lifestyle channel, it can demonstrate fashion victims and fashion disasters, or perhaps repellent personal habits. It can provide anthropological social scientists with key data about group interaction, or the police with information about personal associations of particular individuals. It can be edited into an elegant short documentary showing the minute variations in the regular daily journeys of selected individuals, all set to a tasteful score and exhibited at film festivals around the world. All of these uses can be made of the footage without the express permission of the individuals involved, so long they are not easily identifiable from close shots. Nonetheless, most people would readily identify themselves if they came across their image used in these ways.

Usage attributes meaning to, or extracts meaning from, recordings. Footage and images belong to those who created them, rather than those who are the subject of them. So the modern citizen has virtually no control over the use of recordings in which they feature. The right to privacy allows some control of more specific images and recordings,[3] but this control is usually signed away in giving permission for those recordings to be used as part of the film or programme in which they are designed to appear. The digitisation of the audiovisual has changed this. The re-use of footage has become much easier thanks to new technologies of image search, image retrieval, image transfer and duplication. This understandably provokes anxiety, as footage can be used for purposes very different from the original intention to which those filmed may have readily agreed. Surveillance footage does not involve any consent from the filmed subjects, nor does it have any clearly stated purpose, hence it is a particular focus of anxieties about the use and re-use of footage.

All photos and recordings are documents that can circulate well beyond our effective control, so they threaten to cross the boundaries between our zones of privacy, producing embarrassment and even long-term damage to our reputations. They can be used in ways not envisaged by their original creators. Surveillance is the particular focus for this series of anxieties about photography and recording, as it catches us unawares. Surveillance implies a particular kind of looking, usually called voyeurism – looking without permission. However, just as our anxieties about being photographed and recorded go beyond ideas of surveillance, so the activity of looking at photos goes well beyond the act of voyeurism.

12

WITNESS AND WATCHING

The activity of watching moving image material can involve as many uncomfortable and ambivalent feelings as that of being filmed or photographed. The word 'voyeuristic' is often used to summarise these feelings of discomfort. However, the reality of the process of watching footage, particularly non-fiction footage, is altogether more difficult to describe than the term 'voyeurism' will allow. As it is commonly used, voyeurism implies watching without the explicit consent of the watched other, as in the activity of a peeping tom.[1] In fact, there is an implied permission in the circulation of images and recordings in public and within films and television programmes. These recordings have been used, so someone, somewhere, has decided that they can be looked at. They are organised into texts, and the eventual viewers are addressed by them, and by the attempts at communication contained within them. The decision to bring these recordings to viewers may not have been made by the people shown within the recordings, but there is some kind of permission to watch implicit in their availability. So why is the term voyeurism used in connection with certain kinds of documentary activity? It is often the expression of wider anxieties caused by the footage itself, rather than the act of watching. It is the result of feelings stirred up by the difficult nature of what is being shown, and how it offends our feelings of appropriateness.

The act of watching is complex when the material concerned, both visual and audio, reproduces other times and other places as though they were in some way present. Instead of the term voyeurism, many critics have begun to use the idea of 'witness' (Ellis 2000a; Guerin and Hallas 2007; Frosh 2009; Peters 2009). Modern media place their viewers in the position of the witness, as the persons to whom testimony is directed. It is therefore important to understand this seemingly new and complex form of witnessing that broadcast media have brought about. It is by no means clear what is expected of the millions who view news events or witness

authentic emotions nightly through the relatively new devices of broadcast sound and vision: radio, TV and the internet. Nor is it clear what they expect of themselves.

The particularities of moving image media produce for the viewer a different kind of position from that of an actual eye-witness or bystander at an event. It may be an extension of the natural seeing that such an eye-witness may have, but it is distanced in time and space as the price of extending its scope. Moving image witnessing is also different from the 'second-hand' witnessing of a jury member in a trial, the person who, in Peters' words, 'witnesses a witness bearing witness' (Peters 2009: 25). The viewer of a TV news bulletin or documentary, or of factual footage streamed over the internet, sees in a way that provides an impression of directness and objectivity that differs from the spoken or written account, however vivid or honest, of an eye-witness observer. This is not to argue for the superior 'realism' of the moving image over other forms of depiction. The viewers of audiovisual material do not see and hear for themselves. Instead, they are the people to whom a particularly complex form of testimony is directed. The moral weight of such media witnessing is different. To hear the account of an individual implies a powerful interpersonal relationship: one of both belief and sympathy. Such is the power of the witness provided by Holocaust survivors speaking their accounts to the generations of the future, an activity that is becoming rarer as the years go by, as ageing takes its toll. There is, equally, a direct interpersonal relationship between the formal witness in court proceedings and those who witness them bearing witness. Judges and juries must assess for themselves the veracity of the person giving an account. This depends on interpersonal techniques of judgement, of truth and trust. Many TV courtroom dramas are concerned with the problems of how to seem to tell the truth, of the problems of performing truthfulness in this most treacherous of theatrical spaces (Clover 2000).

Witness carried by, and provided by, the audiovisual is not the same. It is altogether more complex. The moving image does not provide the same direct interpersonal relationship by which the truthfulness of a testimony may be judged; neither does it place the viewer in the position of being the bystander or the direct eye-witness of events. No-one was ever summoned to court to bear witness to events that they witnessed through TV footage. When necessary, the footage itself is called in as evidence. Nonetheless, media witnessing does allow us to see and hear something of the events that took place before the lenses and microphones. Media witnessing may involve certain elements of both the direct interpersonal hearing of an account and the direct seeing of the bystander, but it is not identical with either. Crucially, media witnessing also involves an additional element.

Everyday media witnessing offers the possibility of seeing and hearing directly something of the events. It is possible, sometimes, to see and hear the shells landing, the moment when the interviewee cracks or the interviewer loses patience, when the contestant decides, or the comedian retorts with the perfect comeback. Often, we see moments of elation, disappointment or shame. If footage of such moments is unavailable, then at the very least we see the spaces in which the alleged action took place and the aftermath of these actions. Here is the blood on the tarmac, there are the severed limbs, the wounded being tended. Here is the family trying to come to

terms with the row they have had. Here is the politician reflecting on their mistakes. TV and broadcast images provide viewers with the possibility of seeing almost directly an aspect of the action; there is the possibility of seeing the circumstances, of getting the lowdown. However, this is demonstrably not the same as being on the scene, as being an eye-witness. Seeing through the camera or hearing through microphones is always a position of analysis, of trying to understand a representation rather than experiencing a person or events in front of you. Different reactions on the part of the viewer are appropriate. Importantly, though, action is not possible. It is impossible to offer help, or to console with a hug.

However, this position of distanced observation opens up the possibility of a second element of witnessing, an assessment unencumbered by the feeling that an appropriate form of action is required (the necessary problem for any bystander or participant). Alongside the possibility of observation of fragments of an event, media witness also implies the possibility of judgement. The portrayed events always already attest to something. The portrayal acts as a witness whose truthfulness should be assessed from the position of the viewer of the screen on which they appear. Modern viewers characteristically 'take things with a pinch of salt', viewing with a degree of scepticism or incredulity. The viewer sees events, but knows that the cameras and microphones are placed somewhere by individuals, and that these machines have a necessarily circumscribed view. The viewer can see the interviewees, but knows that the circumstances of the interview are less clear. Many of the elements of being in a shared place are necessarily absent. A juror assessing an uncomfortable witness knows that the room is too hot, or feels unexpectedly sympathetic because they, too, feel discomfort through hunger and the anticipation of lunchtime. The TV viewer does not have any access to such sensory information and its consequences.

So the audiovisual consists of a not quite direct, not quite interpersonal set of relations. In addition, there exists yet a third element to the broadcast audiovisual – the complexly discursive nature of any audiovisual representation. The viewer does not witness the account of one person, or a series of discrete personal accounts, as does the juror. The viewer witnesses an account drawn together from many sources. A news item, or a documentary, or a piece of reality TV is always a complex account when it arrives with the viewer, a complex account constructed by groups of people who work within organisations specifically devoted to this task, organisations devoted to the construction of such accounts within both discursive rules and a particular constrained relationship of interests and powers. The account that they produce is, as Dayan insists, an enounced account. It is a 'monstrance', to use Dayan's term, a particular organised deployment of sounds and images forming an account that is the product and responsibility of both individuals and the organisation for which they work (Dayan 2009). Here, the viewer is not addressed directly by those eye-witnesses who are interviewed on screen. As we have seen in chapter 6, interviewees have a dual address: first to the interviewers and cameras before them, then to their eventual viewers. Nor are viewers direct witnesses to the events that seem to be unfolding before the camera. The viewer is also addressed by the broadcasting organisation, by the BBC, or CNN, or Fox News. Thus viewers also relate to the attempts at

communication that are made by that organisation, as they simultaneously take part in a witnessing relationship to the events and testimonies that are displayed through that communication. As Goffman noticed almost thirty years ago:

> viewers [of TV news], then, can feel that they are rather directly witness to the major events of their day, separated only by space and a very brief time. But it can be argued that viewers are not so much involved in current events as they are in a special type of entertainment, the raw materials for which are provided by the recorded sight and sounds of happenings. [...] The issue is that the recordings themselves are put together in accordance with the constraints and aims of show manufacture.
>
> *(Goffman 1986: 452)*

As Dayan demonstrates, in a world of multiplying images it is not enough that a sequence has been recorded. If it is to acquire meaning and significance, it must be enounced by an agent, and incorporated in a text addressed to a viewer (Dayan 2009). The recording has to be made to make sense, to become relevant or meaningful. This is precisely the task of discursive structures: to take a recording and make of it an attempt at communication. Discursive structures grant a channel and a structure to a recording, an intentionality that it did not necessarily possess as an inert piece of footage. The filmed footage is endowed with a communicative intent through its inclusion (or ingestion) by the communicating apparatus of the broadcasting organisation. It is included in a communicative attempt by that organisation; importantly, this attempt might be greeted with a degree or two of scepticism, or even indifference, by the viewers to whom it has been addressed. Such is the third aspect of audiovisual witness: the organisation of aspects of direct witnessing and testimony witnessing into a further activity of enunciation, of attempted communication.

The media accounts that we witness are always already processed. Even in the case of a live news event such as 9/11, events are quickly brought into narrative order through a continual process of 'recapping' for joining viewers. As Paddy Scannell has shown, this constant structuring was able, by the end of 11 September 2001, to bring the incomprehensible events into a narrative order that has proved relatively durable.

> At first it was utterly incomprehensible but, by the end of the day, the situation had been accurately analyzed and correctly understood. Immediate action had been taken and future courses of action predicted and assessed.
>
> *(Scannell 2004: 573)*

Thus media witnessing is not that of encountering the brute fact, the feeling of participation, or the actual experience. It is witnessing from a privileged position; documentary gives us a discursive construction of a totality of an event. We know that a certain event has taken place, but not what it was like to be a part of it. As a result, we have interviews that try to obtain vivid individual testimony, the story that will provide the means of person-to-person empathy. Media witnessing offers its viewers a

form of multiple seeing, constructed from different points of view and engagements with the events. Nevertheless, the contemporary media user is also painfully aware that this complex seeing is equally a partial seeing, constructed from fragments of larger testimonies and segments of longer shots and sequences. We are addressed by the texts that we witness: they are made for us by agencies which have their communicative intents. Any audiovisual text comes with a dense set of expectations and promises. And any audiovisual text equally, through its mobility of vision, will provide the witnessing individual with multiple instances of address, of attempted communication.

Communicative attempts

A well known interview clearly demonstrates the levels of communicative attempt that can be experienced by the witnessing viewer. When Martin Bashir interviewed Diana, Princess of Wales (*Panorama*, BBC1, 20 November 1995), the aim of many of the parties involved was probably to provoke empathy with the evident distress of the Princess. But any interview involves a further series of communicative acts, which complicate this empathy. The Princess herself has reasons for giving the interview (or submitting to it: both terms, significantly, are in common use). Even as we empathise, we are aware of the calculation behind her statements. Bashir adds another layer of intentionality. This is an exchange, rather than the Princess 'just talking'. It has its own rules, one of which is the interviewer's search for some kind of truth. The institution of the BBC, broadcasting the interview, brings its own reputation into play as a series of implied, framing statements. The placing of the interview within the BBC and its flagship documentary news programme *Panorama* means that this exchange is both important and trustworthy. In addition, this being the medium of broadcasting, we are aware that this whole textual assemblage is not addressed to us specifically but, as Paddy Scannell puts it so felicitously, to 'anyone as someone' (Scannell 2000). So we are aware of the general address of what we are seeing, and can be curious, and perhaps even concerned, about the reactions of others. A sense of what others might say or do also bears down on such exchanges. This being the case, what are we meant to feel?

We witness through a series of communicative attempts. Diana, Bashir, *Panorama*, the BBC, and virtual others within the exchange are all involved in a process through which they attempt to communicate. Just because Diana says something, it does not mean that she succeeds at any level in either communicating facts, or conveying a perspective, or generating an empathic response. The same goes for every single one of the participants, real or virtual. Through the audiovisual, we witness attempts at communication rather than experience communication. Communicative attempts are never

transparent. They come from someone and somewhere. They encounter witnesses who are also located in other spaces and times. So their reception is uncertain, equivocal and not univocal. Aspects of these communicative attempts may work, others may not. This will tend to be different even at an individual level, although generalisations can be made.

Here, conflicting and intermingling feelings are provoked. Direct empathic emotions are felt in response to the Princess, with her heavily mascara'd eyes, her awkward posture and hesitant speech. These feelings tend to be intensified by the nature of the dialogue with Bashir, his gentle questioning within an ambiguous *mise-en-scène* that is both domestic and official. Our intellectual empathy partially conflicts with these emotions. That same unusually heavy mascara may lead us to suspect the Princess's motives as being more calculating, and less a direct expression of her distress. But, above all, intellectual empathy is an empathy with the virtual others in this exchange. These include the people whom the interlocutors (the Princess and Bashir) are discussing. What will they feel about what she is saying about her crowded marriage with Prince Charles, and how will they react? What will be the reactions of those many, nameless yet somehow known, others who are presumed to be watching at the same time? These conjoined empathies set up something of a conflict, but a productive conflict. This conflict is essentially one of emotional ambiguity, of knowing what you feel, yet at the same time not knowing quite how to feel. This emotional ambiguity is underpinned by the constitutive ambiguity of the audiovisual, its status as thereness yet textuality. This emotional ambiguity is of course resolved, but outside the text. We think about it, talk about it, come to a conclusion of some kind, or dismiss the whole thing as a passing show of no great consequence. The extratextual resolves the ambiguity of the textual, as empirical researchers are beginning to understand by looking at conversations with and around television material that take place as programmes unroll, as well as after watching. This emotional ambiguity is also the production, within the text itself, of the 'proper distance' called for by Roger Silverstone (2007).

Structures of expectation attach to any factual footage that we encounter, however short in duration or trivial in content. Just as a feature film or a news bulletin, a modest clip on YouTube brings with it a weight of contextual expectations. We are addressed by the texts that we witness: they are made for us by agencies that have their communicative intents. We come to them, voluntarily, expecting to receive, notwithstanding all the intellectual reservations that we might have about the word, some kind of communication. Any audiovisual text equally, through its mobility of vision, will provide the witnessing individual with multiple instances of address, of instances of attempted communication.

The forms used to construct audiovisual texts are familiar enough to viewers. The forms have levels of discourse and classes of speech. In a reality show, distinctions are

routinely made between the voice of the commentary and the voices of participants. In the current fashion, the commentary tends to be ironic and the utterances of participants are seemingly sincere (but may well not be). The viewer's judgement is guided both by the commentary and by their own observations of body language, tone of voice, and so on. In the different genres of factual footage, images and sounds are combined and different people speak according to rules that are well defined and communally accepted (or at least tolerated). Although these genres are constructed discourses with rules, narratives and storytelling, they are distinct from the forms and discourses of fiction. Those who are acting are acting in a defined set of roles (commentary, reporter, correspondent, interviewer, etc.) under the requirements of being plausibly true, rather than emotionally convincing. Those who present a performance are performing aspects of themselves and preserving and violating their personal privacy in ways that have become familiar, at least since Erving Goffman recognised the practice of dividing behaviour into the front-stage and the back-stage (Goffman 1959). Hence these complex discursive constructions of witness are recognised as distinct from fiction, and are perceived as constructions in which questions of accuracy, completeness, truthfulness and trust are centrally relevant. Yet they remain 'stories', things told to us.

Empathy

Media witnessing allows us to see something of events, but we are neither eye-witnesses nor the direct recipients of live testimony. We witness through complex forms of seeing that are organised for us as attempted communication by the various parties concerned. As media witnesses, we are distanced, and therefore placed in a position of analysing what we see and hear, hence judging what we see and hear. Yet we do not simply judge, we also feel. We still feel the imprint of reality in some of the footage that is presented to us. Distanced feeling is crucial to the operation of media witnessing. Without it, few – if any – would bother to watch.

It is important to remember this because it prevents an overly pessimistic view of modern audiovisual media. Roger Silverstone's important last book tends to examine the text as text, rather than as an alliance of 'thereness' and textuality that gives rise to a complexity of reactions. He is therefore forced into the uncharacteristically pessimistic view that 'proper distance' is not currently achieved in broadcasting (Silverstone 2007). Instead he finds 'a kind of polarisation in the determinations of distance'. He goes on:

> On the one hand we find ourselves being positioned by media representations as so removed from the lives and worlds of other people that they seem beyond the pale, beyond reach of care or compassion and certainly beyond reach of any meaningful or productive action. [...] Per contra the representation, just as frequent and just as familiar, of the other as being just like us, as recoupable without disturbance in our own world and values has, though

perhaps more benignly, the same consequence. We refuse to recognise not only that others are not like us, but that they cannot be made to be like us.

[...] Such cultural neo-imperialism represents the other side of the immorality of distance, in its refusal to accept difference, in its resistance to recognising and to valuing the stranger.

(Silverstone 2007: 172–73)

Both the responses identified by Silverstone may well be felt by those witnessing these media representations. But they will be felt as a stage in a larger process of negotiating empathic responses and working through the many forms of address that compose a contemporary audiovisual text. Both responses imply an exaggeratedly high degree of emotional selectivity when witnessing events through an audiovisual text. There is literally a world of difference between recognising individuals as 'just like us' rather than just 'like us'. To witness distant individuals and to recognise them as persons is inevitably to see them as 'like us'. Yet this recognition involves both sameness and distance, the imaginative attempt to feel what they are feeling and the simultaneous knowledge that they are them and we are us. The position from which we witness is a mobile one, involving twists and turns of emotional empathy rather than one fixed position of identification or rejection. We see not only those whom we might construe as 'just like us', but others as well, in the same scene or in the next shot; others who may be more or less sympathetic, more or less authoritative, more or less persuasive, more or less in accordance with one or more of our fantasy selves. The textual construction of witness offers differing points of view, positioning us at once with the individuals whom we witness, the concrete others who are also interviewed or seen in the same reports or documentaries, and with the virtual others (both people and institutions) who are also involved in the exchange.

In many discussions of the concept of witness, the consideration of the feelings provoked by the activity is effectively collapsed into a narrow range: witness implies witness of suffering. The discussion is then drawn into the terrain of Hannah Arendt's distinction between compassion and pity, and Luc Boltanski's consideration of the nature of distant suffering. The distant yet compelling witness of suffering that has been enabled by the audiovisual is certainly one of the more pressing concerns of our time. Everyone has their own private list of horrors from the past few years witnessed on television, whether they be traffic accidents or 9/11, mass famine or attempted genocide, images of torture or of inconsolable grief. Reflections on these events have produced some of the most powerful of recent documentaries. The events of 11 September 2001 alone have produced films as diverse as the Naudet brothers' *9/11* (2002), Michael Moore's *Fahrenheit 9/11* (2004), *9/11 The Falling Man* (Singer, 2006), and Guttentag and Port's *Twin Towers* (2003), among others. Yet the feelings that these encounters have provoked – and, for many, continue to provoke – receive an uncertain reply from much audiovisual theory. There are many good reasons why this is so. Many theorists are reluctant to endorse a desire to protect children that seems to slide into calls for censorship; the criticism that suffering is cheapened by its audiovisual transmission to remote people and places seems to deny both the power

of the media and the sincerity of the feelings which are sometimes (but not always) provoked. Nevertheless, audiovisual theory has to address these issues directly.

The witness of distant suffering is not qualitatively different from a more general form of witness that underpins the audiovisual. It shocks and appals; we would rather not look at the images or listen to the accounts. But it is not different in status from witnessing more mundane or less disturbing events. Indeed, the witness of distant suffering depends for its efficacy on what we witness in much more mundane audiovisual encounters. Everyday mundane witness underpins the exceptional moments of audiovisual shock: the first encounter with images from Abu Ghraib, footage of starvation in Africa, or of police brutality closer to home. There exists a continuum of reaction to a mundane sofa interview on a light topic on breakfast television, and reaction to suddenly coming upon footage of a massacre. The third phase of documentary is characterised by sceptical viewers who will, in each case, interrogate footage in almost the same instant as it is felt. Its textual nature is probed for the proof of its authenticity and for explanations (or at least context) for the witnessed events that evoke emotions. Annette Hill's research on audience responses at the turn of the millennium has shown how sophisticated, even forensic, ordinary viewers now are (Hill 2005, 2007). Helen Wood's work has examined the dialogic interplay that viewers have with daytime talk shows (Wood 2009). Both these pioneering pieces of empirical research tend to support the thesis that televisual witness involves a complex to-and-fro between seeing, believing and feeling among today's active viewers. The compassion and pity experienced, most of the time, on witnessing traumatic footage should therefore be considered as subsets of a more general emotional process: the process of empathy.

Empathy is a relatively new word, entering the language at the beginning of the twentieth century. It seeks to designate the ability to experience the emotions of others as one's own, of feeling as an other does. As a term, it seems to be used in ways that assume that a 'proper distance' is maintained, that feeling as an other does is not to imply some merging with that other. The self is maintained even as the other is experienced. In Martin Hoffman's definition, empathy is 'an affective response more appropriate to another's situation than one's own' (Hoffman 2000: 4). The term emerged in experimental psychology and aesthetics more or less simultaneously (Keen 2007). It has proved to be particularly valuable as a description of the psychotherapeutic process; yet it has, by its very usefulness, become somewhat diffuse in meaning. A recent review of the literature in the field, while seeking to discern empirical tests of the process in the therapeutic setting, usefully proposes 'that researchers use intellectual empathy to refer to the cognitive process and empathic emotions to refer to the affective aspect of empathic experience' (Duan and Hill 1996). This implies that empathy be seen both as an immediate 'involuntary' response and as a process that involves reflection or a considered projection of self into the place of another. Empathy is therefore potentially a process with several stages, particularly in the sustained process of psychotherapy. Empathy involves 'response with the object (matching responses as with distress to distress or joy to joy), and response to the object (instrumental responses as with consolation to distress or fear to anger)'

(Preston and de Waal 2002: 1). Stephanie Preston and Frans de Waal go so far as to propose a concept of empathy in which 'individuals of many species are distressed by the distress of a conspecific and will act to terminate the object's distress, even incurring risk to themselves' (Preston and de Waal 2002: 1). They propose this non-human-specific concept on the basis of reports of some disturbing experiments on rhesus monkeys and rats. Feelings of empathy might lead one to wish that these had not been undertaken.

Empathy designates the process by which emotions are experienced as the result of an encounter with an other, whether immediate or through the distanced audiovisual process of witness. The emotions are provoked by the perceived experience and the perceived feelings of the other. It therefore implies that the other must be recognised as having a similar (if not identical) status to that which witnesses attribute to themselves. Witnesses have to recognise the other as being like themselves if they are to experience empathic emotions. Hence there is no real empathy with the many incidental victims of an action movie. The genre has an implicit assumption that there are three classes of individuals: characters who are, or seem to be, good; characters who are evil; and the hapless drones who carry out the intents of the evil characters. These drones are attributed no personhood. They exist in relation to plot and to the gleeful celebration of destruction that is the particular pleasure of the genre. When the personhood of the other is recognised by the person who witnesses, then empathy follows. This empathy can be intellectual or emotional, or a combination of the two. Personhood is socially attributed: the long struggle to recognise slaves as full persons being a case in point. Empathy requires that the witness acknowledge the status of the other as a person. Arguably, the rapid development of the audiovisual has contributed, through its ability to present the distant as a simulation of presence, to a wider acceptance of the personhood of remote and different others. It has enabled a recognition of common personhood across the many evident differences in the human race. Equally, it has enabled a rejection of that communality based on the outer appearance of an other (their racial characteristics or dress) even before they open their mouth.

Media witness involves an awareness that does not require action. However, it does call on both empathy and analysis. It is constructed by known organisations into stories that are nevertheless factual and evidential. It enables us to be witnesses not so much to events as to our own times. We share in the unfolding of a complex and largely arbitrary world which we struggle to comprehend. In this process, we feel something of the emotion of others, and have a sense that we are engaged in a difficult process of understanding that is shared by others. We are aware that we both know and do not know. Such awareness is a new phenomenon, born of mass news, but sealed in the complicated constructs of the audiovisual. This awareness frames personal action, constraining it and socialising it, and inducing degrees of anxiety or asociality, depending on the degree to which it is accepted or ignored. Such framing of personal action is not simply of the kind that guides self-interested decisions in the way that an awareness of stock market rumours might guide decisions to buy or sell. It is rather an awareness of ourselves as historical actors, sharing our present with that

of many others. The complex seeing, hearing and narration that it involves provides us, through showing the ideas and actions of others played out over time, an awareness of ourselves within history and as part of specific histories. Media witness therefore gives us a responsibility to know about the actions of others almost as a precondition of knowledge about ourselves. As a result, we carry a sense of responsibility towards what we see on TV. This responsibility towards events is not that of the witness called to attest. Yet it has significant features in common with the position of a witness in court. Media witness also carries the sense that seeing brings with it a set of social implications and an emotional commitment. Although it is less than a century old, it has become one of the defining features of contemporary civilisation. The experience of audiovisual witness is usually as close as we need to get to events, and even then it has a capacity to make us feel uncomfortable and even, on rare occasions, to shock and traumatise. However, as a process, media witnessing is far from being an activity of voyeurism.

Witness and the sceptical viewer

Audiovisual witnessing extends across all genres of factual representations, from news to chat, from current affairs to lifestyle, from audioblog monologue to reality TV. Its forms have become more complex and self-assured as audiovisual technologies have become more common in the past century and more. With TV in the 1950s came a new emphasis on the close-up shot (Jacobs 2000: 121–39; Delavaud 2005: 163–70; Newcomb n.d.: 2467) and ordinary speech, allowing documentary to develop a rich second phase of observation. TV allows us to witness a vast repertoire of communicative attempts and to become aware of their particular styles. The role of the impressionist has grown with this increasing awareness of communicative styling. It is no longer enough to capture the voice of a famous figure, whether politician or TV personality; contemporary impressionists such as Rory Bremner imitate their entire styles of speech, their typical vocabularies and turns of phrase, their hesitations and speech patterns, their rhetorics and their blindnesses. A further development of this tendency is fictional: the creation of behind-the-scenes series such as *The West Wing* or *The Thick of It*, which claim to present the forms of communication that take place beyond public pronouncements, in the backstage of politics.

Through TV, we witness communicative attempts rather than successful communication. In Peters' view, this emphasises the isolation of the individual (Peters 2000); in Scannell's more optimistic view, this emphasises the constant everyday negotiations that constitute social life (Scannell 2007). This awareness is an ingredient in the media literacy that is part of the equipment of the modern citizen. It extends to the media's own speech: the attempted communications that we experience across the genres of factual TV. As a component of media witnessing, we are aware that individuals within institutions attempt to communicate a particular gathering and structuring of disparate material that is, for want of a more accurate term, 'drawn from reality'. The eventual viewers of documentaries are aware of the complexity of this process, and examine what they see using a wide range of ideas about the ethics of documentary,

about how documentaries are made, and about the moral purpose of the genre as a whole. These ideas are sophisticated and subtle, as chapter 13 demonstrates. However, it is also clear that the sheer complexity of the different attempts at communication found within any one documentary can lead to radically different perceptions of a film and what it is trying to achieve. Differences of opinion often resolve themselves into difference of reading.

13

ETHICS, INTERPRETATION AND THE NEW VIEWER

Using data derived from students has fallen out of fashion, for good reasons. However, I make no apology for doing so here. In this chapter I quote from comments posted in an online forum over three years by successive groups of second-year undergraduate students. They were asked to post their immediate reactions to a specific documentary after the screening and before the following week's seminar discussion. I have used these comments as a guide to the kinds of practical ethical beliefs that are brought to bear in discussion of documentary. I believe they are more reliable than the comments posted in public online forums, simply because postings in online forums are anonymous and these class postings were always signed. So there was no covert direction of the conversations by those associated with the filmmakers (a characteristic of public online debates about feature films), and the participants were all known to each other. This gave the exchanges a different quality, and my moderation was confined to requiring expression in a more or less academic style. The comments revealed much that I did not know, from aspects of the films that I had not noticed, to the changing use of the word 'manipulate' from a pejorative term to a useful neutral term for the textual process itself. So if any of my students read this book, please accept my thanks for your input, which neither you nor I will be able to identify as all quotes have been anonymised.

Anonymity is justified here because the quotations are from a well defined group. All are students studying TV and film practice and theory at a London university. They are almost exclusively nineteen to twenty-one-year olds, with a slight predominance of women over men, so are homogenous in age, and are 'digital natives'. They are diverse in cultural background, with around 30 per cent having English as their second language. The quotations come from a four-year period during which their general patterns of media consumption changed markedly. At the beginning of the period (2007), most watched TV programmes on a TV; but by the end (2010), most were watching streamed or downloaded TV material on laptops and other

devices. The numbers of students ranged between thirty and fifty each year, and during this time there was never unanimous agreement about any film. However, over the period, the general ideas and preoccupations exhibited in relation to the films and to documentary as a genre remained consistent. Individuals brought different emphases and came to markedly different judgements; what concerns me here is the basis of those judgements, rather than their conclusions.

A number of ethical concerns run through all the considerations of the films. They relate to the social purpose of documentaries as information or instruction, and the judgement of the resulting attempts to be truthful. They show a vivid perception of the dangers (and the need) for the exploitation of individuals by filmers in making documentaries. This is balanced by an appreciation of the status of performance, on the part of both subjects and filmmakers. They are aware of, and are occasionally uncomfortable about, the need for judgement on the part of the viewer. Many of these concerns are expressed in ways that, in earlier phases of the development of documentary, were almost exclusively expressed by filmmakers and other professionals, including critics.

The purpose of documentary

The comments reveal a commonly held belief that documentaries have a clear social and ethical purpose. Typically, this is seen as justifying a degree of exploitation of documentary subjects, as one viewer argues regarding *MacIntyre Undercover – Chelsea Headhunters* (1999):

> 'Given the importance of the subject and society's interest in advancing knowledge and understanding; the level of exploitation is justified.'

A common attitude is to find a justification for even undercover filming in the ideas of social purpose:

> 'Overall I feel that undercover filming can be justified to an extent, although I understand it is an invasion of privacy in certain situations. I think it can be justified if it will uncover something that will be beneficial to the greater good.'

A significant minority, however, think that the 'greater good' does not outweigh considerations of privacy, even in the case of criminal activity:

> 'I don't think that undercover filmmaking is ever justifiable, not when it will be shown to the public. I can understand why it can be useful and can provide the public with an insight into a world that wouldn't be able to be accessed if permission for filming was needed. However, I think that in the cases like *MacIntyre Undercover*, where we focus on individuals, undercover filming isn't justifiable. I think that if the hooligans who were singled out had had their

identities hidden, that this would have been more justifiable. No matter who you are, whether you are a criminal or not, it isn't right that you are followed around without your knowledge, and then have it shown on television.'

A student from China agreed that this particular programme was an invasion of privacy. The activities of football hooligans did not, for him, justify that invasion of privacy. However, drawing on an obvious knowledge of contemporary documentary practice in China, he states:

> 'The cutting edge of undercover filmmaking should be used more seriously and effectively. In the situation of concealed monopolization, children abuse, violation of human rights of mineworkers in blockaded areas, hidden food security problems in some food corporations, undercover filmmaking will serve its best purpose and be more justifiable.'

There is a general belief that documentary activity can rely on a sense of its social purpose to show things 'for the greater good'. But definitions of the nature and limits of that greater good differ, and are sometimes hotly debated.

This attitude may reflect the students' choice to study documentary in the first place. Nevertheless, every year some of the films shown on this course are extensively criticised or even rejected by those who believe in documentary's social purpose. Broomfield's approach seems to cause particular difficulties. Two reactions to *Heidi Fleiss: Hollywood Madam* (1995) give a sense of this difficulty:

> 'Broomfield brought us into the lives of these strange people, but he didn't really seem to try to make any overarching argument or impose a moral with what we were seeing. I thought it was very easy to understand as a simple entertainment piece, but I would be confused if someone tried to tell me it was more than that.'
>
> 'Nothing was resolved for me, but at the same time, I didn't ask any questions – because it just wasn't thought provoking. [It was] not effective at all and I wouldn't recommend it because it doesn't seem to make any kind of social commentary, which is what I feel a documentary should do.'

For these two viewers, Broomfield's film frustrated the moral purpose of documentary: to provoke thought by providing both information and a moral or social commentary. This vision is often explicitly opposed to an idea of entertainment: 'It is hard to analyse if this film was made more for entertainment or as a serious informative piece.' This juxtaposition is taken further by many comments on Broomfield's film on the South African racist leader Eugène Terre'Blanche, *The Leader, His Driver and the Driver's Wife*. A typical comment is 'Broomfield's techniques however are not efficient in creating a deeper portrayal of any subject.' The term 'deeper' recurs in many comments. Documentary is concerned with 'insight', and is, in the words of one, 'an in-depth version of the news and journalism, an exposure of a particular

subject that will have benefits to the viewing audience'. This is a classic definition of documentary, combining the ideas of showing something unknown or concealed with a particular purpose: the 'benefit' of the audience. This benefit is often defined as provoking thought rather than action. The deeper portrayal that many viewers sought from Broomfield's film would serve this purpose:

> 'I think his technique is for entertainment purposes more than to get a deeper portrayal of his subject, this is because when given the chance to get a personal interview he wastes it on silly questions and getting Terreblanche more angry.'

This commentator concludes that Broomfield's approach 'lead[s] me to think that the idea of getting an interview was more exciting for Nick than the actual interview'. This is a frequent comment from those who are nonplussed by the persona that Broomfield adopts in his documentaries: the slightly stupid but argumentative sound recordist. Some are clearly taken in by this behaviour, just as some of Broomfield's subjects have been, even though they acknowledge, unwittingly, that the technique is effective:

> 'Broomfield's techniques however are not efficient in creating a deeper portrayal of any subject. Rather such tactics (of following until being told, often rudely, to leave) result in entertaining but ultimately very difficult and very short encounters with individuals that often ultimately reveal nothing, but the insecurity and paranoia of the AWB organisation itself.'

Many others disagree, and assert that Broomfield's technique is explicit and finely calculated to achieve the classic documentarist aim of enlightenment:

> 'When he entices the leader, it has been said [in other comments] to be entertaining. However I think that it is a very serious matter. To annoy one of such power could result in terrible consequences and Broomfield accepts this. He will push things as far as they must go in order to attain a reaction or development. Therefore he sees a deeper portrayal of the leader and how he reacts in situations, therefore a deeper portrayal of the leader as an individual and what he can do.'
>
> 'The documentary shows his endless attempts to get to know the infamous leader. Broomfield clearly fails to achieve the intimate interview he requires, and when he does it is centred on him being five minutes late. However in the process he succeeds to expose the leader's pompous elitism, utter lies and idiocy. He also shows how unfair[ly] the leader's choice of lifestyle affects his little daughter who has no friends as we see her dancing on her own on the dance floor.'

This second commentator feels the need to bring in concrete evidence from elsewhere in the film to support their belief that the film is effective.

Broomfield's attempted communications are clearly misunderstood by many of these viewers. In Goffman's terms, he introduces a dissonant keying into his encounters. He deliberately presents himself as harmless and more than a little incompetent. But his underlying but unstated attempt at communication is to reach out to a viewer who will appreciate the irony in his approach:

> 'It is quite entertaining because we wouldn't expect a documentary of this topic, to have the interviewer basically mock the leader, a very respected man with a very high status. However, the fact that we see how irrational the leader of such a serious organisation is, is quite amusing.'
>
> 'In some respects Broomfield's filming technique adds to the entertainment of the filmmaking as by seeing him on the camera, we are more aware of the relationships in which he has with his subjects, it is also more interesting to see him in this position – for example, we learn that the cameraman has been hit by a bodyguard – I think this is an added effect, Broomfield's use of a different film technique.'

Broomfield's 'different technique' throws him into sharp focus in his films, which he narrates as the journeys of a naive and frustrated seeker of truth. This causes problems for many:

> 'Despite all the facts, interviews, meetings, observations in the film, it is very superficial and is basically a story about a filmmaker who got anxious while trying to make a meaningful documentary.'

Broomfield is always in danger of being taken at face value, it seems. However, even some who appreciated his use of irony and a constructed persona have expressed their doubts:

> 'Broomfield obviously couldn't get access to his chosen subject (the leader) any other way, seeing as he was an extremely difficult person to converse with in the first place. So the film seemed to revolve around Broomfield's insistent pursuit of this character – a technique that led to the leader being portrayed as an incredibly bizarre and irritating 'monster'. Therefore as viewers we may be 'entertained' by Broomfield's constant harassing of this villainous figure. However as some people have already argued – by actively placing himself into his own film, Broomfield essentially becomes the subject of his own documentary. Thus in this sense the film somewhat forgoes a deeper portrayal of the leader and the AWB.'

Clearly here, the attempted communication of the filmmaker, even when fully grasped, conflicts with the need for a deeper portrayal. Broomfield's communication is getting in the way of the communications of other parties in the film. This is

regarded both negatively ('It felt as if Nick was the "star" of his own documentary which is rather self-gratifying') and positively, as producing a genuinely dislocatory effect:

> 'On the other hand this makes it an interesting documentary but perhaps for all the wrong reasons. What do we really learn from this in the end? That the leader is a raging monster, or that Broomfield just wants the camera on him a little more. [...] In this case it could be said that the subject isn't even the AWB or the leader but Broomfield himself as he probes the intensity of documentary itself, and the lengths at which people go for the "truth".'

Broomfield's distinctive approach raises the purpose of documentary very clearly. The vast majority of the comments reveal a common belief that 'serious, informative' documentary takes its viewers to a deeper understanding of a situation. The situation portrayed therefore must be of some interest or importance to the individual viewer or to a wider society. The information, however, need not be explicit. Commenting on a classic observational documentary of the 1960s, *Dont Look Back* (D.A. Pennebaker, 1967), several made clear that documentaries can simply observe and leave conclusions up to the viewer:

> 'The film's purpose obviously was not to convey information, in the sense of names or dates. What the film communicates to the viewer isn't necessarily a story, but an experience; a series of moments in their present. The film provides context and information to the viewer in its own ways.'
>
> 'Arguably, observational documentary provides a more honest account, allowing audiences to observe and decide for themselves.'

In Broomfield's case, many are not able to draw their own conclusions from what they see because of the presence of the 'voice' of the director. Or, rather, they interpret the presence of the director as 'egotistical', and so getting in the way of observing what is happening in his interactions with others. Broomfield's approach is often misunderstood by these viewers, or seen as unduly intrusive, even though its effect is to provide a rather 'deeper' insight and more genuine 'information' than could have been achieved by many other approaches.

The director's voice and motives

There is a general awareness of the status of documentaries as complex statements rather than as portrayals of a truth.

> 'The filmmaker has concealed his involvement as much as possible, so the viewer does not understand that this is one man's opinion they are being invited to share [rather than] simply the true version of what happened.'

So the role of the filmmaker in this process is seen as one that organises what is presented to viewers:

> 'The viewer is able to see Dylan in a variety of contexts which the ordinary person or fan would not have access to. I think it's important to consider that despite the absence of narration, the film is part of the selective vision of Pennebaker. We see what Pennebaker sees, and what he chooses to show us, which is the product of the editing, sequencing, and structuring, decided by Pennebaker himself.'

The status of the directorial communication presents particular difficulties, as other reactions to *Dont Look Back* also demonstrate:

> 'I found the film did exactly what a documentary needs to do, which is to document. But this method of concealing the presence of the director, him not intervening or interacting with the subject made the film difficult to understand; what was its purpose? The absence of a narrator also contributed to the difficulty of understanding.'

This is common concern. Clearly, the directorial presence can be too discreet as well as too intrusive (as many found Broomfield to be):

> 'I found I reached difficulties when it came to understanding the film. The lack of information given to the footage we were seeing made it hard to interpret the context. At times I found myself confused as to the location, the people and the general situation. I appreciate that the film was attempting an honest interpretation with minimal intervention. However, I believe structure and purpose is needed for a successful documentary and, to achieve this, a certain amount of prompting or intervention is needed from the documentary filmmaker.'

The role of the voice of a director (an overall textual organisation and narrative) is generally seen as crucial in navigating the different and conflicting voices that come through in a documentary. Students differ markedly in their reactions to the presence of a directorial voice. One contrasts the absent but pervasive presence of Errol Morris in *The Thin Blue Line* (1988) with the openness of Andrew Jarecki's approach in *Capturing the Friedmans* (2003):

> 'It is clear to see that this documentary shares similarities with *Capturing the Friedmans* in terms of its subject matter and the investigative role it subjects to us as the viewer. However, I think unlike *Capturing the Friedmans* it allowed for no external thought but that of the filmmaker. Ideas were in a sense "bulldozed" our way with no real incentive to "make us think".'

These viewers show a common aversion to being told what to think rather than being able to come to their own conclusions. However, many others hold absolutely the opposite opinion of the explicit directorial style of *The Thin Blue Line*:

> 'This technique also helped in building the layers of tension throughout the film, as some shots were repetitive, but had different people's views of how it happened. It allowed a pluralist view to one story and allowed the audience to feel as if they were in the heat of the action.'
>
> 'I think this method of reconstruction without the aid of a voice-over may not always help in the understanding of what actually went on, but it does let us make our own choice and at the end it reveals the truth which is also satisfying as it provides some closure to the documentary.'

It is common to find such opposite and strongly expressed opinions of the approach of particular films. These are people at a similar stage of their lives, watching together under the relatively controlled conditions of a class screening. Nonetheless, they report having very different experiences of how they were addressed by particular films.

The issue of directorial voice provides for many the focus of their doubts about the ethical nature of the documentary interaction. The director's motives have to be pure; impossibly pure by some standards. Suspicions of directorial motives are cast in terms of 'personal' or 'hidden' agendas:

> 'The filmmaker's goal must be made clear and scrutinised in order to separate the greater objective of the film from any personal agendas. This is of course not an easy line to draw especially if the footage gained turns out to be particularly damaging to an institution or person.'
>
> 'Undercover filmmaking in theory is justifiable to a certain degree when you want to find the truth. However the editing and cutting of all the film that is shot still leads to the subject being portrayed in a subjective manner or with a hidden agenda that might stretch further than the images that you are witnessing unravel on screen.'

A further concern sometimes surfaces, but in relation to the project of documentaries in general, rather than to any specific example offered on the course:

> 'If a documentary copied *The Truman Show* (1998) and applied it to real life, it would be completely unjustified since you are taking advantage of a person for a gain instead of a public need for information.'

Usually such 'gain' is seen as both financial and reputational: it is believed that directors can make both a living and a name at the expense of their subjects. Exploitation, however, is more often seen in emotional rather than financial terms. It is the focus of a keenly felt set of ethical concerns.

Exploitation

Thoughts about exploitation are particularly vividly developed around Paul Watson's *Rain in My Heart*. This is a 2006 BBC2 documentary about alcoholism, which follows four alcoholics, three of whom are involved in self-destructive drinking. The fourth, Nigel, has not drunk for several years, but is now terminally ill as a result of his past consumption. Watson's film is an impassioned plea about the real nature of alcoholism and how it intersects with the other life problems of its sufferers. Watson is also concerned to foreground some of the dilemmas he found himself in while filming. He speaks to camera on occasions to explain how difficult it was to gain access to potential subjects through the hospital system ('this is not reality TV' he says in one exasperated phone call), and his own concerns about filming. Sometimes he is driven to intervene rather than to observe; at other moments he is concerned that filming might not be helping his subjects. The film itself raises questions of exploitation, so it provides material for some very revealing comments about the issue, particularly as a significant number of the students admit to their own habits of heavy drinking.

Many acknowledge that Watson's exploration of his role gives the film a special character:

> 'Paul often went in front of the camera, you can hear his voice asking questions, and the subjects responding. Without this insight of him investigating into the lives of the subjects, the documentary would have maybe had a more exposé approach. Take Channel 4 *Dispatches* for example, they often try to expose the happenings of a certain sequence, whereas Watson empathises with the subjects. Although a clear juxtaposition is shown of that of Watson as a concerned bystander to that of Watson as filmmaker; but I feel this sense of empathy from Watson shows a fairness to the subjects, and perhaps in the case of Vanda and Mark, gave them someone to talk to, hopefully giving them an insight into what they are doing to themselves, and also Watson giving the viewer an insight, that of a warning, of an education, of an understanding of the effects of alcoholism.'
>
> '[Watson's] subjectivity and involvement served to show his humanity and how he too just wanted to understand what drives people to those situations.'

Watson's strategy clearly worked for almost all the viewers, yet the film still raised various kinds of unease about the level of exploitation of his four subjects. Many reactions express a fundamental ambivalence which recognises the position of Watson's subjects but acknowledges the need for such a film.

> 'The subjects were exploited but the exploitation was necessary to the aim of the documentary'.
>
> 'I believe that Paul Watson was absolutely exploiting his subjects in the film. Whether this is a bad thing or not is another matter. The subjects must have

been aware that in agreeing to be a part of this documentary, their representation was to be left in the hands of Watson, to be edited in a way that suited his aims and needs as a filmmaker. Watson exploits his subjects to get from them what he needs. His film may not have been as powerful[ly] truthful if he had not done so.'

Many felt that the film's aims justified this 'exploitation', but others were not so sure:

'I DO believe, however, that he crossed a line by not only filming them in a state of total despair but also to keep filming at moment where they as well could have died. I do agree with Paul's comment in the film that it was hard for him and that he was forced to be an observer that isn't allowed to intervene in order to sustain their trust. […] I find it difficult to argue this point as I do find supporting arguments from both points of view.'

This deeply felt ambivalence contrasts the idea of documentary as observation with an acute awareness, reinforced by Watson, that common humanity would force most people to abandon the role of observer in favour of that of helper, and in so doing to abandon the filmmaking process, at least for a while.

Exploitation is defined in terms of the interactions that are presumed to have taken place during the filming. Watson is unusually frank at points about this process. Nevertheless, much of the ambivalence that viewers felt lies in the fact that:

'Paul was talking to, for the majority of the time, drunken, hardly conscious people who were most likely unaware of his intentions by asking questions that I felt were loaded for someone in a vulnerable state to consider.'

Such ideas of 'informed consent' are common to many comments. In this conception, a person's consent to filming is contingent rather than absolute. They have to be in a frame of mind in which they can take responsibility for their actions. Interestingly, many who hold this position do acknowledge that Watson's subjects did indeed give their consent to filming. However, these commentators do not hold that this consent stretches to moments when these subjects are incapable through drink. In such cases, it is seen as 'taking advantage' to continue to film, despite this being both the point and the power of the film.

'Watson's participants being under the influence and mentally unstable causes some to question whether he is acting ethically responsibly or taking advantage; allowing them to reveal personal issues and granting him full access. Vanda completely exposed herself, I believe as her urge to communicate because of her ongoing loneliness, insecurity and bottled up complexes.'
'There were moments in *Rain in my Heart* that I felt Paul Watson stepped out of line and began to exploit his subjects. I felt that the questions he asked them occasionally went beyond the purpose of the documentary and risked

damaging their already vulnerable state of mind. For example, he pressed Vanda to imagine how many people might turn up at her funeral: I think this is an example of a filmmaker detaching himself too far from the subject and exploiting her vulnerability for a rhetorical flourish.'

This second comment reveals a doubt about the directorial voice ('rhetorical flourish') at particular moments of fine judgement. A few go even further to argue that, in the case of one particular sequence, Watson should have refused to film despite having permission:

'The only thing I did not agree with was the fact that Paul Watson did decide to keep the camera on when one of the patients was dying. Even though the wife of the man allowed Paul to carry on filming I feel that he should have taken the initiative and given the man that respect to die without cameras being there.'[1]

Exploitation is an issue over which many struggle:

'Personally, I feel that if you are going to make a documentary about people and their lives, whether it's alcoholism or anything else, it seems almost necessary to exploit them in order to truly delve into the issues that interest the filmmaker and the audience. Although, in this particular case, the issues brought up truly torment the subjects, Paul Watson made it clear to them that he wasn't trying to force information out of them. When he's talking to a tearful Vanda, for example, he asks her if she wants to stop. This shows that the filmmaker is only exploiting his subjects to a certain extent, as they do have the freedom to decide when and what to talk about, and when to stop. That said, however, Paul Watson wanted to make a documentary about the demons that live inside alcoholics, so essentially I feel that he has to take advantage of the situations Nigel, Toni, Mark and Vanda are in, in order to make a shocking, provoking and effective film.'

For many, the explicit cooperation of the subjects in the making of the film is the crucial determinant of whether exploitation took place:

'One may consider Watson's probing of Toni and Vanda's reasons behind drinking to have been exploitative, but it is justified by his aim to explore the causes of alcoholism, which he noted at the start of the film. Though such moments are part of the private life of the subjects, they are shared so that the public can have a more human understanding of alcoholism. Mark admits in one scene, that he would serve as the perfect advertisement against drinking. Mark's story, along with those of the other subjects, warns the viewers of the dangers of alcohol addiction. Although Watson may have chosen footage to heighten the dramatic impact of his film, he treats his subjects fairly, attempting to communicate the realities of alcohol addiction.'

'In my opinion Watson was not really exploiting his "victims" as they knew what can possibly happen and how they look and behave when they are under influence of alcohol. They gave him their consent when they were sober. I think they knew he was using them to prove his message.'

The notion of informed consent and cooperation of subjects arises acutely in the issue of undercover filming. Most resort to justification in terms of 'the greater good', as we have seen, but some have their doubts:

'However, using a hidden camera on someone is essentially an abuse of their trust, and I feel this is wrong. But then again, in the situation of *MacIntyre Undercover*, his films served a purpose of showing the general public the inside world of organised violence and football hooliganism, as well as providing the police with sufficient evidence to prosecute the men in the film. But there is still an issue in the fact that MacIntyre filmed the men without their permission and broadcast it to the world. I am by no means saying they didn't deserve this, but in the instance of the man in charge of the 'Reading Youth Firm' boasting in the pub about his violence, I found it uncomfortable to be watching when the conversation was evidently meant to be between friends with a drink. The fact that he had been drinking and was probably exaggerating to impress his friends also struck me as something we shouldn't be watching.'

This comment is unusual in its ethical stance, but typical in another respect. It pays close attention to the film as an interaction in order to justify that stance. It draws conclusions both from the nature of the exchange ('probably exaggerating') and from an awareness of feeling compromised as a viewer ('something we shouldn't be watching'). Indeed, in deciding whether exploitation has taken place, many weigh up their own moral scruples against the evidence of the personal filmmaking interactions. They deduce much from the details of what they see:

'Paul also mentioned several times that he felt like he was "taking advantage" and I certainly felt like that when he was checking her pulse, the camera was neatly framed still, even though she could have been dying. He of course had to detach himself from the situation but there is a fine line between your expectations as a filmmaker and a human.'

Here, the 'neat' nature of the framing is instanced as evidence that the filmmaker was maintaining a greater professional distance than the situation demanded. Another makes larger deductions from the look of the film:

'Paul uses obtrusive camera techniques to create a sense of intimacy, framing close to the subject's faces (and his own) whilst asking questions to vulnerable people. He is effectively putting words in their mouths. He could have asked

them anything and they would have agreed. Any conclusion could have been drawn, depending on what he decided to ask.'

This commentator expresses a minority view, and concludes that:

'I believe the four alcoholics have been exploited because Paul Watson didn't represent their reality, just the stories he wanted to display.'

This minority reaction is based on a belief that filmmakers are powerful and their subjects powerless; nevertheless this is typical in drawing such conclusions from observations of the nature of the filmic encounters. More typical is a nuanced appreciation of the nature of the interactions in what was clearly a long shooting period. Some instanced an evolution in the relationship between Watson and his subjects, consistent with the film being a shared project of revelation of the conditions of chronic alcoholism:

'The fact that Watson uses the camera as a prop, or even a "silent friend", can also be included in the discussion of whether he exploits his subjects or not. As the film goes on, the patients seem to grow fonder of Watson and the kindness and, to a certain extent, the friendship he offers them. As a result, they seem to almost forget that the camera is rolling and that their every emotion is being recorded. A good example to prove this is the fact that, at the beginning of the documentary, Vanda seems very suspicious of the film crew and is not willing to answer some of Watson's more personal questions. However, as time goes by, she gets noticeably more comfortable around him and eventually blurts out her deepest and darkest secret – a crucial trigger of her alcoholism.'

Watson expresses his own unease about some of the situations he finds himself in. Most think that the caring and clear-sighted attitude of the filmmaker compensates for any exploitation:

'To his credit, Paul was open and frank about the challenges he knew he would be/was facing and at times, such as when Cath asked him to film Nigel's last moments, he endeavoured – through the footage he included and his narration – to justify to us his levels of involvement/intrusion.'

The idea of 'exploitation' is closely allied to that of shame, which is experienced differently in different cultural contexts. The following comment eloquently summarises the unease that the film provokes:

'I do agree with many of the arguments [about exploitation], specifically when you can consider how easily the subjects could be exploited. However I would also argue that these people agreed to be filmed for a reason. To me it seemed that, their state of minds, the influence of their heavy drinking, and their

slowly decaying bodies had almost driven them to a point where they were ready to completely throw themselves down in front of the camera for everyone to see what they had become.'

Reactions to *Rain in My Heart* raise a series of ethical issues around the relationship between the filmer and the filmed. The comments are concerned with the limits that filmers should place on their behaviour: when they should intervene rather than continue filming; whether they should assume that consent to film covers moments when a subject's decision-making capacities are impaired; and what degree of discretion should be exercised over the subsequent use of footage gained in this way. These are concerns that have long exercised the consciences of filmmakers. I believe it to be a new development that they are now widely debated among viewers themselves. Other researchers have found that vivid discussions take place about such issues in domestic situations as well (Hill 2005; Wood 2009).

Truth and sincerity

Filmers, however, are not the only ones with responsibilities in relation to documentaries. The filmed subjects are also required to behave in certain ways: they must give an honest or sincere account of themselves, rather than pretending to be what they are not. The issue of fakery is felt acutely. The students were shown *The Connection* (de Beaufort, 1996), a TV documentary about drug trafficking which won several industry awards before being revealed as a fake (Ellis 2005). Reactions are remarkably aggressive, and invariably take one of two forms. One set of comments accepts that the film is effective:

> 'The documentary is extremely clever if it was intentional. It uses all the premise of documentary, the formula, the voice of god, professionals etc. which add up to provide facts to unsuspecting viewers but of course this isn't the case. The uproar that was caused only highlights how people value documentary as truth, lying through a documentary is like lying to your parents, it leads to disappointment and anger. Coincidentally, these were the feelings that I had when it finished, disappointment that I had been lied to for an hour and anger that I now had to write about how much I disliked it.'

The other line of attack rounds on the documentary and denies that it is effective in the first place:

> 'To be honest I have no idea how so many people were fooled by this film. To me, everything looked false. If they had shown the same footage and claimed it to be a reconstruction, I would have seen where it could have been believable, but the whole thing was so blatantly set-up. The attempt at giving a hidden-camera effect was terrible — they either wobbled the camera too much to seem real, or had a far too steady view.'

The truth claims of documentary are still seen as the bedrock of the genre: 'lying through a documentary is like lying to your parents'. However, this is a clear case of deliberate imposture on the part of a whole production, and one that fooled the TV industry as well. Far more tricky is the requirement that individual documentary subjects should also refrain from hiding their true identity or motives. This is clear from the case of Molly Dineen's film *Geri* (1999) about pop star Geri Halliwell immediately after she walked out on the highly successful manufactured group Spice Girls.

There is widespread acknowledgement that it is difficult for a viewer to judge the status of what they see in such a film:

> 'I think that although [Halliwell] may be sincere throughout the documentary, she must be aware of the cameras and therefore putting on a performance at times. She does seem sincere when she is talking about being lonely, however it feels as if she knows the camera is there and is putting on a performance at different points. It is hard to be sincere when you have a camera following round, you are bound to want to try and look your best.'
>
> 'Through this documentary one thing is clear: that Halliwell at least attempted to be herself in front of the camera. It is also true that we can observe her personal life instead of watching as a fan. However how truthful can a person be when he or she knows there is a camera in front? [...] In terms of philosophy we don't even know which is our fundamental face. Thus it will never be 100 per cent sincere nor 100 per cent fake. In my opinion the most successful thing in this film is it gives audiences or fans a different visual angle to understand Halliwell's life. On the other hand, it is also possible to say that Halliwell successfully gave audiences or fans a more approachable and understandable public figure.'

Given this perspective, reactions to the film go in three directions, and result in very different understandings. The first is to deny absolutely that there is anything more in the film than Halliwell's determined performance, and so to conclude that the documentary has little value.

> 'Geri Halliwell is clearly an attention seeker and she does put on an embarrassing performance in front of the camera. In that sense she is "being herself" because this is who she is. She shows her feelings sincerely however, as we already established, people generally behave in a certain way when they are aware of the camera and Geri is not an exception. Regardless of Geri being herself or not, the documentary was pretty pointless and I wonder why would anyone want to make it.'

Others even conclude that Halliwell made a shrewd calculation in advance of the kind of impression she wished to create:

'I think she was well aware of how to behave and react to certain situations that arose when the camera was present. The fact that she called Molly specifically to film her, and knew that she would have no control over mediating the footage [meant that she] could only be sure of portraying a sincere side by performing for the camera.'

A variant of this reaction accepts that performance for the camera is natural for someone of Halliwell's background, and finds interest in this:

'[Halliwell] reveals an excessive amount about herself, as if the viewer was a new friend, relaying information of her personal life, her sex life and access to seeing her in different and private locations. This gives the viewer the impression they are watching the "real Geri". However, I believe this is part of her motive and her performance for the camera and therefore lacks sincerity and authenticity. Overall I feel we see a preview of Geri Halliwell but can only psychoanalyse her performance to understand who she really is underneath it.'

This view posits another identity which lies, inaccessibly, behind the performance. Others will go further and see performance as exactly the essence of her identity:

'I think Geri comes across as herself but that person is someone who has spent a large portion of her adult life in front of the camera wanting others to like her. Perhaps in this documentary nothing has changed.'

'Geri is being herself it seems throughout the whole film. When she's with her family (people not familiar with the spotlight) she acts in the same way as when it's just her and the camera. She comes across as genuine and at times naive; an attractive quality in what is a confident egotistical industry. She says at the beginning of the film that it's her film, but is quite rightly told by the filmmaker that it is in fact her film and she will not simply cut out bits, Geri is put in her place and treated almost like a child. I found that she was quite childish at times. Geri is honest in admitting that she wants to convey a certain image, it is after all her job … .'

The second group of reactions acknowledges the belief that Halliwell's increasing frankness is also a calculated performance, but then claims that the camera was able to catch her off guard, or to reveal something beyond or behind the performance:

'I believe that on the most part every individual would want to portray a positive image of themselves. Interestingly though, Geri Halliwell (who had spent just under a decade in the public eye up until this point) comes across particularly frank within the documentary. She shies away from very little; talking about her personal life, her sex life and even allowing the camera to be present when she is naked in her dressing room. This gives the viewer an overall impression of "the real Geri". However, I do believe that this in itself is

part of her performance. I took it that, rather than what she says in the film to be the real her, it is the awkward looks and moments that she may have pre-ferred that the camera did not capture [that are] an actual glimpse into the performer's true being in everyday life.'

'When the camera caught her off guard, you could see she was being sincere.'

A third attitude is to combine both of these views. They claim Halliwell is producing a performance motivated by the need for attention, confirmation and public accep-tance. Yet they also claim that any glimpses beyond that performance confirm the reasons for this rather than revealing a 'deeper' self:

'Geri's original intention to start the documentary was obviously for publicity, but as the documentary went on I think Geri became more and more used to the camera's presence and thus became more herself. She came across as a very sad character, she never seemed to be happy with herself and seemed only to be truly happy when she was being adored by fans. I think this was her being truly sincere. Molly edited the documentary to make her look a bit desperate, clutching on to fame, which was very sad.'

Most comments, like this one, attempt to tie the film into a single impression of Halliwell's character, even though some admit to having doubts along the way:

'Whether or not Geri was acting sincere can also be quite ambiguous. I remember constantly questioning how much of it was real whilst watching the film. Although I do feel she was quite sincere with most of her emotions, it was clear that she was trying a bit too hard to act like an "ordinary" person and gain our sympathy. Nevertheless, the need to act a particular way or put on a particular façade of "sincerity" also says something about her in the end, how she is striving for acceptance and love.'

A significant minority, however, refuse to make overall conclusions, simply pointing out that her behaviour is inconsistent during the filmed sequences:

'Throughout the film she did produce differing kinds of performance of herself in different scenes, and just like anyone she too has different parts that make up her personality. Therefore filming over a long period at a time when this girl's life is going to be turbulent where there is bound to be lots of ups and lots of downs, and her "performance" if only for the camera will change. But what surprised me was how humble and open she was […] the shoots of her living with her family in the farm cottage.'

'As for Geri's sincerity I can see both sides. At times I felt she was being herself, like when she snapped at Molly for filming her mum too much, and other times I thought she was playing up, like when she was getting overexcited because she was "happy".'

Others set a yardstick for measuring 'sincerity': the need to know someone personally:

> 'It is hard to say whether Geri was being sincere or not, as I do not know her, and do not know if how she acted on camera differs to how she would normally be.'
>
> 'Not personally knowing Geri, I could not make a full judgement to whether there were moments of sincerity to her behaviour … .'

The range of comments on *Geri* reveals that sincerity, or the truth about someone, is an important requirement for these viewers. They acknowledge that performance is always a component of this impression, absorbing ideas about the nature of personal behaviour in a world full of cameras and recording devices. But what is remarkable is the lack of consensus about the 'truth' of a documentary subject such as Halliwell. Some find vulnerability where others find a calculated appeal to the viewer's emotions. Some find ordinariness where others find pretence. Many attempt to iron out the inconsistencies of her behaviour, but a few prefer not to reach any firm conclusion. Behind all this lies a feeling that judgement is required from the viewer. While, for these viewers, this may again be a result of the academic setting, it is clear from other studies that many feel that documentaries carry such a requirement. It is the obverse of the social role of the genre and the idea that it 'makes people think' or provides information.

Judgement

Judgement is an ethical concern. The felt requirement to take a position can certainly be refused, with words like 'I can't see why I should be interested' or 'I was moderately bored throughout'. These views, though expressed, remain a minority. Most feel an obligation to reach a judgement, as this response to *Capturing the Friedmans* demonstrates:

> 'I have never found it quite so hard to form a judgement of a character or situation. There seems to be so much conflicting evidence, and the testimonies at times seem both false and outrageous.'

Errol Morris's *The Thin Blue Line* provokes a similar reaction:

> 'This documentary requires the viewer to be active (employing no narration to guide the viewer) more so I feel than any other documentary I've watched on this course. […] It is a technique which is far more effective and just; due to the fact that Morris allows the viewer to objectively analyse, providing them with information from various points of view to render a fair judgement. A stylised and exposing crime investigation.'

These films belong to a group of recent documentaries that are constructed to both invite and frustrate judgement, and so to provoke an examination of the judging

function itself. Some are frank enough to admit that *Capturing the Friedmans* does indeed confront how they have viewed documentaries in the past:

> 'I felt that at the end there would be a resolution and my mind would be at peace, but this was not the case as the ending made me feel even more unsettled than the beginning. After the documentary I was led to do more research because I felt like I just needed some closure, never before have I been affected the way I did about this film, I was so intrigued and wanted to know the truth.'

This viewer feels a need for a 'closure' in relation to film narratives, especially ones like *Capturing the Friedmans* or *The Thin Blue Line*, which revolve around a crime. The requirement is for a piece of evidence or a turn in the narrative that shows (or even tells) a viewer what the truth is. If this is unavailable from the film (and the situation and characters are engaging enough), this viewer will try to seek out that evidence. Others, too, feel clearly the moral requirement that they should reach a judgement; and a judgement moreover that is not clouded by emotions:

> 'I found the documentary a little bit too open to interpretation. There was almost too much information so we became over-involved and thus it became hard to be objective and decisive with what info was being presented.'

Capturing the Friedmans is effective in revealing this attitude to judgement because it incorporates footage with a superior status as evidence: home movie footage. But, as one viewer elegantly put it:

> 'The video footage is there, showing us, telling us exactly what happened, but we have no idea what the truth is.'

Instead, the film deliberately plays with the viewer's sympathies for its different characters:

> 'It was really impossible to tell who told the truth and who didn't. More and more facts did come out. The most fascinating thing is the change of sympathy for the different characters. First I felt for the mother but after about fifteen minutes I started hating her and I felt more sympathetic towards the victims which then turned out to having been forced into different statements (apparently) and towards the end I felt really sorry for the father and the son. [...] I find it really hard to make up my mind about this whole film, which is at the same time the reason why I love it so much.'
>
> 'I felt as if the presentation kept the audience engaged and the use of opinions (e.g. from Friedmans) and story within story (lawyer talking about Arnold getting aroused when he saw the little child bouncing up and down within this documentary) targeted the audience's intellect and ability to question. This provided us (the viewer) with the pleasure of not only seeing a story unfold, but also questioning the way it was unfolded to us.'

The Thin Blue Line has no equivalent of the home movie footage.

> 'The audience is forced to rely on people's word in this documentary. We begin to accuse David Harris, as seemingly more reliable sources deem him a part of the murder and the eventual recorded confession supplies the climactic end of the documentary itself.'

Instead, the film uses stylised reconstructions that challenge the viewer in a different way:

> 'They tried to show conflicting points of view through reconstructions which are almost identical to the previous set up. Personally I found this difficult to follow, as the similarities in the sequences made them difficult to distinguish. I imagine my difficulties stemmed from usually expecting the use of reconstruction within the documentary genre to show the audience what "actually happened". The use in *The Thin Blue Line* threw me because I had to analyse instead of watching passively.'

This is a clear example of a viewer finding the task of judgement unexpectedly difficult as the film refuses to provide the usual indicators of truth through the visual.

Throughout the comments runs a high level of awareness of the ethical dimension of documentary filmmaking. Ethical questions are seen in terms similar to those that have been used by filmmakers for many years. They reveal viewers who are far from naive about filmmaking, who nevertheless bring particular issues of their own in forming their particular judgements. They often refer to perceived norms of behaviour. Many responses to *Capturing the Friedmans* will contain something along these lines:

> 'To be honest I found something very uncanny about both the father and son. They did not seem passionate about their innocence nor did they seem as badly affected as the rest of the family. For someone to accuse you wrongly of so many counts of sexual abuse they showed little anger or betrayal.'

And, on occasion, anecdotal evidence is produced with a flourish to prove a point:

> 'I spoke to a tattooist who said that he wouldn't continue to tattoo someone when they were unconscious, so I don't believe that the scene where this happens to MacIntyre was real (not faked).'

However, most of the time, detailed evidence is produced from within the films to support a particular line of reasoning. The comments show an overall belief in the social purpose of documentaries, which entails the need for viewers to make judgements as well as simply to be informed. There is a belief that truth is not so much a function of filmic representation as a result of the filming process. Truth is sought not

in the photographic but in the interpersonal, in the exchanges between filmer and filmed. So filmmakers have to be careful not to exploit their subjects, and those subjects have a duty to be honest, however much they may perform for the camera. The role of the viewer in forming their judgements is one of seeing through the most flagrant performances to a greater truth, whether it is the truth of a personality or the true course of particular events. The role of the director's 'voice' is to assist the viewer in that process.

14

CONCLUSION

This book aims to examine documentary as a series of efforts of communication. But, as John Peters points out, 'communication is a risky adventure without guarantees. Any kind of effort to make linkage via signs is a gamble, on whatever scale it occurs. [...] Meaning is an incomplete project, open-ended and subject to radical revision by later events' (Peters 2000: 267). This is particularly true of mediated communications. Documentary communication may often be adequate, but it is never perfect. It never lives up to the expectations of either filmers or filmed. The very technologies that enable documentary filming also frustrate its most idealistic aims of showing things as they are. As those machines have changed, so too have beliefs about what constitutes an adequate documentary communication. At the same time, close examination shows that any documentary is the result of a series of communicative attempts by all the parties involved. Depending on their skills and intentions, the filmed can be just as skilled as the filmers in negotiating this process. They reveal and conceal according to how they hope to be received. Recent developments in digital technology have changed the process significantly. In production and post-production, they have enabled commissioning and broadcasting organisations to become more closely involved in the details of the eventual production. Their branding becomes more marked as a result. For the eventual viewers, the everyday use of digital cameras has broadened the general level of appreciation of what it is to film and be filmed, and have rendered obsolete more mystical beliefs about the nature of photography and recording.

The result, however, has not been an increase in the clarity of communication. The different voices involved in any documentary are still heard in different ways, and at differing levels, by individual viewers. These viewers now interrogate what they see and hear by reference to their ideas about what might have happened during shooting. Filmmakers have fed this tendency with more self-referential styles of filmmaking. This increase in the general level of appreciation of how documentary

works has also led to sharply different judgements about its ethics. One person's acceptable technique is another person's unacceptable exploitation. Such ethical stances feed into the varying interpretations that viewers make of complex documentaries, as chapter 13 shows. The result, however, is not unanimity about what any documentary might be trying to say. Documentaries still excite argument and debate, just as much as they provoke strong empathetic emotions. As communications, they are all the more urgent now that we can appreciate their complexity, both in their production and in their viewing.

NOTES

2. From reconstruction to observation: a history of documentary 1895–1995

1 The term 'good-enough mother' is developed in psychoanalysis by Donald Winnicott in opposition to an idealising tendency he found in Kleinian approach. It does not therefore mean 'barely adequate', but rather 'fully able to satisfy in the concrete circumstances of life'. So it is with documentary images. See Bram, Jan and Hjulmand, Knud (2007) *The Language of Winnicott: A Dictionary of Winnicott's use of Words*. London: Karnak, 220–35.

2 Such general trends always have a few dramatic exceptions. See, for example, Esfir Shub's film *K-Sh-E, Komsomol, Chief of Electricity*, analysed in chapter 4.

3 Yet, as Stella Bruzzi shows, this evidence remains inconclusive, open to interpretations (Bruzzi 2006: 17–26).

3. New attitudes to documentary

1 An early contribution to the debate was Brand, Stewart, Kelly, Kevin and Kinney, Jay (1985) 'Digital retouching: the end of photography as evidence of anything', *Whole Earth Review* 47, 42–49.

2 See report by Larry Rohter, 'Iconic Capa war photo was staged', *New York Times* 17 August 2009.

3 I first came across this term in French, in an issue of *Communications* in which social scientists and anthropologists interrogate their routine use of video as a research tool. They do not claim to be filmmakers in the tradition of Jean Rouch or Frederick Wiseman: they do not create for an audience. However, they are using film in a sophisticated way as a tool in their research. Hence they needed a term to describe their status: *'un filmeur'* was the elegant solution. *Communications* 80, Editions du Seuil, Paris, 2006, edited by Daniel Friedmann.

4 A participant recorded the moment when a passer-by, newsvendor Ian Tomlinson, was hit by one of the police, a blow that resulted in his death. The video was posted on the websites of several newspapers. See for instance 'Video of officer hitting Ian Tomlinson', *The Guardian*, www.guardian.co.uk/uk/g20-police-assault-ian-tomlinson?INTCMP=SRCH

5 Photographers Fabrice Chassery, Jacques Langevin and Christian Martinez were at one point condemned by French courts to a prison sentence, but eventually had to pay symbolic damages of €1 for invasion of privacy.

6 See Ben Dowell and James Robinson, 'Amy Winehouse wins court ban on paparazzi at her home', *The Guardian* 2 May 2009, 11.

7 Discussion, 11 November 2008, Long March Canteen. Participants: Fu Xiaodong, Gu Zhenqing, Han Yuting, Li Hongyu, Lin Tianmiao, Liu Wei, Lu Jie, Colin Chinnery, Wang Gongxin, Wang Jianwei, Wang Wei, Zhan Wang, Zhu Yu. Transcript provided by Long March Space.

4. The changing technologies of documentary filmmaking

1 *K-Sh-E* is a bravura performance and begins with an exposition of the process of filming with sound recording itself, shown in some detail; sequences of women working in a telephone exchange; of Radio Moscow broadcasting; of the American supervisor of the hydroelectric project, etc. The film is available at http://service.filmandsound.ac.uk (subscription site restricted to academic institutions in the UK).

2 Sport again figures here as a significant driver of technological innovation in broadcasting.

3 Significantly, it was introduced three years before the 35mm version, which would be used primarily in cinema film production.

4 A recent costing for low-budget filmmaking shows that such levels of cost still exist, despite the ubiquitous use of digital editing of film rather than the celluloid-based processes of the 1990s. 'Cost of 400ft roll of 16mm color negative film stock, plus developing, plus editing – a minimum of around $250 or so. A 400ft roll runs for 11min 7sec. Or around $1350 per hour of footage. Now, in terms of how much actually has to be shot for, say, a 90min feature, let's assume a minimal 3:1 shooting ratio for film; that works out to 4.5 hours of footage. The final result for the cost of shooting stock for a 90min feature: 16mm film: $6075.' www.cinema-astoria.com/cinematography/arri/index.html

5. Performance and self-revelation

1 Some research shows that *Facebook* users have developed strategies for dealing with this, basing their friend network on face-to-face encounters only. Nevertheless, they still have a significant number of 'dormant' friends. See Richardson, K. and Hessey, S. (2009) 'Archiving the self? Facebook as biography of social and relational memory', *Journal of Information, Communication & Ethics in Society* 7, 25–38.

6. Documentary filming as personal interaction

1 Interviewed 19 May 2005.

2 Nixon's fee was $600,000 and 20 per cent of any profits (Frost, David and Zelnick, Bob (2007) *Frost/Nixon: Behind the Scenes of the Nixon Interviews*. New York and London: Harper Perennial).

7. Editing, narrative and separation

1 Interviewed at the Nordiske Mediedager, 2010.

2 Collerton, Patrick (2004) 'Production – on location – preparing for death', *Broadcast* 5 April. www.broadcastnow.co.uk/news/multi-platform/news/production-on-location-preparing-for-death/1091604.article

3 '*montrer, ce n'est pas simplement tender le bras pour désigner. C'est marquer une compassion, exprimer une jubilation, se livrer à une denociation. L'acte de montrer est une pratique professionelle. C'est aussi une forme d'agir, un 'faire' au sens ou, comme le disait J.L. Austin, « dire c'est faire ».*'

8. The changing technologies of documentary editing

1 *The Technique of Film Editing* (Reisz and Millar 1974: 393–95) gives an account based on 1950s feature film practice: 'the mechanical operations performed in the cutting room are relatively simple'. Reisz and Millar describe using a Moviola. By the 1980s the far superior Steenbeck had come into general use. Originally written by Karel Reisz and published in 1953, Gavin Millar's revisions include a discussion of cinema verité documentary editing (Reisz and Millar 1974: 297–322).

9. Slow Film

1 Granada's *World in Action* series 1981–86, *The Murder of Stephen Lawrence* (1999), *Bloody Sunday* (2002), *Omagh* (2004).
2 The blog goes on 'I think the upsetting qualities of the visuals in *The Bourne Ultimatum* derive principally from the particular way the handheld camera is used. Several of Ebert's writers complain that the camerawork made them nauseated, and there seems little doubt that the shots are bouncier and jerkier than in much handheld work. Adding to the effect is the fact that Greengrass often doesn't try to center or contain the main action. Sometimes, as in a fight scene, the camera is just too close to the action to show everything, so it tries to grab what it can. At other times Greengrass pans away from the subject, or shoves it to the edge of the 2.40:1 frame. In the standard technique of over-the-shoulder reverse angles, we see one character's shoulders in the foreground and the primary character's face clearly. Greengrass likes to let a neck or shoulder overwhelm the composition as a dark mass, so that only a bit of the face, perhaps even just a single eye, is tucked into a corner of the shot. This visual idea was already on offer in *The Bourne Supremacy*.'
3 Readers in British universities can access these bulletins online at www.nfo.ac.uk. The bulletin for 9 August 1965 has the persistent URL http://service.nfo.ac.uk/purl/article/0014-0005-4788-0000-0-0000-0000-0. The bulletin for 3 April 2001 has the persistent URL http://service.nfo.ac.uk/purl/article/0014-0005-4566-0000-0-0000-0000-0
4 See also Petrini, Carlo (2004) *Slow Food: The Case for Taste* (*Arts and Traditions of the Table*). New York: Columbia University Press [italics in original].

10. The eventual viewer

1 Commenting on the photo of herself on the cover of the February 2003 edition of *GQ* magazine, Winslet said: 'The retouching is excessive. I do not look like that and more importantly I don't desire to look like that,' she said. 'I actually have a Polaroid that the photographer gave me on the day of the shoot […] I can tell you they've reduced the size of my legs by about a third. For my money it looks pretty good the way it was taken' (*Hello!* magazine 10 January 2003).
2 In August 2007, it was widely reported that L'Oréal Paris had issued an advert for its Féria hair colour, which showed the black singer Beyoncé Knowles with dramatically lightened skin as well as the blonder hair that Féria can produce. L'Oréal denied that image manipulation had taken place.

11. Ambivalent feelings about photography and recording

1 Fox News/Opinion Dynamics poll, 17–18 July 2007, of 900 registered voters nationwide.
2 See Rehabilitation of Offenders Act 1974.
3 Specifically, the Data Protection Act in the UK allows a degree of control over record-ings (especially surveillance material) of which the individual has been the specific subject rather than just 'caught on camera' as they passed by.

12. Witness and watching

1 Voyeurism often involves the fantasy that the watched other has given their consent in some way, for instance by not closing the curtains sufficiently.

13. Ethics, interpretation and the new viewer

1 The issue of filming the moment of death is one that Watson has encountered in other films.

FILMOGRAPHY

Single documentaries

The Battle of the Somme d. Geoffrey Malins, J.B. McDowell, 1916, 74min
Bing'Ai d. Feng Yan, China 2007, 114min
The Boy Whose Skin Fell Off d. Patrick Collerton, UK Channel 4, 25 March 2004, 21:00, 60min
Capturing the Friedmans d. Andrew Jarecki, USA 2003, 107min
The Connection, d. Marc de Beaufort, UK ITV, 15 October 1996, 22:40, 56min
Coronation of Edward VII d. Georges Méliès, UK 1902, 3min
Dont Look Back d. D.A. Pennebaker, USA 1967, 96min
Fahrenheit 9/11 d. Michael Moore, USA 2004, 122min
Fires Were Started (aka. *I Was a Fireman*), d. Humphrey Jennings, UK 1943, 63min
Geri d. Molly Dineen, UK Channel 4, 5 May 1999, 21:00, 90min
Haxan: Witchcraft Through the Ages d. Benjamin Christiansen, Denmark 1922, 87min
Heidi Fleiss: Hollywood Madam d. Nick Broomfield, UK etc. 1995, 106min
Housing Problems d. Arthur Elton, Edgar Anstey, UK 1935, 13min
An Inconvenient Truth d. Davis Guggenheim, USA 2006, 100min
K-Sh-E, Komsomol, Chief of Electricity d. Esfir Shub, USSR 1932, 56min
Land Without Bread (Las Hurdes) d. Luis Buñuel, Spain 1933, 30min
The Leader, His Driver and the Driver's Wife d. Nick Broomfield, UK etc. 1991, 85min
London d. Patrick Keiller, UK 1994, 85min
Nanook of the North d. Robert Flaherty, USA 1922, 79min
Night Mail d. Harry Watt, Basil Wright, UK 1936, 24min
9/11 (2002), d. Gédéon and Jules Naudet with James Hanlon, Rob Klug, USA 2002, 112min
9/11 The Falling Man d. Henry Singer, UK Channel 4, 15 March 2006, 21:00, 90min
Ordinary People, d. Jack Lee, J.B. Holmes, UK 1941, 27min
Primary d. Robert Drew, USA 1960, 60min
Profils Paysans d. Raymond Depardon, France: *1. L'Approche* 2001, 90min; *2. Le Quotidien* 2004, 85min; *3. La Vie Moderne* 2009, 88min
Rain in My Heart d. Paul Watson, UK BBC2, 21 November 2006, 21:00, 90min
Rough Aunties d. Kim Longinotto, UK Channel 4, 3 August 2010, 22:00, 135min
Sunless d. Chris Marker, France 1982, 100min

The Thin Blue Line d. Errol Morris, USA 1988, 103min
Twin Towers d. Bill Guttentag, Robert Port, USA 2003, 34min
With Captain Scott R.N. to the South Pole (aka *The Great White South*) d. Herbert Ponting, various versions 1911–1936

TV series and formats

An American Family documentary series d. Craig Gilbert, PBS USA, twelve episodes from 12 January 1973
Big Brother format, originally Netherlands, Veronica, 1999, UK Channel 4 2000–10 etc.
Candid Camera format, USA 1948–present, mainly CBS; ITV, UK 1960–65, 1974, 1976 etc.
Channel 4 *Dispatches* current affairs format, UK Channel 4, 55min approx., seasons from 1987
The Family documentary series d. Paul Watson, Franc Roddam, BBC UK, 12 × 30min from 3 April 1974
Game for a Laugh format, UK ITV, 58 episodes from September 1981–November 1985
The House documentary series, UK BBC2, 6 × 60min from 16 January 1996, 21:30
MacIntyre Undercover current affairs series, UK BBC1 then Channel 5, 1999–2003
Monarchy: The Royal Family at Work documentary series, UK BBC1 5 × 60min from 26 November 2007
The Nixon Interviews series, USA syndication, 4 × 90 min, 4–26 May 1977
Noel's House Party format, UK BBC1, eight series 23 November 1991–20 March 1999
Panorama current affairs format, UK BBC1 1953–present, episode Martin Bashir interviews Diana, Princess of Wales, 20 November 1995
Piers Morgan's Life Stories, interview series, UK ITV 2009–10
Police documentary series d. Roger Graef, UK BBC1, 6 × 40min, 1982
Russian Wonderland documentary series, p. Colin Luke, UK BBC2, 13 × 30min
Video Nation format, UK BBC2 then Community Channel, 1994–2009

Fiction films and TV

Armageddon d. Michael Bay, p. Jerry Bruckheimer, 1998, 150min
Blow-Up d. Michelangelo Antonioni, p. Carlo Ponti, 1966, 111min
The Bourne Ultimatum d. Paul Greengrass, p. Frank Marshall, 2007, 115min
The Fall of the Roman Empire d. Anthony Mann, p. Samuel Bronston, 1964, 188min
Flags of Our Fathers d. Clint Eastwood, p. Clint Eastwood, Steven Spielberg, 2006, 132min
Frost/Nixon d. Ron Howard, p. Tim Bevan, 2008, 122min
Gladiator d. Ridley Scott, p. David Franzoni, Branko Lustig, 2000, 155min
Lord of the Rings: The Fellowship of the Ring d.,p. Peter Jackson, 2001, 178min
The Matrix d. Andrew Wachowski, Lana Wachowski, p. Joel Silver, 1999, 136min
NYPD Blue TV series p. Steven Bochco, David Milch, USA 1993–2005, 263 episodes
Spartacus d. Stanley Kubrick, p. Edward Lewis, 1960, 184min
The Thick of It TV series, p. Armando Iannucci, UK 2005–09
The Truman Show d. Peter Weir, p. Scott Rudin, 1998, 103min
The West Wing TV Series, p. Aaron Sorkin, USA, 1999–2006, 154 episodes

BIBLIOGRAPHY

Anon. (1894) *Amateur Photographer* 27 September, 194.

Arriflex (n.d.) 'History', www.arri.de/about_arri/history.html

Ascher, Steven and Pincus, Edward (2002) *The Filmmaker's Handbook*. Harmondsworth: Penguin.

Aufderheide, Patricia (2007) *Documentayr Film: A Very Short Introduction*. Oxford: Oxford University Press.

Austin, Thomas (2007) *Watching the World*. Manchester, UK: Manchester University Press.

BBC (2004) 'Editor sacked over 'hoax' photos', *BBC News*, 14 May. http://news.bbc.co.uk/1/hi/uk_politics/3716151.stm

——(2007) 'BBC One boss quits over Queen row'. *BBC News*, 5 October. http://news.bbc.co.uk/1/hi/7029940.stm

——(2010) *Editorial Guidelines*. Last updated 19 October. www.bbc.co.uk/guidelines/editorialguidelines/page/guidance-access-agreements-summary

Berry, Chris (2007) 'Getting real: Chinese documentary, Chinese postsocialism', in Zhang, Zhen (ed.) *The Urban Generation: Chinese Cinema and Society at the Turn of the 21st Century*. Durham, NC: Duke University Press, 115–34.

Bordwell, David (2005) *Figures Traced in Light: On Cinematic Staging*. Berkeley, CA: University of California Press.

——(2006) *The Way Hollywood Tells It: Story and Style in Modern Movies*. Berkeley, CA: University of California Press.

Bradshaw, Peter (2010) 'Review: *Rough Aunties*', *The Guardian* 16 July: 8.

Briggs, Asa (1958) 'Self-help. A centenary introduction', in Smiles, Samuel (ed.) *Self-Help: The Art of Acheivement Illustrated by Accounts of the Lives of Great Men*. London: John Murray.

Bruzzi, Stella (2006) *New Documentary*. London and New York: Routledge.

Caldwell, John Thornton (1995) *Televisuality: Style, Crisis and Authority in American Television*. Piscataway, NJ: Rutgers University Press.

Carpentier, Nico (2003) 'The BBC's Video Nation as a participatory media practice: signifying everyday life, cultural diversity and participation in an online community', *International Journal of Cultural Studies* 6, 425–47.

Chanan, Michael (2007) *The Politics of Documentary*. London and New York: Routledge.

Chapman, Jane (2009) *Issues in Contemporary Documentary*. Cambridge, UK: Polity Press.

Clover, Carol (2000) 'Judging audiences: the case of the trial movie', in Gledhill, Christine and Williams, Linda (eds) *Reinventing Film Studies*. London: Edward Arnold.

Collerton, Patrick (2004) 'Production – on location – preparing for death', *Broadcast* 5 April. www.broadcastnow.co.uk/news/multi-platform/news/production-on-location-preparing-for-death/1091604.article (subscription).

——(2005) 'Interview: Patrick Collerton – uplifting misery', *Broadcast* 6 June. www.broadcastnow.co.uk/news/multi-platform/news/interview-patrick-collerton-uplifting-misery/1025443.article (subscription).

Cooke, Rachel (2010) 'Radio review', *The Observer* 10 October, 35.

Cullars, John (1998) 'Photomontage', *Design Issues* 14, 67–68.

Dayan, Daniel (2007) 'Le ralenti d'une explosion: les performances de 11 Septembre', in Dayan, Daniel (ed.) *La Terreur Spectacle*. Paris: INA/De Boeck.

——(2009) 'Sharing and showing: television as monstrance', *Annals of the American Academy of Political and Social Science* 625, 19–31.

Dayan, Daniel and Katz, Elihu (1992) *Media Events*. Cambridge, MA: Harvard University Press.

Delavaud, Gilles (2005) *L'art de la télévision: histoire et esthétique de la dramatique télévisée*. Paris: INA/de Boeck.

Didi-Huberman, Georges (2009) *L'Oeil de l'histoire: Tome 1, Quand les images prennent position*. Paris: Minuit.

Don, Katherine (2009) 'Xu Zhen', *Art in America* March, 168.

Dovey, John (2000) *Freakshow: First Person Media and Factual TV*. London: Pluto Press.

Duan, Changming and Hill, Clara E. (1996) 'The current state of empathy research', *Journal of Counseling Psychology* 43, 261–74.

Ellis, John (2000a) *Seeing Things: Television in the Age of Uncertainty*. London: I.B. Tauris.

——(2000b) 'British cinema as performance art', in Ashby, Justine and Higson, Andrew (eds) *British Cinema, Past and Present*. London and New York: Routledge, 95–109.

——(2005) 'Documentary and truth on television: the crisis of 1999', in Corner, John and Rosenthal, Alan (eds) *New Challenges in Documentary*. Manchester, UK: Manchester University Press, 342–60.

——(2007) *TV FAQ: Uncommon Answers to Common Questions about TV*. London: I.B.Tauris.

——(2009a) 'Mundane witnessing', in Frosh, Paul and Pinchevski, Amit (eds) *Media Witnessing: Testimony in the Age of Mass Communication*. London and New York: Palgrave Macmillan, 73–88.

——(2009b). 'What are we expected to feel? Witness, textuality and the audiovisual', *Screen* 50, 67–76.

——(2010) 'The digitally enhanced audience', in Gripsrun, Jostein (ed.) *Relocating Television*. London and New York: Routledge.

——(2011) 'The performance of self on television: the case of ITV's first gameshow', in Delavaud, Gilles and Marechal, Denis (eds) *Television: the Experimental Moment*. Paris: INA.

Feng, Yan (n.d.) 'Director's statementi', *China Independent Documentary Film Archive*, www.cidfa.com/documentary_info/Bing_Ai.htm

Fetveit, Arild (1999) 'Reality TV in the digital era: a paradox in visual culture?' *Media, Culture & Society* 21, 787–804.

Fisher, Bob (n.d.) 'A conversation with Joan Churchill, ASC', *On Film Interviews*, Kodak website, http://motion.kodak.com/US/en/motion/Publications/On_Film_Interviews/churchill.htm

Fowler, Rebecca (1995) 'Julia Somerville defends "innocent family photos"', *The Independent* 5 November.

Friday, Jonathan (1997) 'Digital imaging, photographic representation and aesthetics', *Ends and Means* 1, 7–11.

Frosh, Paul (2001) 'The public eye and the citizen-voyeur: photography as a performance of power', *Social Semiotics* 11, 43–59.

——(2003) *The Image Factory: Consumer Culture, Photography and the Visual Content Industry*. Oxford: Berg.

——(2009) Telling presences: witnessing, mass media and the imagined lives of strangers', in Frosh, Paul and Pinchevski, Amit (eds) *Media Witnessing: Testimony in the Age of Mass Communication*. London and New York: Palgrave Macmillan.

Garland, David (2001) *The Culture of Control: Crime and Social Order in Contemporary Society*. Chicago, IL: University of Chicago Press.

Girardin, Daniel and Pirker, Christian (2008) *Controverses: une histoire juridique et ethique de la photographie*. Lausanne: Actes Sud/Musee de l'Elysee.

Goffman, Erving (1959) *The Presentation of Self in Everyday Life*. New York: Doubleday.

——(1971) *Relations in Public: Microstudies of the Public Order*. New York: Basic Books.

——(1986) *Frame Analysis: An Essay on the Organization of Experience*. Boston, MA: Northeastern University Press.

Grierson, John (1966) *Grierson on Documentary*. Berkeley, CA: University of California Press.

Guerin, Frances and Hallas, Roger (2007) *The Image and the Witness: Trauma, Memory and Visual Culture*. Brighton, UK: Wallflower Press.

Hansen, Miriam (1991) *Babel and Babylon: Spectatorship in American Silent Film*. Cambridge, MA: Harvard University Press.

Hill, Annette (2005) *Reality TV: Audiences and Popular Fiction*. London and New York: Routledge.

——(2007) *Restyling Factual TV: Audiences and News, Documentary and Reality Genres*. London and New York: Routledge.

Hoffman, Martin L. (2000) *Empathy and Moral Development: Implications for Caring and Justice*. Cambridge, UK: Cambridge University Press.

Hopkins, John (1973) *Video in Community Development*. London: Ovum Press.

Jacobs, Jason (2000) *The Intimate Screen: Early British Television Drama*. Oxford, UK: Oxford University Press.

Johnson, Catherine (forthcoming) *Branding*. London and New York: Routledge.

Jones, Alice (2010) 'Hotel Inspector', *The Independent* 23 July.

Keen, Suzanne (2007) *Empathy and the Novel*. Oxford, UK: Oxford University Press.

Kermode, Frank (2000) *The Sense of an Ending*. Oxford, UK: Oxford University Press.

King, Geoffrey (2002) *New Hollywood Cinema: An Introduction*. London: I.B.Tauris.

Kuehl, Jerry (1999) 'Lies about real people', in Rosenthal, Alan (ed.) *Why Docudrama?: Fact–Fiction on Film and TV*. Edwardsville, IL: Southern Illinois University Press.

Lasswell, Harold D. (1948) 'The structure and function of communication in society', in Bryson, L. (ed.) *The Communication of Ideas*. New York: Harper & Row.

Loomis, Amy (2004) 'Candid Camera', in Newcomb, Horace (ed.) *The Encyclopedia of Television*. Chicago, IL: Fitzroy Dearborn/Museum of Broadcast Communications.

Lyon, David (2003) 'Surveillance technology and surveillance society', in Misa, Tom, Feenberg, Andrew and Brey, Philip (eds) *Technology and Modernity*. Cambridge, MA: MIT Press.

MacLeod, Scott (1994) 'Life and death of Kevin Carter', *Time* 12 September.

Maerkle, Andrew (2010) 'Xu Zhen: The Path to Appearance is Always', ART iT, www. art-it.asia/u/admin_ed_itv_e/5Vsp7C1ZfHEvBW8qoblX/?lang=en

Marx, Gary T. (2001) 'Murky conceptual waters: the public and the private', *Ethics and Information Technology* 3, 157–69.

Mensel, Robert E. (1991) 'Kodakers lying in wait: amateur photography and the right to privacy in New York 1885–1915', *American Quarterly* 43, 24–45.

Mitchell, William J. (1994) *The Reconfigured Eye: Visual Truth in the Post-Photographic Era*. Cambridge, MA: MIT Press.

Mittell, Jason (2004) *Genre and Television: From Cop Shows to Cartoons in American Culture*. London and New York: Routledge.

Montagu, Ivor (1964) *Film World: A Guide to Cinema*. Harmondsworth: Penguin.

Moore, Charlotte (2010) 'I want', *Broadcast* 26 November, 31.

Morgan, Piers (2010) 'My Week', *Mail on Sunday*, *Live Magazine* 22 August.

Nagra (n.d.) 'History', www.nagraaudio.com/pro/pages/informationHistory.php

Neale, Steve (1985) *Cinema and Technology: Image, Sound, Colour.* Bloomington, IN: Indiana University Press.
——(2000) *Genre and Hollywood.* London and New York: Routledge.
Newcomb, Horace (n.d.) *Encyclopedia of Television.* Chicago, IL: Fitzroy Dearborn.
Nichols, Bill (1991) *Representing Reality.* Bloomington, IN: Indiana University Press.
Norman, D.A. (1988) *The Psychology of Everyday Things.* New York: Basic Books.
Peters, John Durham (2000) *Speaking into the Air: A History of the Idea of Communication.* Chicago,IL: Chicago University Press.
——(2009) 'Witnessing', in Frosh, Paul and Pinchevski, Amit (eds) *Media Witnessing: Testimony in the Age of Mass Communication.* London and New York: Palgrave Macmillan, 23–48.
Ponce de Leon, Charles (2002) *Self-exposure: Human-Interest Journalism and the Emergence of Celebrity in America,* 1890–1940. Chapel Hill, NC: University of North Carolina Press.
Portinari, Folco (n.d.) 'The Slow Food Manifesto', *Slow Food.* www.slowfood.com/about_us/eng/manifesto.lasso
Preston, Stephanie D. and de Waal, Frans B.M. (2002) 'Empathy: its ultimate and proximate bases', *Behavioural and Brain Sciences* 25, 1–72.
Reisz, Karel and Millar, Gavin (1974) *The Technique of Film Editing,* 2nd edn. Oxford, UK and Woburn, MA: Focal Press (first published 1953).
Renov, Michael (2004) *The Subject of Documentary.* Minneapolis, MN: University of Minnesota Press.
Ricoeur, Paul (1980) 'Narrative time', *Critical Inquiry* 7, 169–90.
Robinson, Luke (n.d.) 'Contingent and event in China's new documentary film movement', *Nottingham ePrints,* http://eprints.nottingham.ac.uk/546/1/Luke_Robinson_RAE1.pdf
Russell, Patrick (2007) *100 British Documentaries.* London: British Film Institute.
Scannell, Paddy (1996) *Radio, Television and Modern Life: A Phenomenological Approach.* Oxford, UK: Blackwell.
——(2000) 'For anyone-as-someone structures', *Media, Culture & Society* 22, 5–24.
——(2004) 'What reality has misfortune?', *Media, Culture & Society* 26, 573–84.
——(2007) *Media and Communication.* London: Sage.
Schneider, Ira and Korot, Beryl (1976) *Video Art: An Anthology.* San Diego: Harcourt Brace Jovanovich.
Silverstone, Roger (2007) *Media and Morality: On the Rise of the Mediapolis.* Cambridge, UK: Polity Press.
Smiles, Samuel (1905) *The Autobiography of Samuel Smiles.* New York: E.P. Dutton & Co.
Smith, Jacob (2008) *Vocal Tracks: Performance and Sound Media.* Berkeley, CA: University of California Press.
Smither, Roger (1993) 'A wonderful idea of the fighting: the question of fakes in "Battle of the Somme"', *Historical Journal of Film, Radio and Television* 13, 149–68.
Sontag, Susan (2010) *Regarding the Pain of Others.* New York: Picador.
Tincknell, Estella and Raghuram, Parvati (2004) 'Big Brother: reconfiguring the 'active' audience of cultural studies?', in Holmes, Su and Jermyn, Deborah (eds) *Understanding Reality Television.* London and New York: Routledge, 252–69.
Tryhorn, Chris and O'Carroll, Lisa (2004) 'Morgan sacked from *Daily Mirror*'. *The Guardian,* 14 May. www.guardian.co.uk/media/2004/may/14/pressandpublishing.iraqandthemedia
Turner, Graeme (2009) *Ordinary People and the Media: The Demotic Turn.* London: Sage.
Turnock, Rob (2007) *Television and Consumer Culture: Britain and the Transformation of Modernity.* London: I.B. Tauris.
Vaughan, Dai (1983) *Portrait of an Invisible Man: The Working Life of Stuart McAllister, Film Editor.* London: British Film Institute.
——(1999) *For Documentary.* Berkeley, CA: University of California Press.
Weitz, Anna (2008) 'Portrait: Kim Longinotto', *Nisimazine,* www.nisimazine.eu/Kim-Longinotto.html
Winston, Brian (1999) *Fires Were Started.* London: British Film Institute.

——(2000) *Lies, Damn Lies and Documentary*. London: British Film Institute.

Wood, David (2008) 'Broadcast at 50: 50 Years of Technology supplement', *Broadcast* 13 February.

Wood, Helen (2009) *Talking with Television: Women, Talk Shows and Modern Self-reflexivity*. Champaign, IL: University of Illinois Press.

INDEX

www.routledge.com/media

The Ideal Companion to *Documentary*

Routledge Film Guidebooks
Documentary

David Saunders

Dave Saunders' spirited introduction to documentary covers its history, cultural context and development, and the approaches, controversies and functions pertaining to non-fiction filmmaking. Saunders examines the many methods by which documentary conveys meaning, whilst exploring its differing societal purposes. From early, one-reel 'actualities' to the box-office successes of recent years, artistic complexities have been inherent to non-fiction cinema, and this *Guidebook* aims to make such issues clearer.

After a historical consideration of international documentary production, the author examines the impact of recent technological developments on the production, distribution and viewing of non-fiction. In addition, he explores the increasingly hazy distinctions between factual and dramatic formats, discussing 'reality television', the 'docu-drama', and less orthodox approaches including animated and fantastical representations of reality.

Documentary encompasses a broad range of academic discourse around non-fiction filmmaking, introducing readers to the key filmmakers, major scholars, central debates and critical ideas relating to the form. This wide-ranging guidebook features global releases from the 1920s through to 2009.

Hb: 978-0-415-47309-5
Pb: 978-0-415-47310-1
eBook: 978 0 203 85268 2

For more information and to order a copy visit
www.routledge.com/9780415473101

Available from all good bookshops